IMAGES
of America

ROCHESTER'S LEADERS
AND THEIR LEGACIES

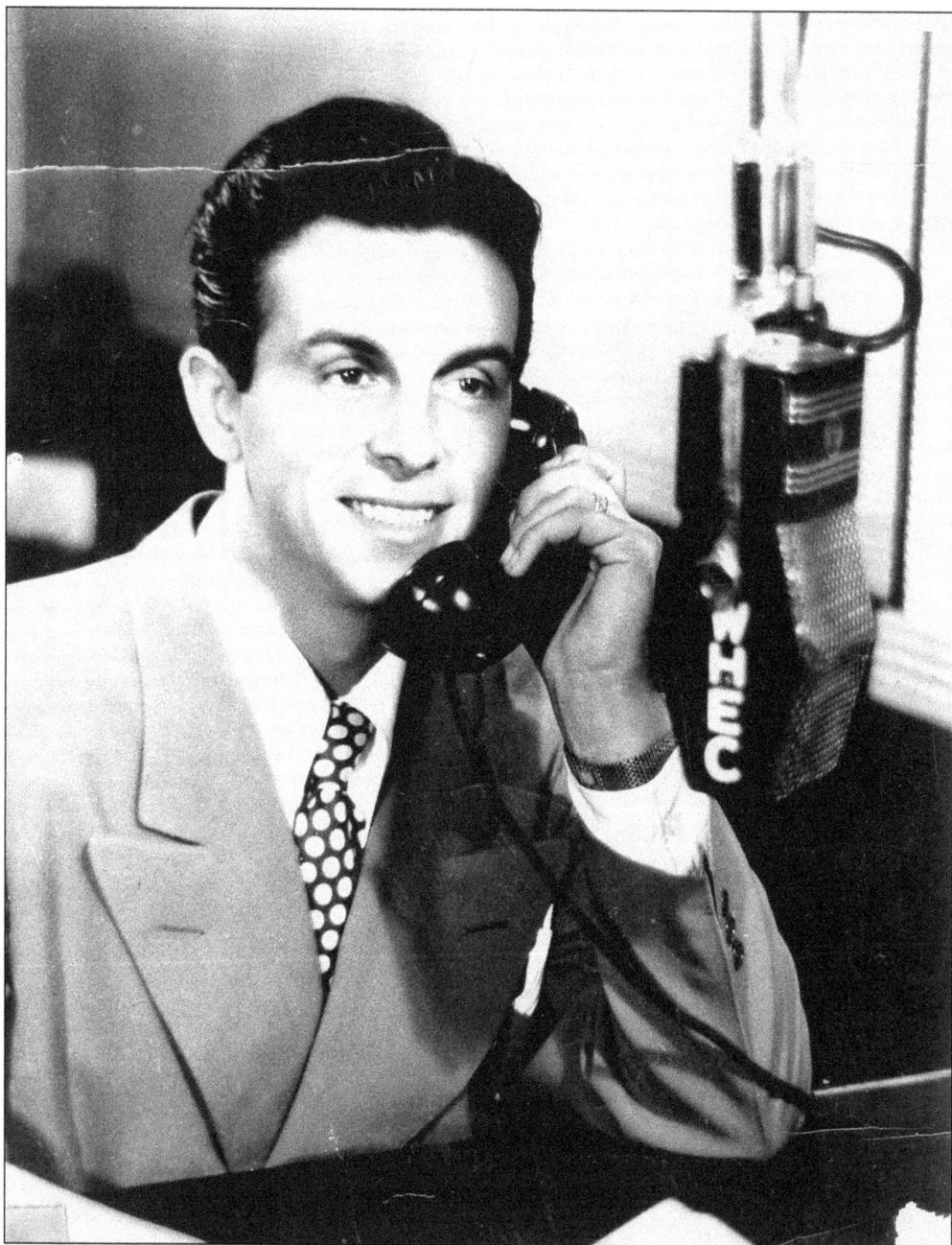

Eddie Meath was one of Rochester's leading radio and television personalities. For years, he was the voice behind the microphone at radio station WHEC. He devoted much of his time off the air to charities and served as master of ceremonies at many civic, fraternal, and social events. His penny fund paid for toys that were presented to children following their stay at Rochester hospitals.

IMAGES
of America

ROCHESTER'S LEADERS AND THEIR LEGACIES

Donovan A. Shilling

ARCADIA
PUBLISHING

Copyright © 2005 by Donovan A. Shilling
ISBN 978-1-5316-2275-6

Published by Arcadia Publishing
Charleston, South Carolina

Library of Congress Catalog Card Number: 2005924387

For all general information contact Arcadia Publishing at:
Telephone 843-853-2070
Fax 843-853-0044
E-mail sales@arcadiapublishing.com
For customer service and orders:
Toll-Free 1-888-313-2665

Visit us on the Internet at www.arcadiapublishing.com

CONTENTS

ACKNOWLEDGMENTS

The fifth book in the Arcadia series has been the most challenging. We wish to thank Steve Fell, Gerry Muhl, Emerson Klees, and my ever patient and supportive wife, Yolanda, for their encouragement, assistance, and advice. Those members of the Historical Division of the Rochester Public Library, the Rochester Historical Society, and others who made information or photographs available for inclusion in this book are also much appreciated.

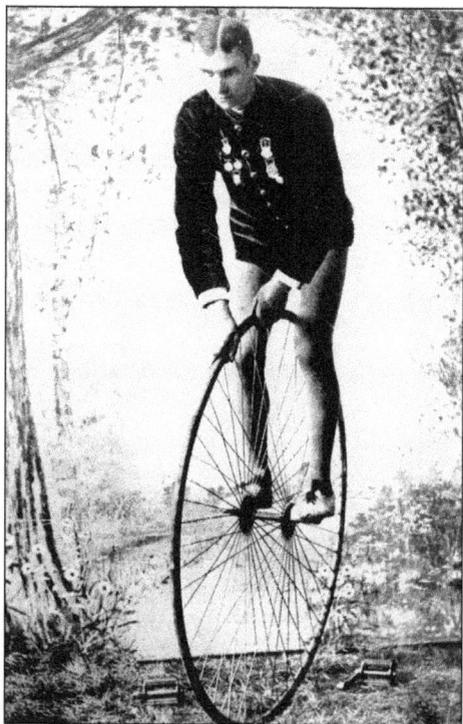

An amazing show was given by Nick E. Kaufman of Rochester, performing at Ontario Beach Park with an almost unbelievable series of acrobatic tricks on his high wheeler. As shown in this c. 1911 photograph, Kaufman has lost most of the bicycle and is now balancing on the axle. He is wearing a treasury of medals won during his 1909 international tour performing for various royal courts in London, Paris, and Berlin.

INTRODUCTION

Rochester Leaders and Their Legacies is a treasury of rarely seen images of more than 40 leaders from the city's past. It reveals Rochester as a unique city winning a place for itself in history, culture, and industry. Included is a cross section of greater and lesser known leaders—talented entertainers, bold civic leaders, ingenious inventors, and resourceful entrepreneurs—who together made their city the third-largest in the Empire State and whose legacies earned Rochester the titles of Flour City, Flower City, and Image City.

Vintage images show nurserymen and seedsmen James Vick, Elwanger and Barry, Charles Green, the Briggs Brothers, and Hiram Sibley—all who helped Rochester become the center for horticulture, earning it the title of the Flower City.

Rare photographs record the legacies of current and bygone industries that manufactured gear-cutting machines, stoves, playing cards, root beer, ice cream, trolley wheels, telephones, thermometers, and photographic and optical products.

In sports there are the "gems of the green diamonds," Albert Mattern, who played for the Rochester Beau Brummels, and "Big Jawn," who played for the Rochester Hustlers, plus additional photographs of the fans and sandlot baseball clubs.

Rochester entertainers and their venues were many. Selected are a few of the talented folks whom earlier generations enjoyed at local playhouses, concert halls, and nightspots, among them the Dodworth and Gilmore's Bands, Shakespearian actor Robert Mantell, and violinists Mademoiselle Filomeno, Susan Tompkins, and David Hochstein. They entertained at Falls Field, the convention center, Washington Rink, Odenbach's Peacock Room, and the Lyceum, Eastman, and Little Theatres.

The book also contains a photograph-filled chapter of those not-to-be-forgotten department stores—the ones that made the trip downtown an enjoyable adventure for so many. Memories of Edwards, McFarlin's, McCurdy's, and Sibley's are rekindled through images of the founders, intriguing window displays, and merchandise-filled interiors.

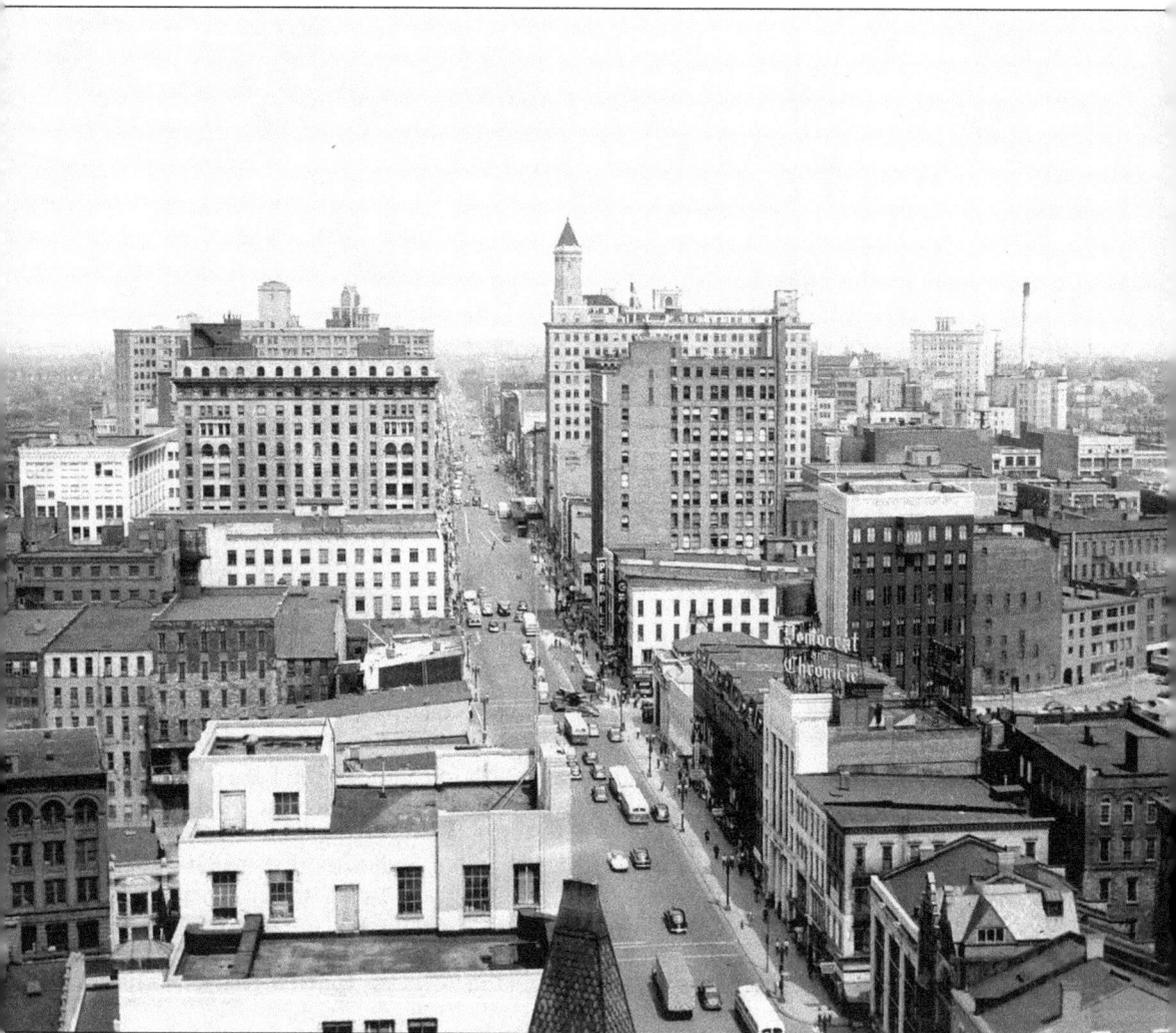

Looking east down Main Street, this aerial view was taken around 1941. The Genesee River (center) is completely hidden by buildings. The tall Commerce Building (right), on the corner of South Avenue and Main Street, was razed to make way for the convention center.

One

PERSONALITIES OF THE PAST

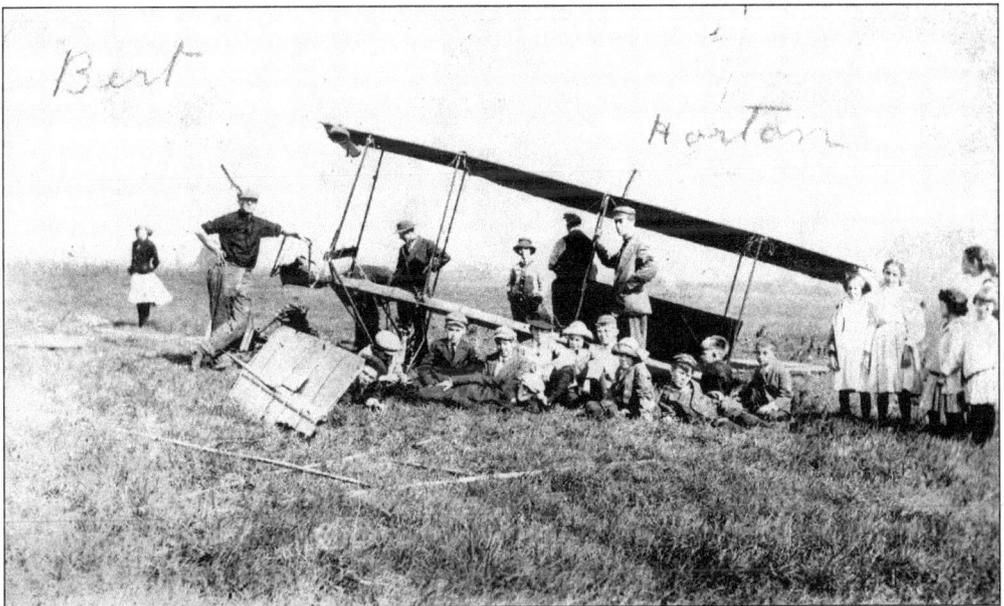

This rare c. 1903 photograph was taken in South (Genesee) Park. The vintage aircraft was piloted by John J. Frisbee, one of Rochester's pioneer aeronauts. Bert and Horton are identified by only their first names. The on-lookers may have witnessed the plane's crash landing that Frisbee survived.

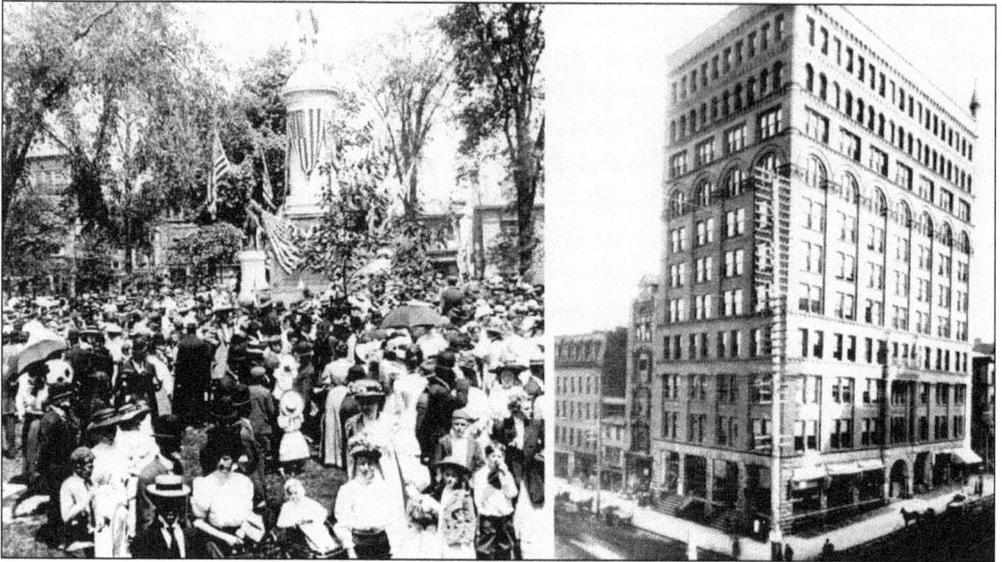

In the 1890s, Rochester had two telephone companies: the Home System and the Bell System. Clusters of wires and poles dominated downtown as photographed from the Wilder Building looking north down State Street. On November 21, 1899, the Home Telephone Company became the Rochester Telephone Company with Frederick Cook as president. The first telephone exchange was established in 1879 at 10–12 Main Street Bridge. (Courtesy Eastman House collection.)

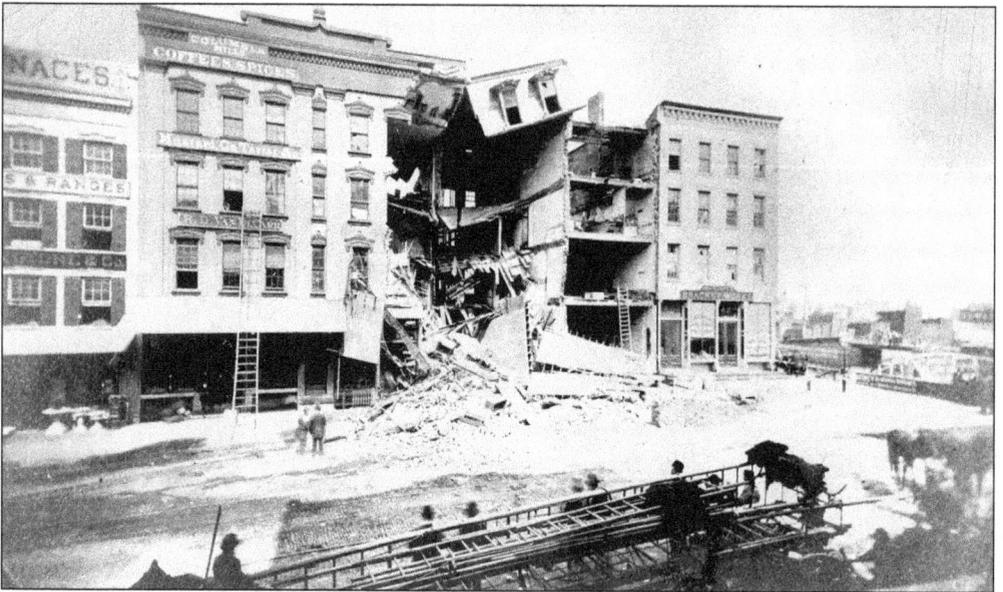

The façades of two of Rochester's early buildings cascaded onto Exchange Street creating a mound of broken brick and rubble. On June 14, 1878, this awesome incident occurred. Whether it was due to poor construction or a gas explosion is not known. A horse drawn hook and ladder truck is in the foreground with the Erie Canal to the right.

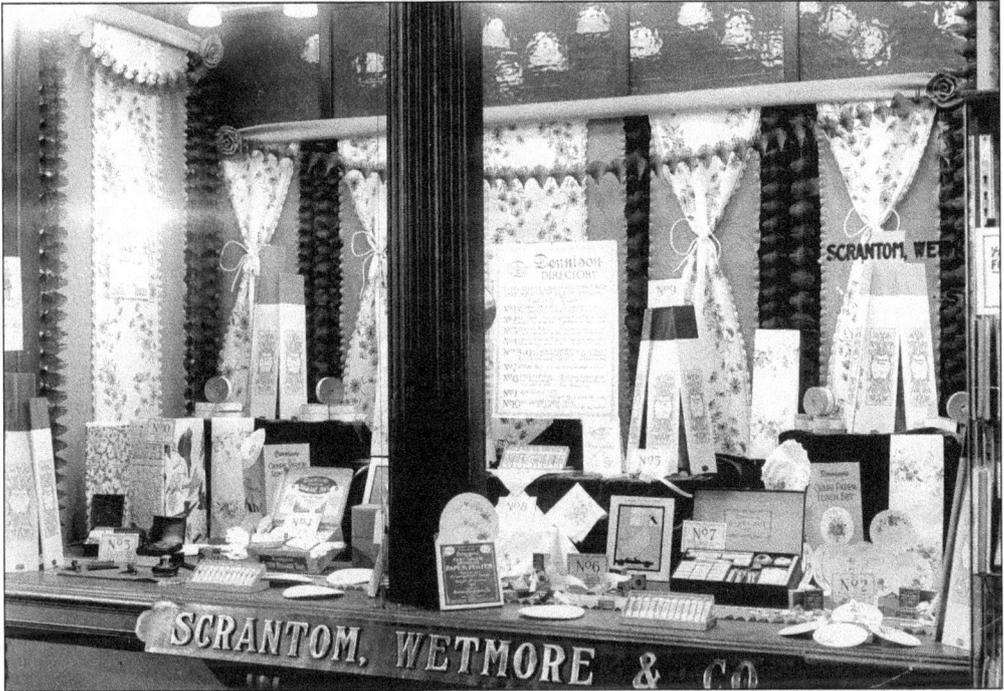

In the summer of 1889, Scrantom, Wetmore, and Company opened a new store in the Powers Building at 22 Main Street. The window display at that location is shown around 1920. By 1928, the company had a large store at 334–336 East Main Street. During the 1950s, Scrantom's had stores in three plazas: North Gate, Culver Ridge, and South Town.

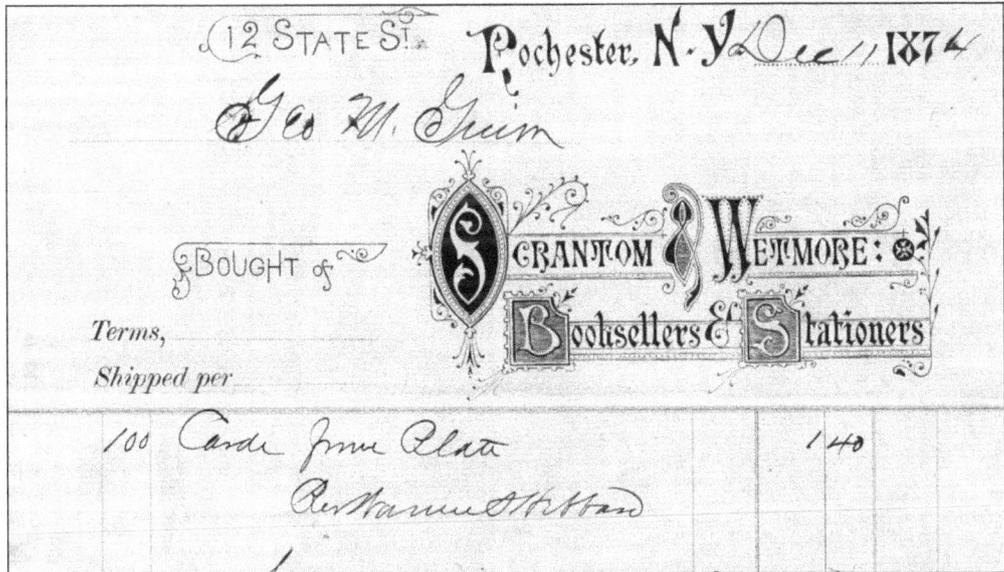

The fancy billhead for the Scrantom and Wetmore Booksellers and Stationers dates back to 1874. The company was formed on May 30, 1868, and the store at 12 State Street was operated by Elbert Henry Scrantom and Lansing G. Wetmore. Scrantom's ancestor, Hamlet Scrantom, was the first permanent settler on the 100-acre site that became the heart of Rochester. The Scrantoms and their descendants have long been leaders in Rochester.

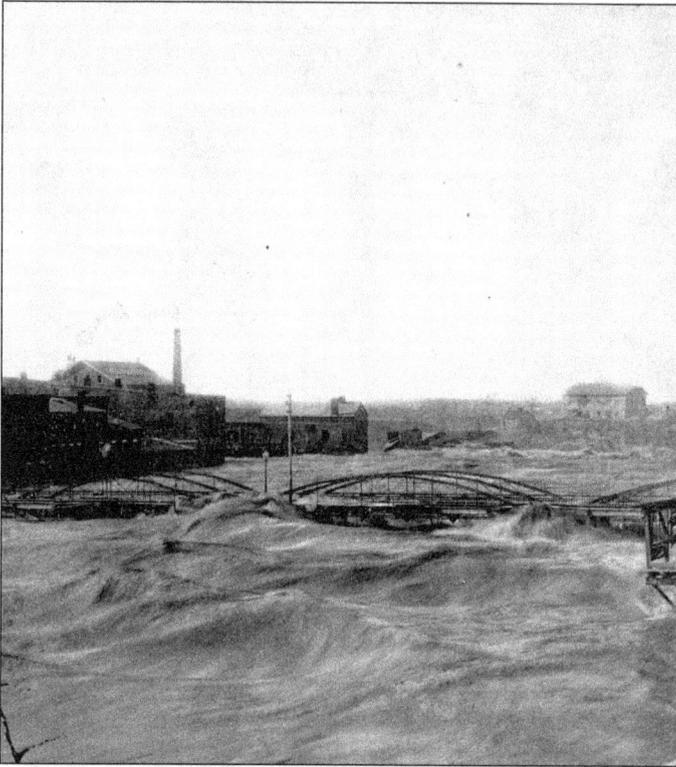

It is almost impossible today to envision the devastating Genesee River flood on March 14, 1865. Looking north, this dramatic scene shows the floodwaters so high they surge over the old Andrews Street Bridge. Front and Water Streets and other riverside streets were inundated. The cellars of businesses were filled with water, and damage to merchandise totaled thousands of dollars.

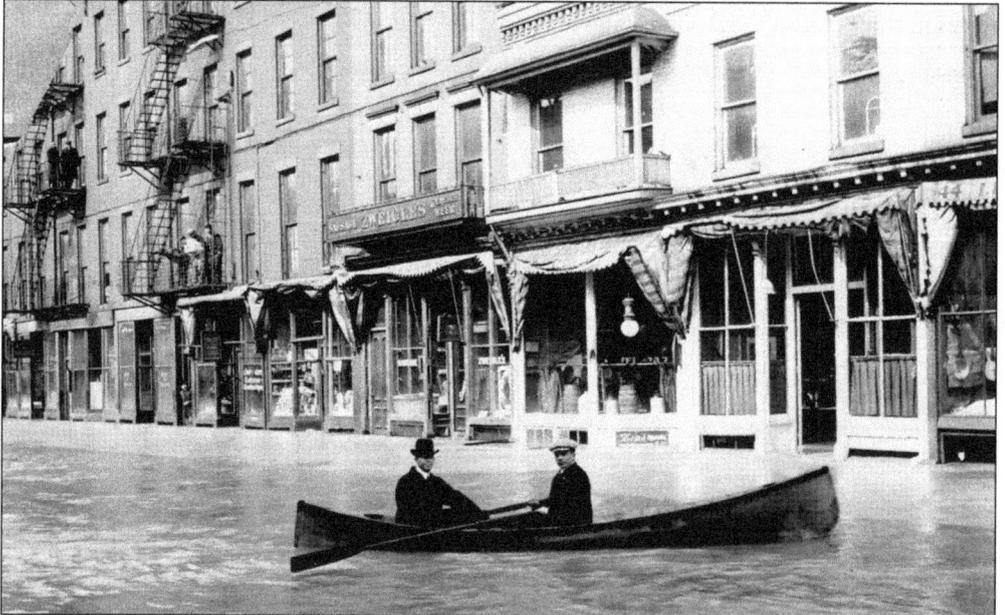

Floodwaters from the mighty Genesee River once again inundated parts of downtown Rochester on March 28, 1913. Rowing their canoe past Zweigle's Sausage Shop, the two gentlemen seem unruffled as they float past Front Street shops whose basements are flooded and have river water lapping their store fronts. The Mount Morris Dam has halted such unusual travel. (Courtesy Rochester chapter of the National Railway Historical Society.)

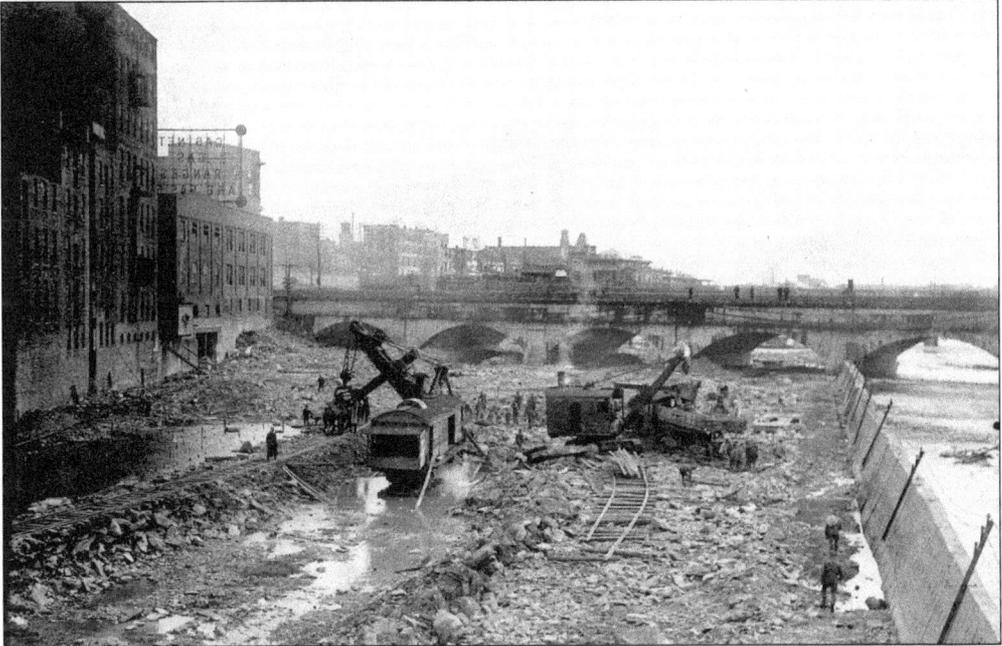

The city spent $700,000 during the 1914–1919 period to control the rambunctious Genesee River and prevent it from flooding over its downtown banks. A concrete wall was constructed, as seen at the right, to channel the river aside while the east side of the river bed from the Aqueduct (Broad Street) to the Main Street Bridge was deepened.

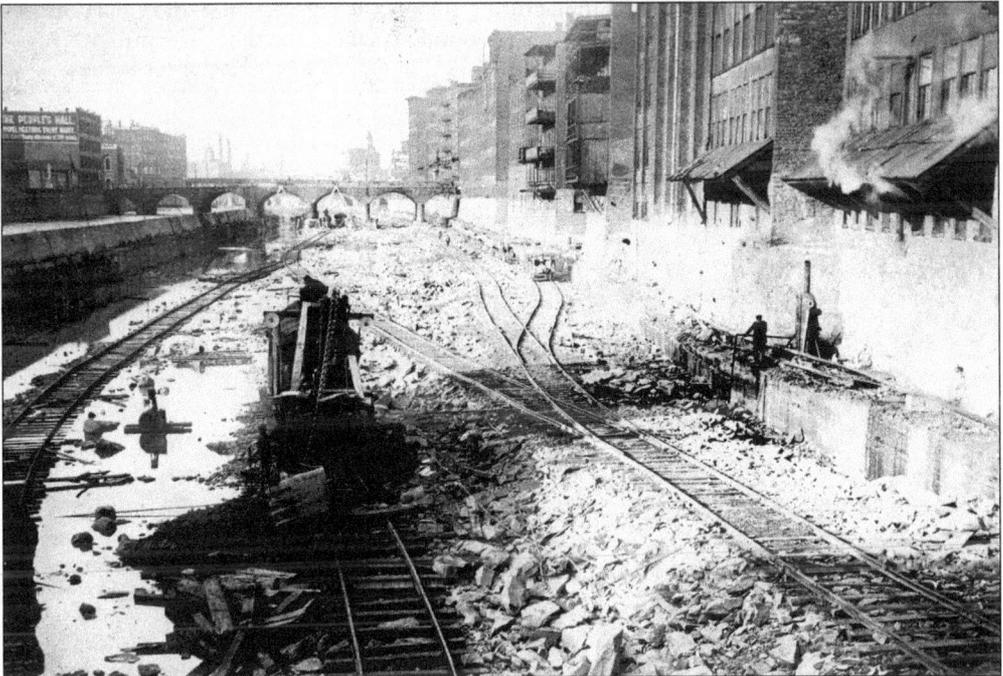

Steam-powered shovels removed more than 126,000 cubic yards of rock in 1916 from the west side of the river from the Andrews Street Bridge to the brink of the High Falls. Railroad tracks were laid to facilitate the movement of steam shovels. High Falls is no longer 96 feet high.

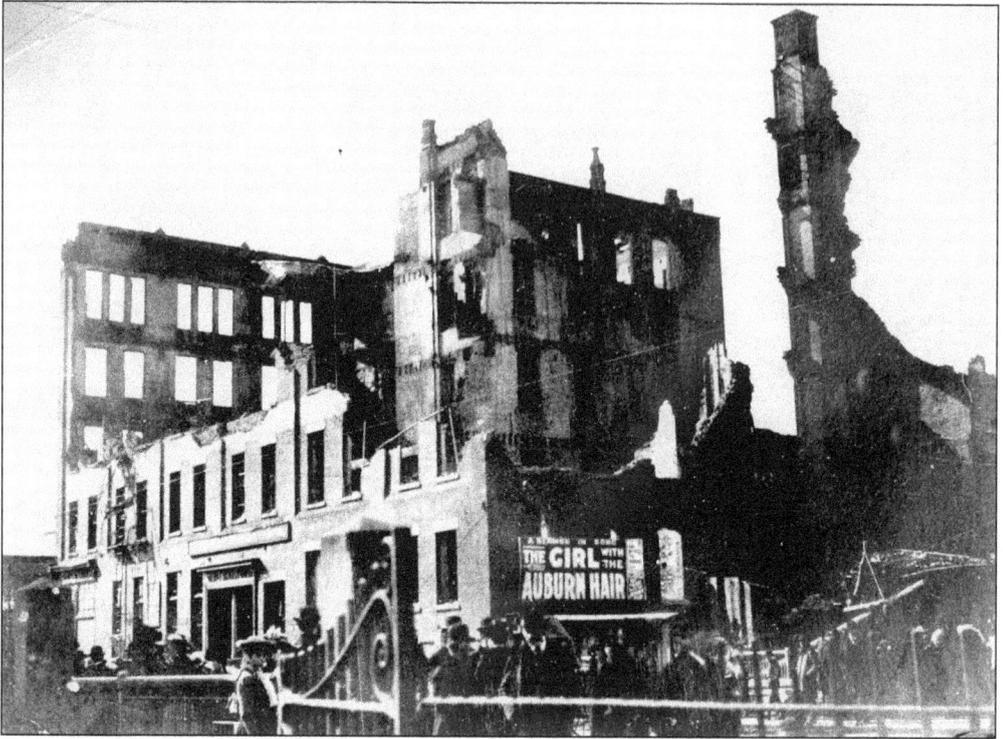

The Hayden Building fire on March 25, 1903, ranks as one of the city's more costly early blazes. Flames swept through the five-story manufacturing complex at 119 Exchange and Court Streets. The result was an estimated loss of $200,000, an enormous sum at the time. The firm was noted for its fine furniture, mantels, and interior woodwork that graced many Rochester homes.

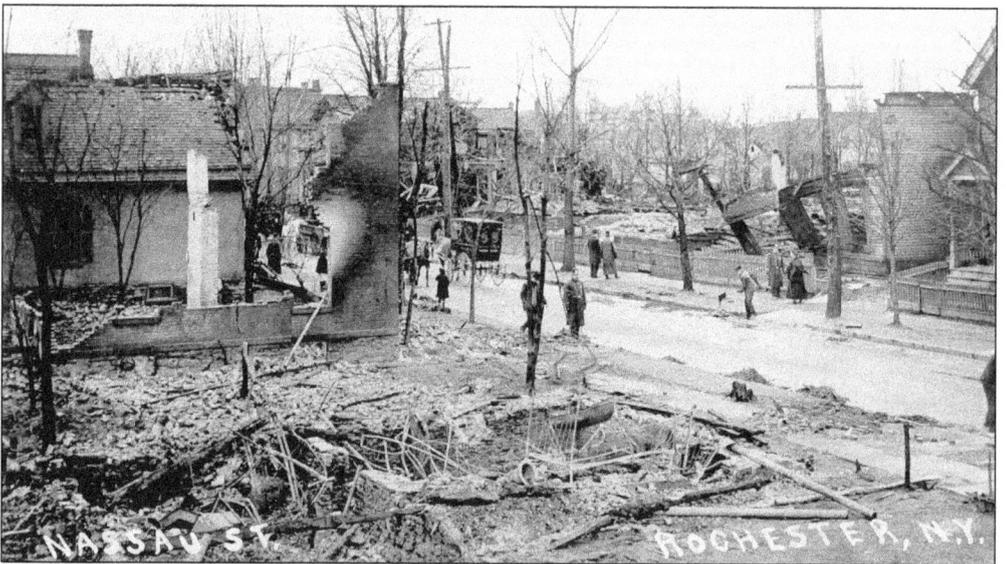

It is hard to imagine such warlike devastation right in the heart of Rochester. On April 13, 1909, fire driven by fierce winds swept through Grove Place and Griffin Street. It destroyed the First Dutch Reformed Church, St. Peters Presbyterian Church, the Selden Building, and Temple B'rith Kodesh, leveling 90 buildings on eight streets.

14

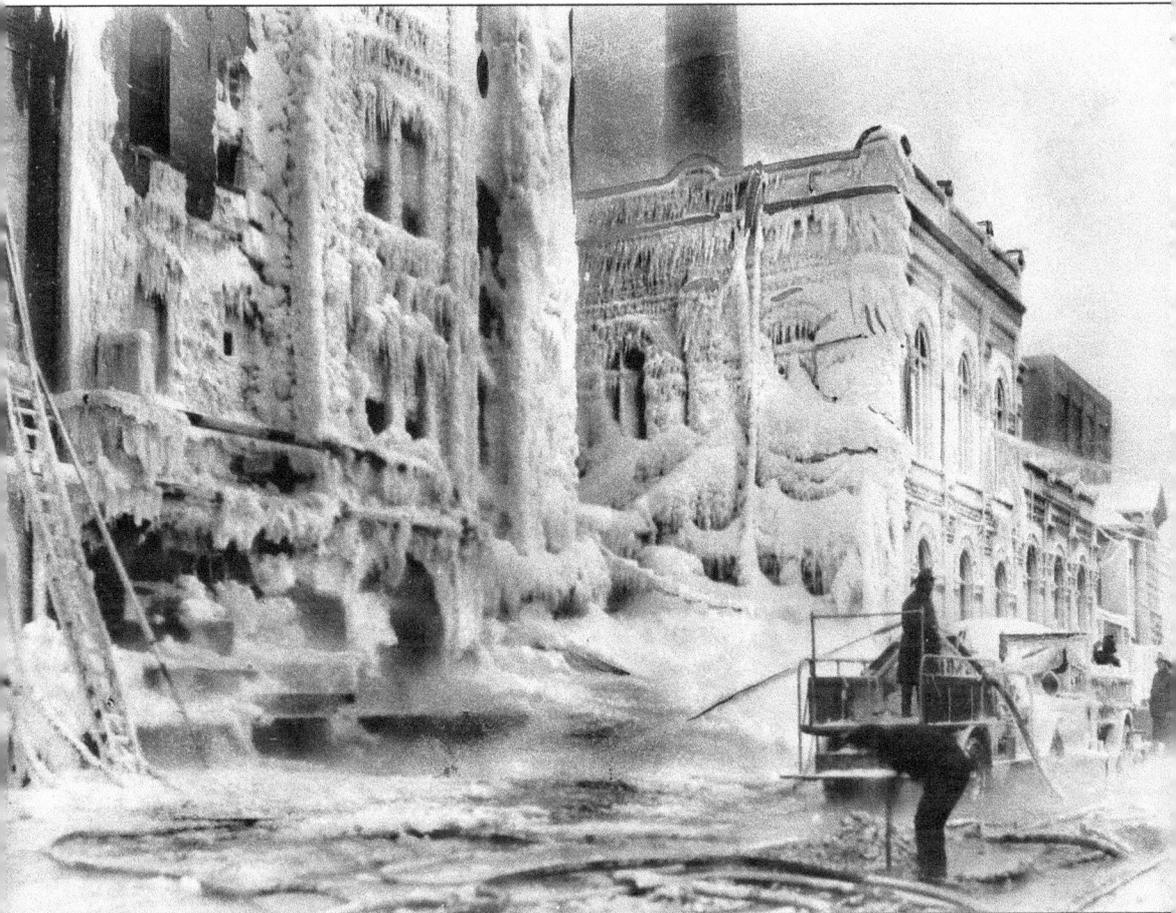

Water to extinguish the flames and sub zero temperatures in January 1927 created deep coats of ice blanketing the façade of the Upton Warehouse. This photograph captures the awesome scene as firefighters fought the stubborn blaze for more that 89 hours, which is a city record.

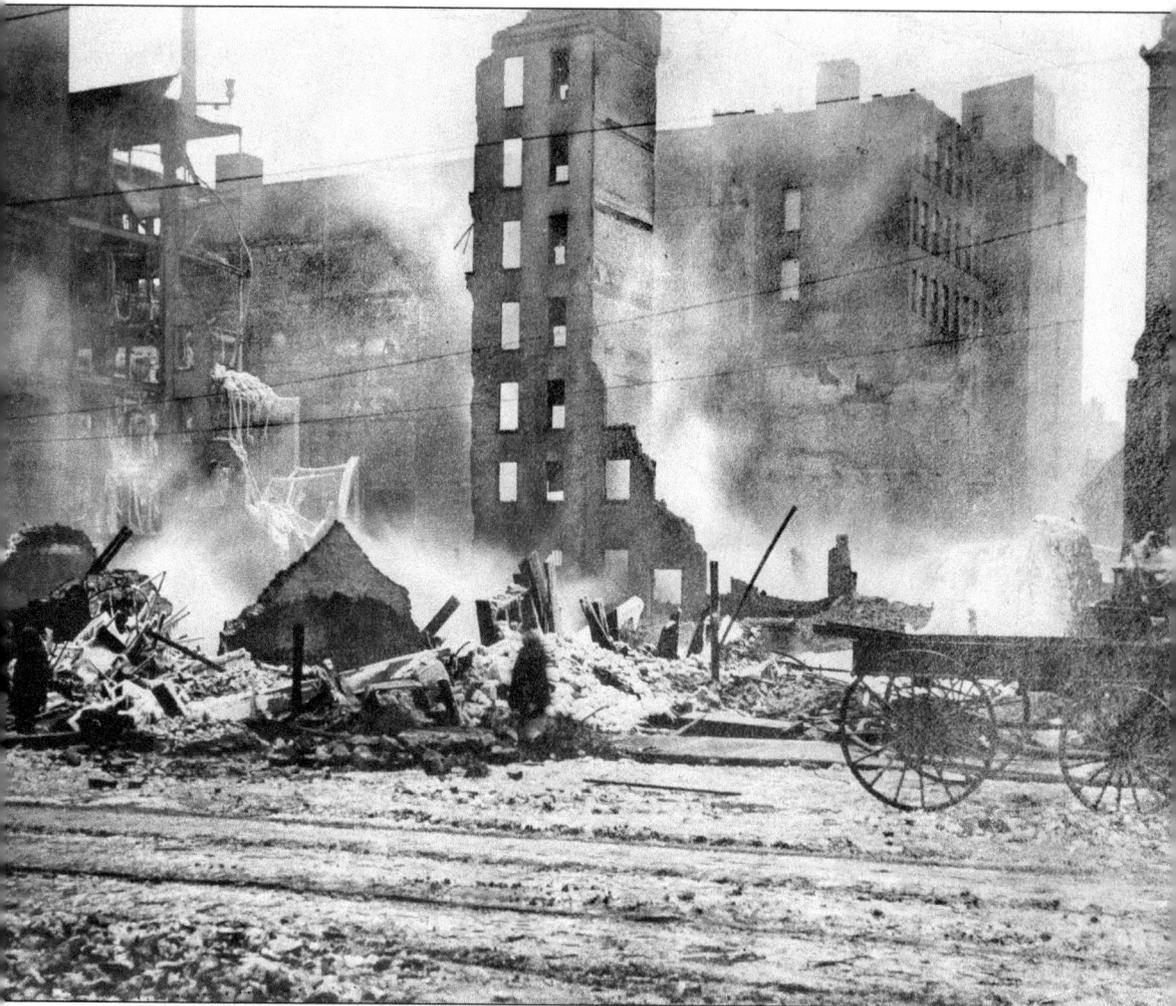

The heart of Rochester's shopping district along East Main and St. Paul Streets lies in smoking ruins after the devastating fire on February 26, 1904. Known as the Sibley fire, the extensive blaze became the most financially costly in local history. Additional photographs are seen in the last chapter.

An early horseless carriage appears behind the first wagon at the left. Downtown parades were a familiar summer event during the beginning of the 20th century. (Original from the Stone collection, Rochester Museum and Science Center.)

Although Rochester's citizens saw a fair share of parades as the Convention City, the crowds line the sidewalks four deep in 1912 to watch the annual Work Horse Parade. Looking east on West Main Street near the Four Corners, a line of horse-drawn wagons travel on both sides of the stopped trolleys.

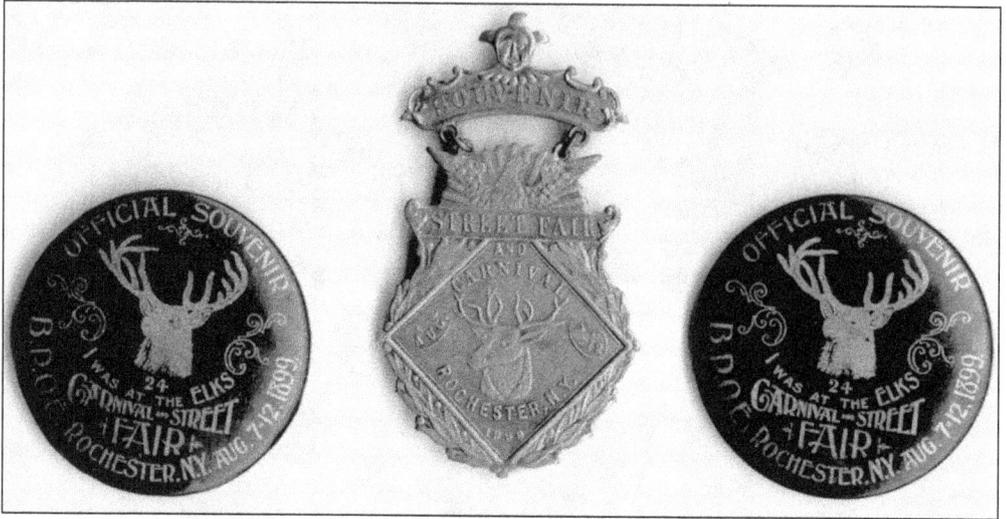

Rochester was renowned for its state conventions during the late Victorian Era. One of its largest conventions was a joint venture between the chamber of commerce and the Benevolent Protective Order of Elks, Lodge No. 24. The badge and buttons were treasured souvenirs of that mammoth street fair and carnival held during August 7–12, 1899.

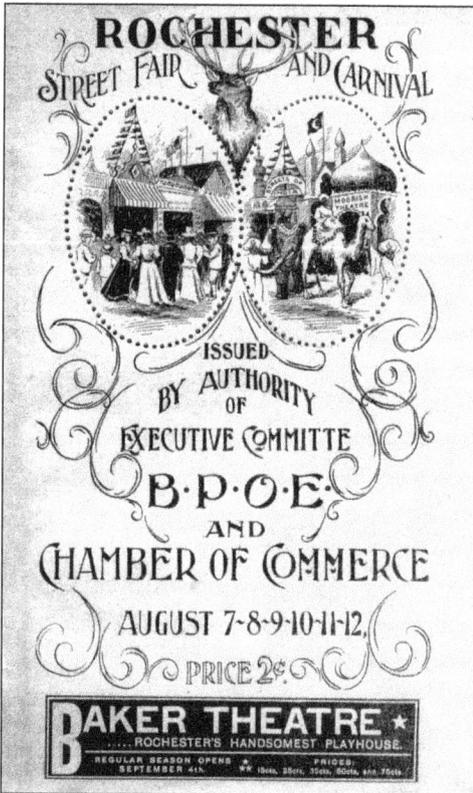

Rochester Street Fair and Carnival programs sold for two cents. The 48-page booklet was filled with photographs and information detailing the six-day event. Advertisements inviting patrons to local restaurants, hotels, and services were included. Sibley's Department Store, then in the Granite Building, stated, "At the Fair, we have only 750 feet of show space. The store has nearly 300,000 feet, six and one half acres. Every Fair visitor should be a store visitor this week."

Two wires lead to the electric lights framing the giant Elk's welcome sign hung high above West Main Street. To the left is the white façade of the Duffy Powers Building on the corner of North Fitzhugh Street. To the extreme right a portion of the Shubert Theatre sign can be seen.

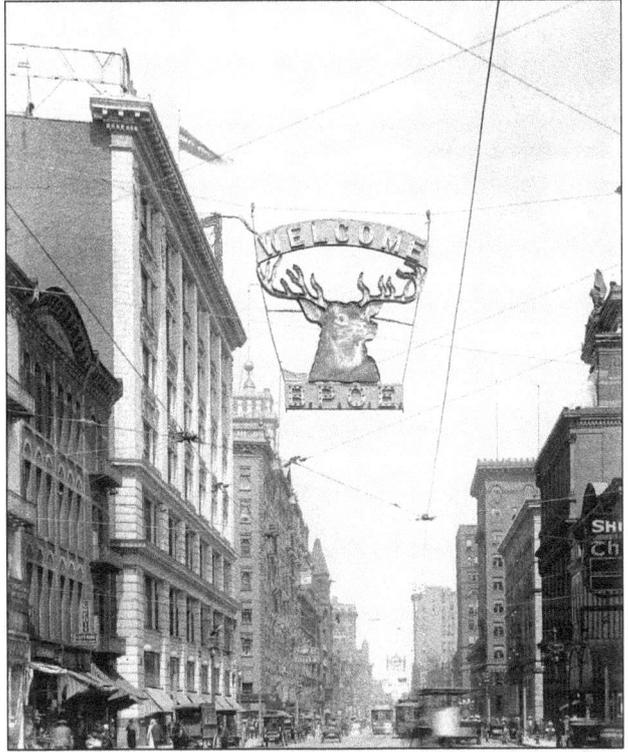

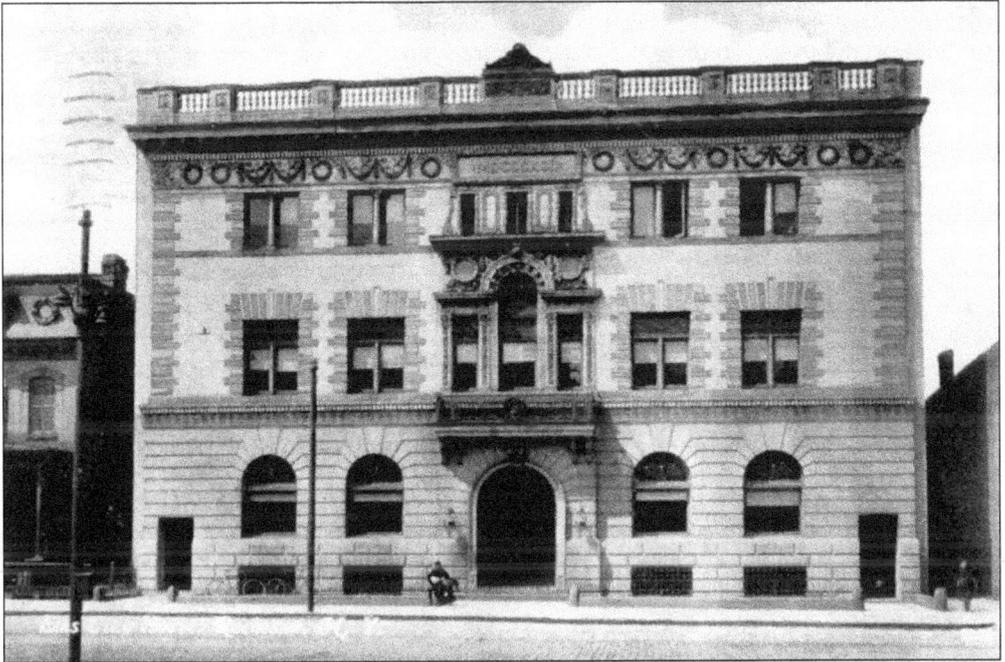

The fraternal society, the Benevolent Protective Order of Elks, originated with a group of actors and journalists on May 29, 1868, while meeting at 29 Delaney Street in New York City. Rochester's order was organized in 1884 as Lodge No. 24. Its members met in this handsome building at 113 North Clinton Avenue nearly every Wednesday evening.

19

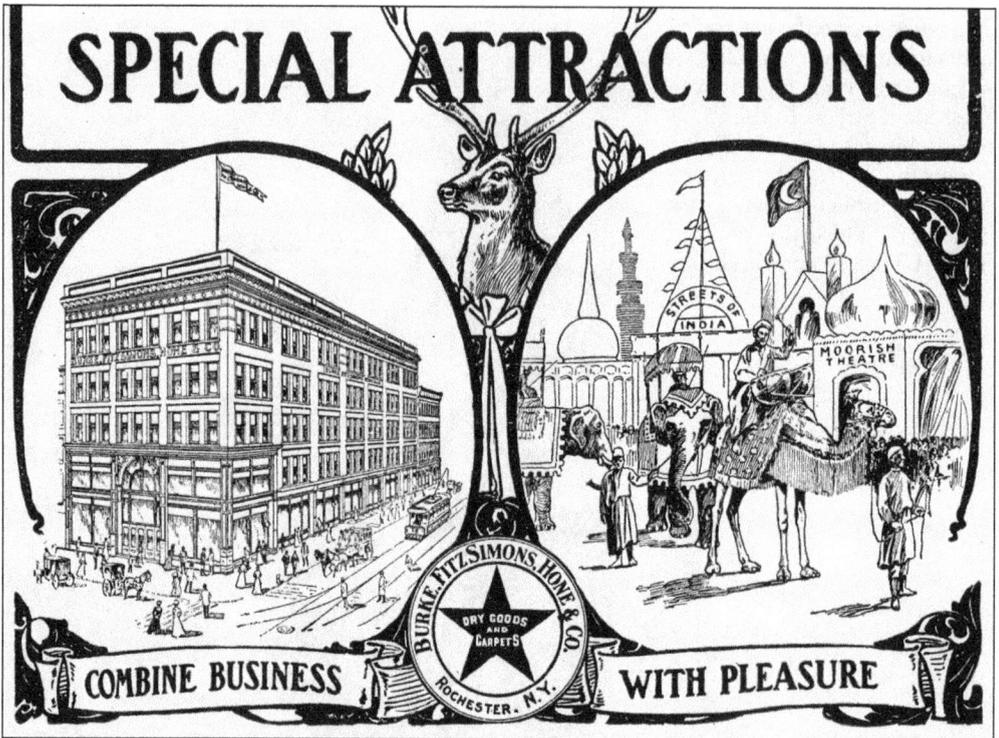

Burke, FitzSimons, Hone, and Company, at East Main and St. Paul Streets, operated as a dry goods and carpet store. Their advertisement announcing the Elk's convention depicts the store to the left. To the right, the image illustrates the "Streets of India and Moorish Theatre," a part of the large midway at the Elk's carnival. La Freda the moolah dancer performed at the Moorish Theatre.

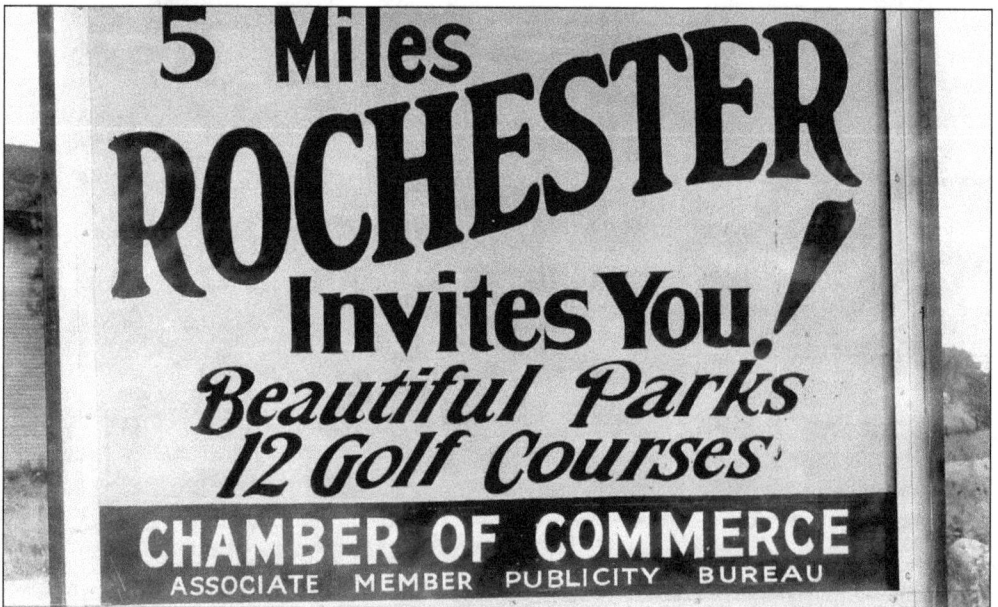

Rochester was proud of its "Beautiful Parks and 12 Golf Courses." Around 1919, the Rochester Chamber of Commerce displayed this large billboard inviting tourists to the city just "5 miles away."

In 1938, John F. Fraatz, an artist for the Rochester Museum of Arts and Sciences at Edgerton Park, drew this map documenting the dates and types of flowers in bloom at the city's many park locations. The map states that the Flower City is "A Community of Homes Set in a Forest Upon a Carpet of Flowers." (Courtesy Rochester Museum and Science Center.)

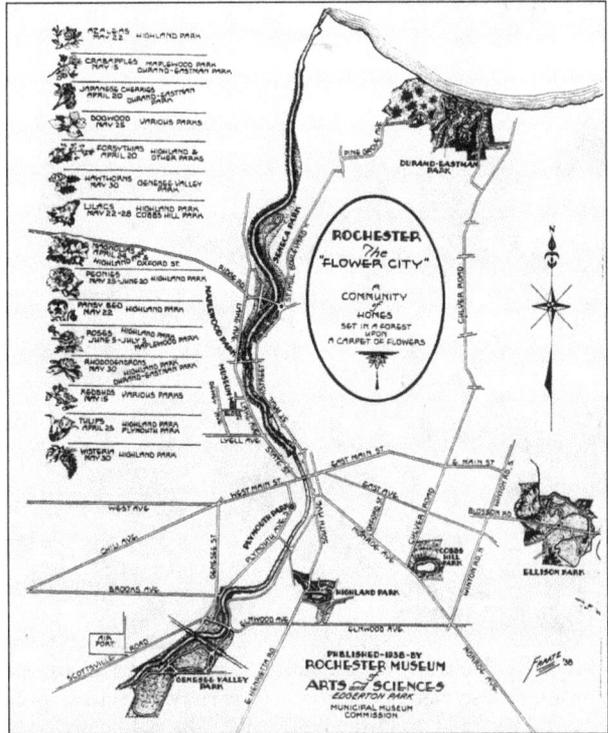

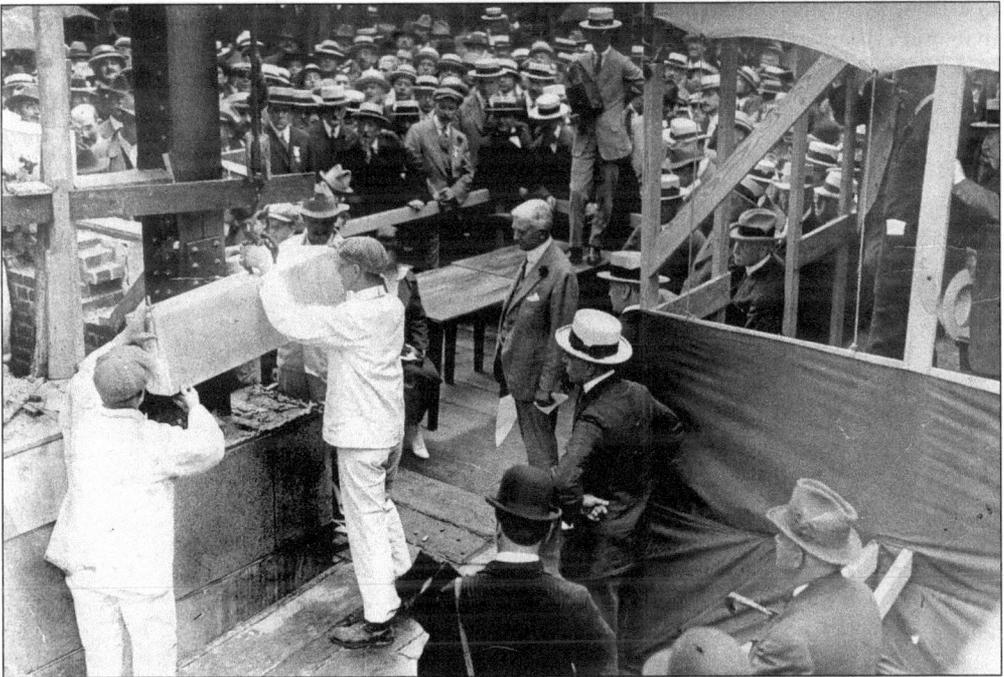

In 1919, George Eastman (hatless, holding trowel) takes part in the cornerstone-laying ceremony for the public bathhouse at Durand-Eastman Park. Admiring onlookers, most of whom are wearing straw skimmers, gather to witness the event. Dedicated in 1909, the 965-acre park was a gift to the city from Dr. Henry Strong Durand and George Eastman.

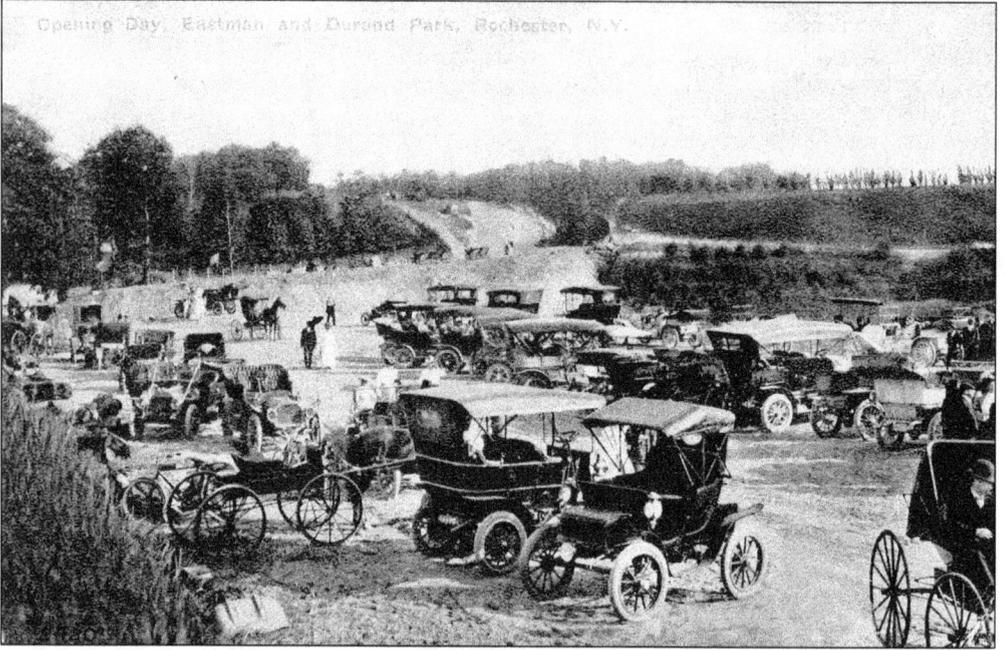

When Dr. Henry Strong Durand donated part of his estate to the city, he called the site "an almost undiscovered country." A variety of native pines, ash trees, birches, and black oaks covered the wild and hilly landscape. The public arrived by horse-drawn and horseless carriages to witness the grand opening of Durand-Eastman Park in 1909. By 1915, some 141,300 deciduous trees and 7,200 evergreens had been planted, many by Bernard "Barney" Salvin.

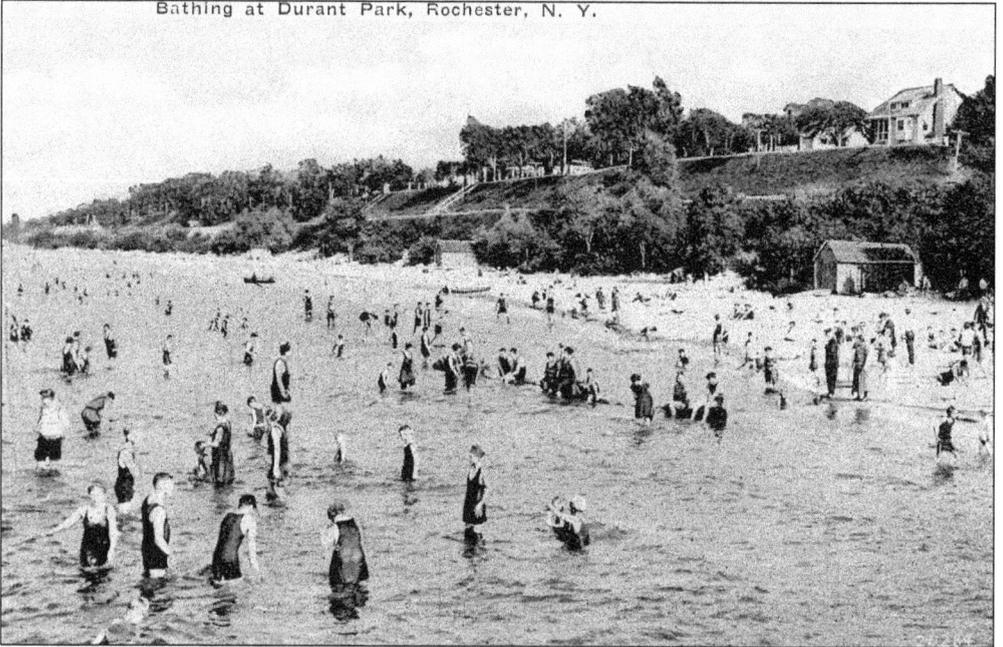

On a sweltering summer day, cool lake waters bring scores of bathers to the sandy shores of Lake Ontario at Durand-Eastman Park. In the 1920s, all bathers by law had to cover their chests with tank-type bathing suits. The park's beach covers 5,000 feet of waterfront.

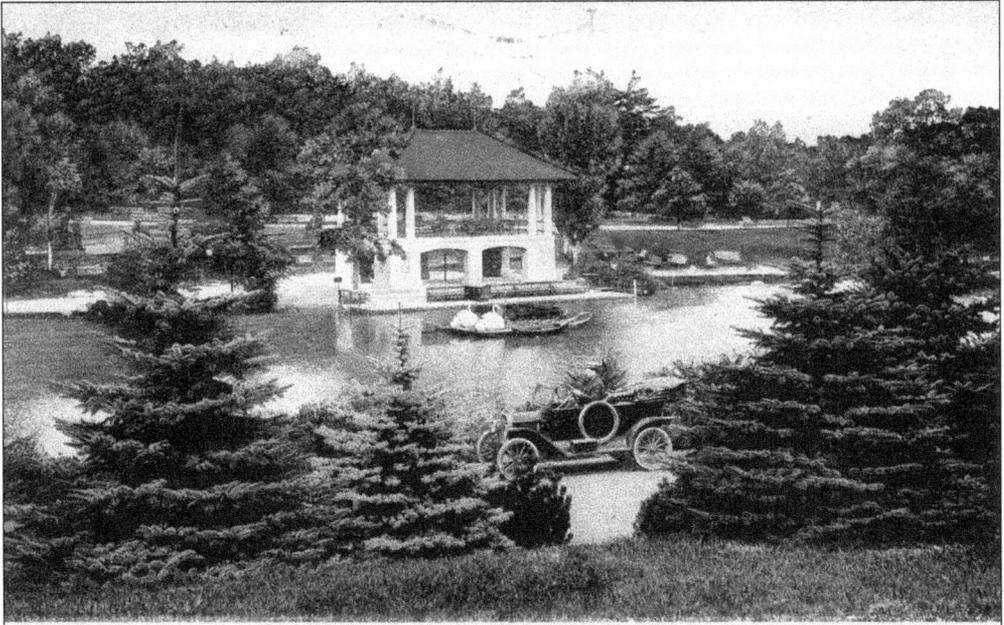

BAND STAND AND LAKE, SENECA PARK, ROCHESTER, N.Y.

One of the features of another city park was the bandstand at Trout Lake in Seneca Park. Located on the east bank of the Genesee River Gorge, the park was called North Park when it was created in 1888. Designed by Frederick Law Olmsted's company, the 297 acre, 3 mile long riverside preserve was renamed Seneca Park to recognize its American Indian heritage.

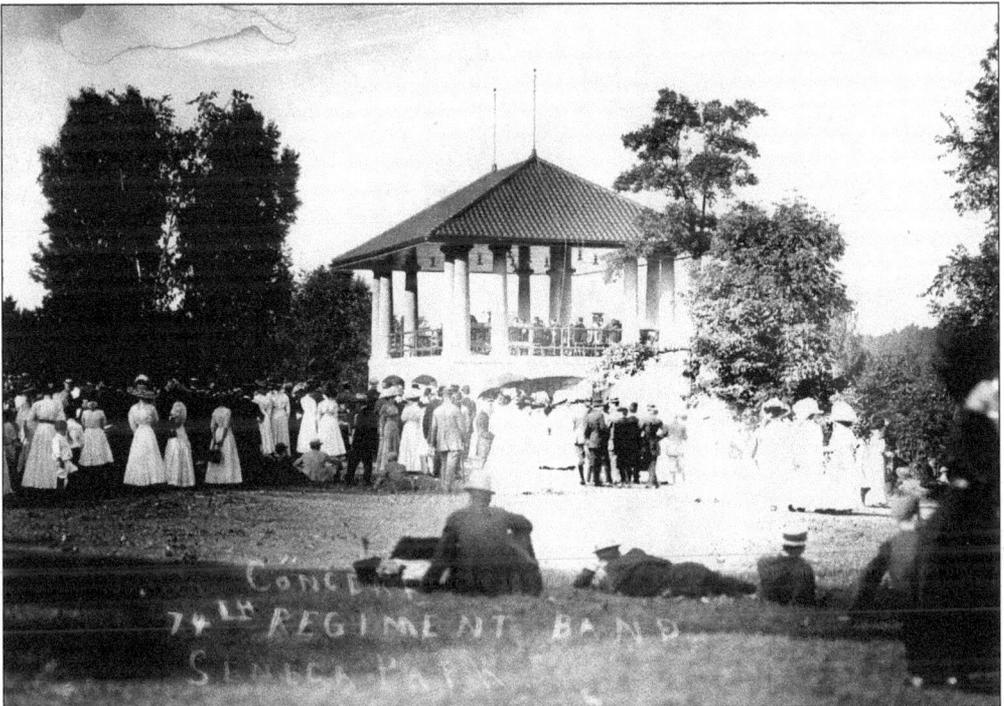

Victorians enjoy a Sunday band concert performed by the 74th Regimental Band on the elaborate two-story bandstand at Seneca Park.

23

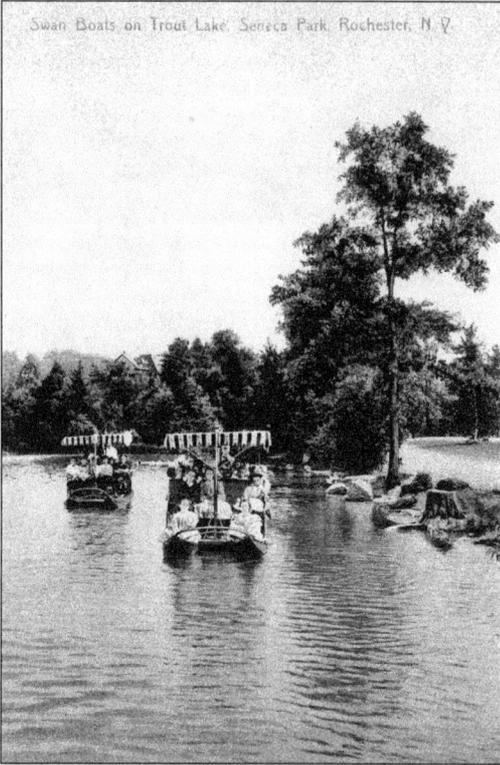

Swan Boats on Trout Lake, Seneca Park, Rochester, N.Y.

Visitors enjoy pedaling swan boats around Trout Lake. These boats graced the lake from about 1900 to 1922. A large aviary was located on the shore of the lake.

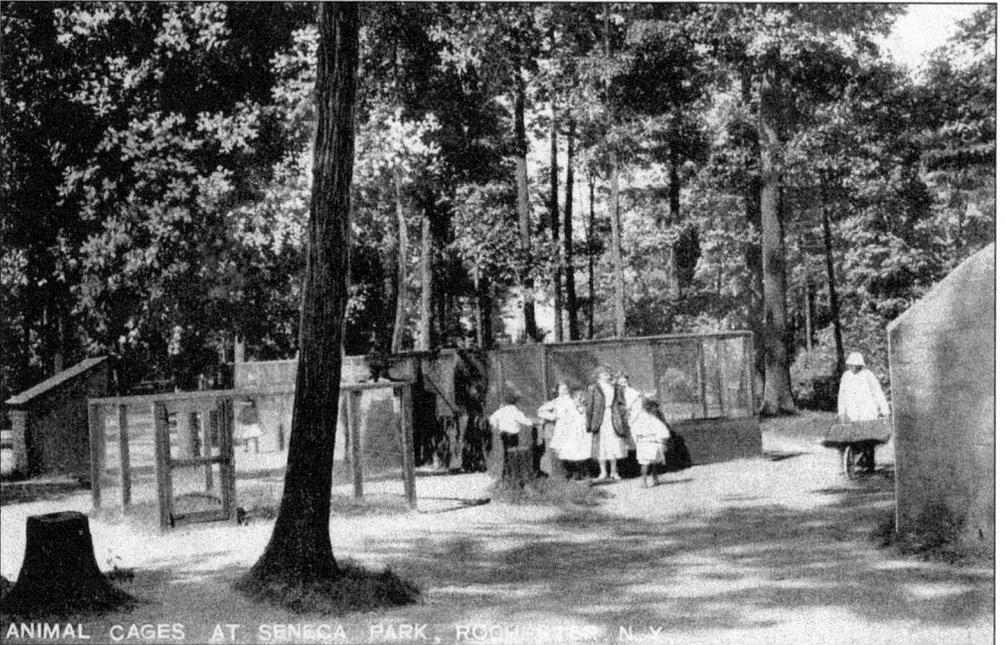

ANIMAL CAGES AT SENECA PARK, ROCHESTER, N.Y.

Young and old come to see the animals at the zoo at Seneca Park around 1910. The zoo opened in 1894 and attracted legions of children and their parents. Today, it houses more than 600 animals representing some 200 species. Vying for the visitors' attention are elephants, lions, polar bears, and orangutans.

24

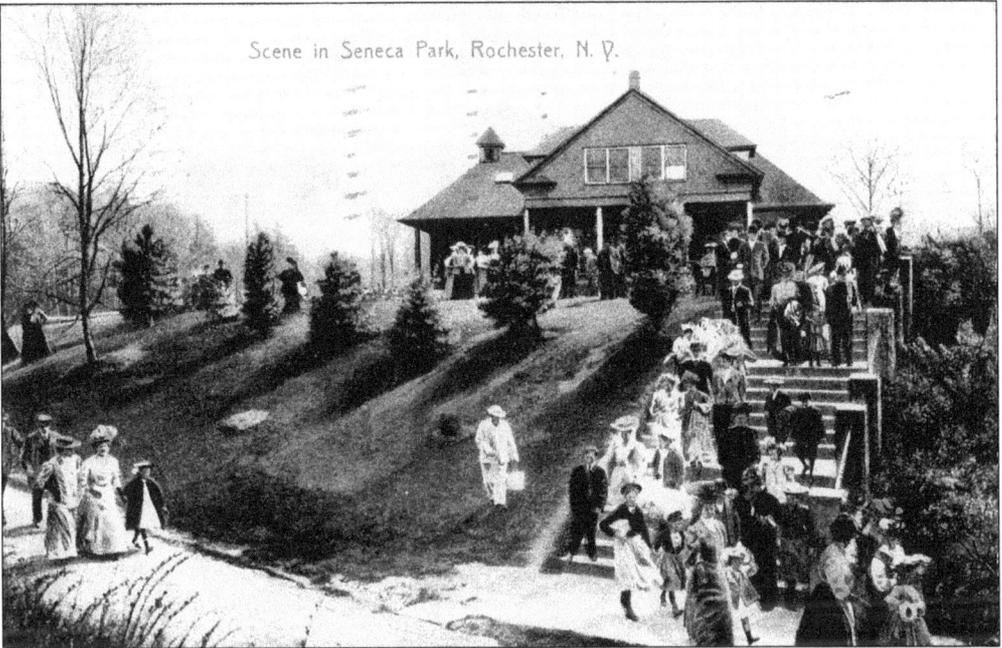

Scene in Seneca Park, Rochester, N. Y.

Patrons in their Sunday best leave the Seneca Park refreshment stand around 1909. Going to Seneca Park was a special treat for many Rochester families. Huge crowds rode the trolley to enjoy the park's many attractions.

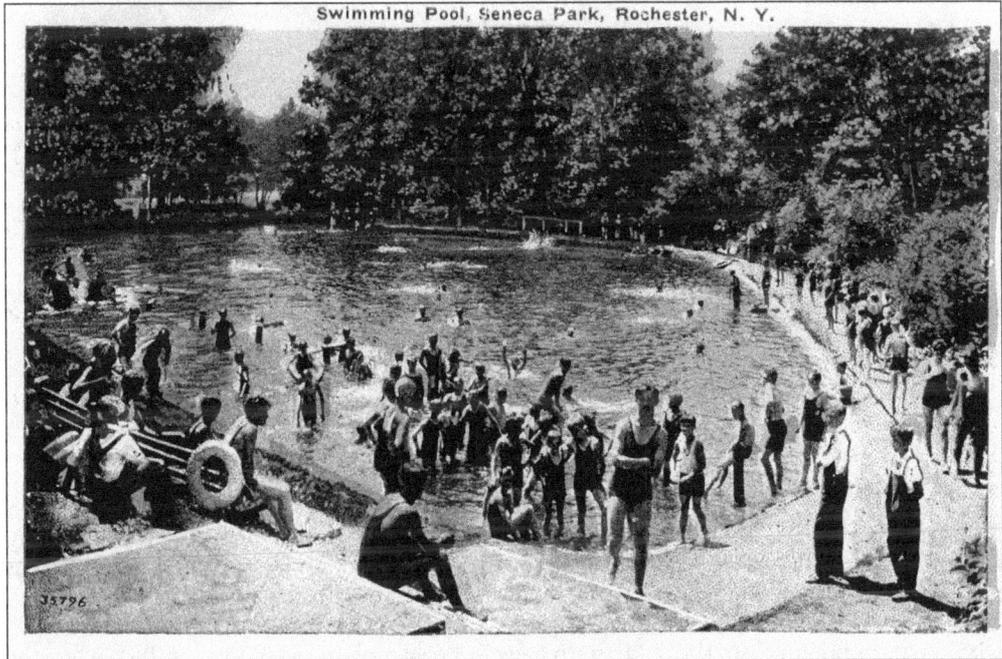

Swimming Pool, Seneca Park, Rochester, N. Y.

Over the years, Seneca Park provided swimming pools for the community to enjoy. This large public pool is pictured in 1933. The park no longer has a pool. Since 1962, Seneca Park has been operated by the County of Monroe, although the city retains ownership.

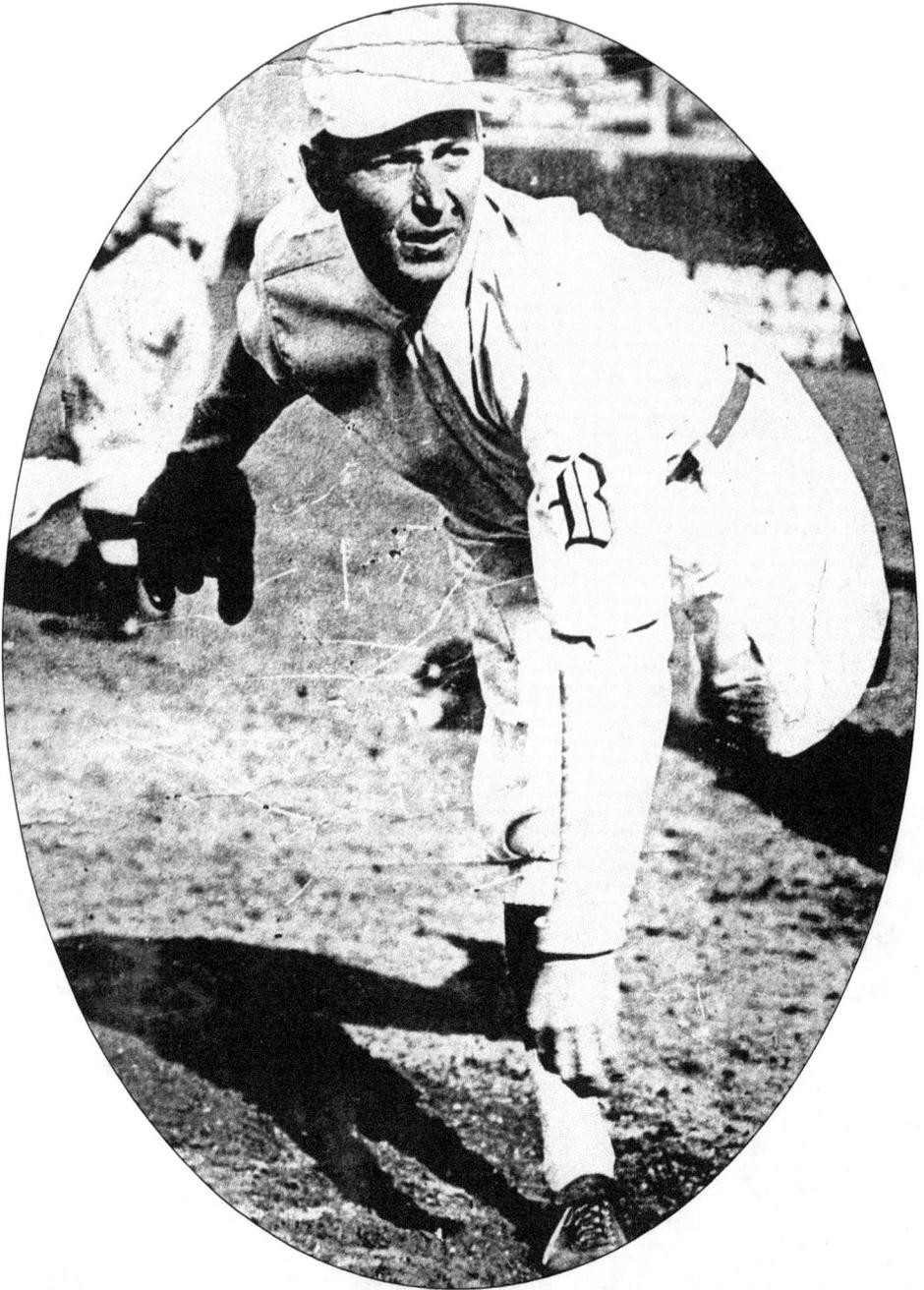

Rochester baseball fans should relate to this dusty attic photograph. This is Albert A. Mattern, a former baseball star, once owner of the A. A. Mattern auto agency in West Rush. Mattern played professional ball for a dozen years, six as pitcher for the Boston Nationals when Christy Mathewson, Clark Griffith, and Honus Wager were in their prime. Starting in Rochester in 1905 with the Beau Brummels in the old Eastern League, he later played for Boston in 1908 when the photograph was taken. In 1909, he "set a record that still stands. . . . winning 15 games for a third of his club's total season victories." His professional career ended with Newark in 1917, and he passed away in 1958 at the age of 80.

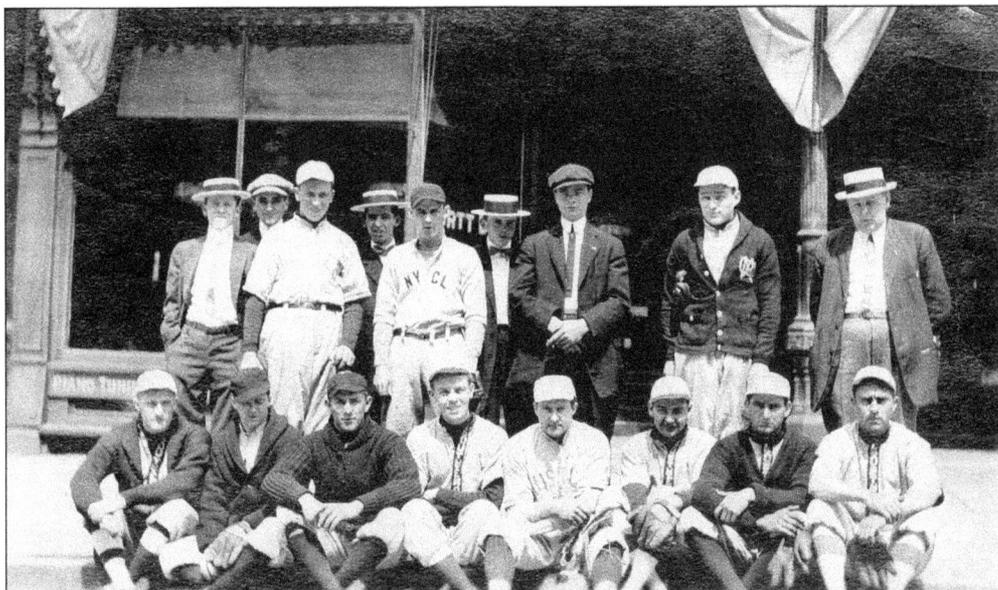

The 1909 season opened with owner Charles T. Chapin selecting "Big Jawn" Ganzel as manager of the Hustlers. Big Jawn is seen seated in the bottom row, third from the left. The talented team won pennants in 1910 and 1911, placed second in 1912 and 1913, and came in third in 1914.

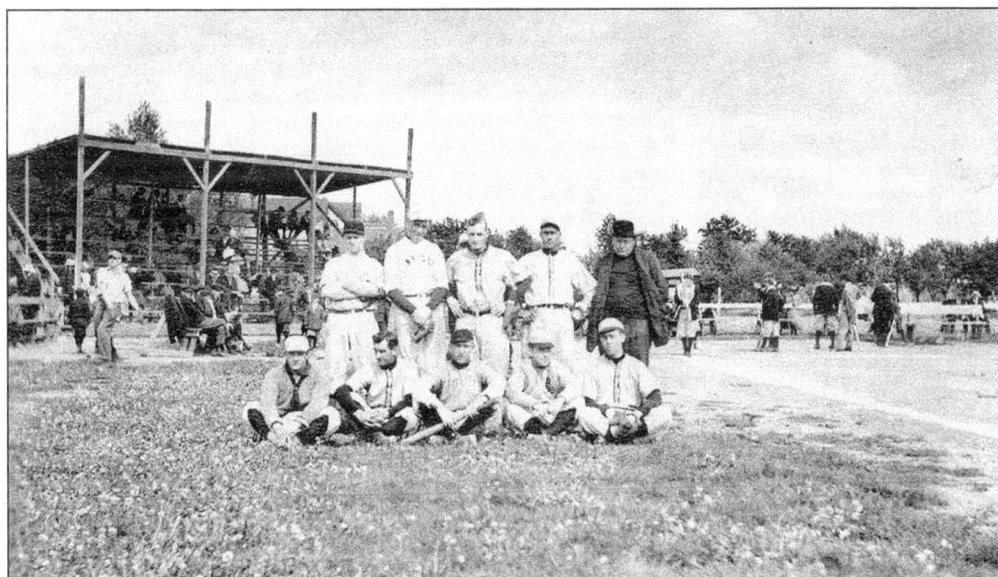

The Hustlers play their games at the North Union Street ball park at Weld Street. Contrast Frontier Field with the seating accommodations seen at the left that served Rochester baseball fans in the first years of the 20th century. Notice the ball diamond had no dugout or fence to protect players and no screen to protect fans when a foul ball came rocketing back.

This aerial photograph taken in 1930 provides a unique view of yesterday's city landscape. Norton Street, seen to the right, passes both the new Red Wing Stadium (built in 1929) and the even newer Benjamin Franklin High School at the top right. East Ridge Road is to the left. At the time, Irondequoit was renowned for its truck gardens and fruit orchards, many of which are seen in the center.

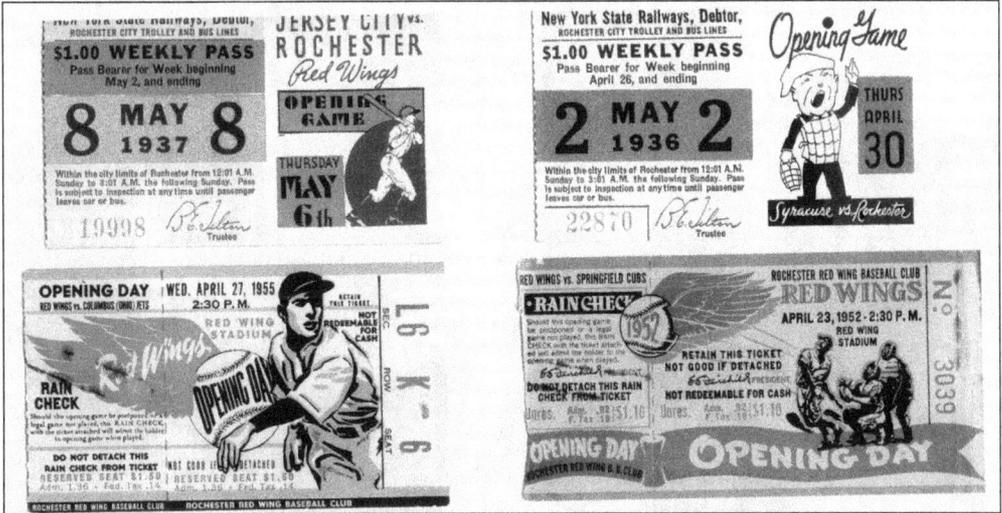

These rare opening day Red Wing baseball ticket stubs and trolley passes were treasured mementos saved over the years by avid baseball fans. Some of the mementos are more than a half century old.

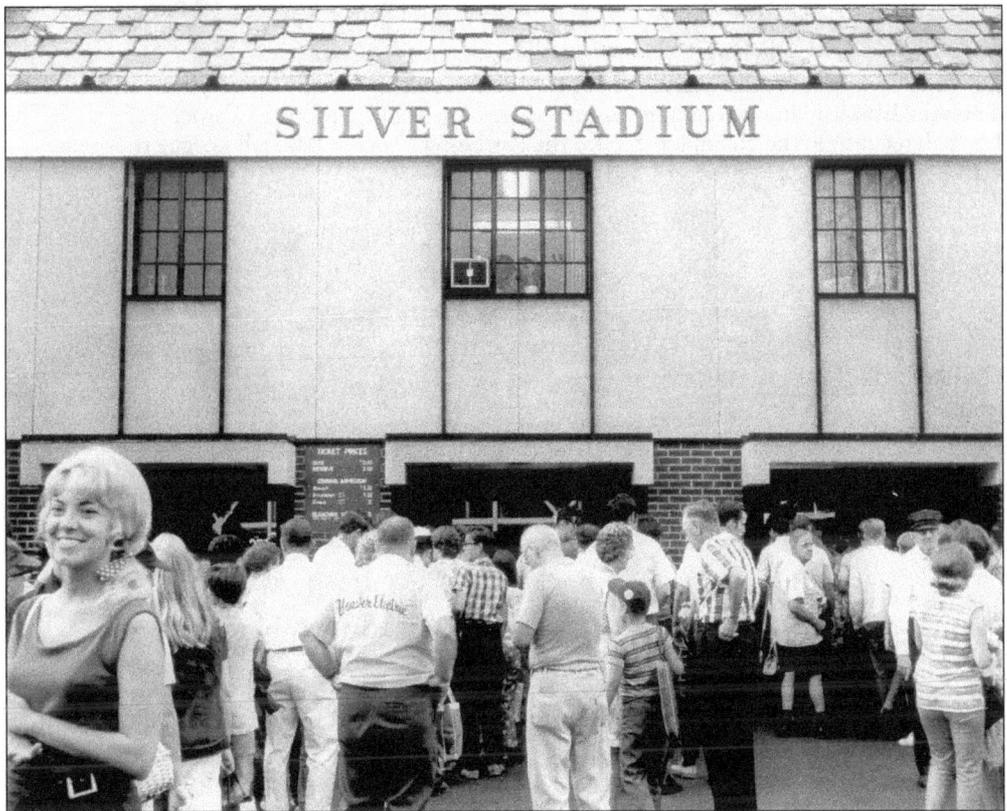

Remember the old Red Wing ticket office on Norton Street? It was a balmy summer day in the 1950s when Silver Stadium box seats cost $2.50, and the bleachers were only 75¢. We are sure the Red Wings won their game.

The year 1934 was an outstanding season for the boys from St. Monica's Parochial School. The baseball team took the championship for the Rochester Diocese Baseball League that year.

In the 1930s, the Rochester Trust Banking Company had its own athletic team. Their uniforms appear to be for softball. Notice that the manager is wearing a tie.

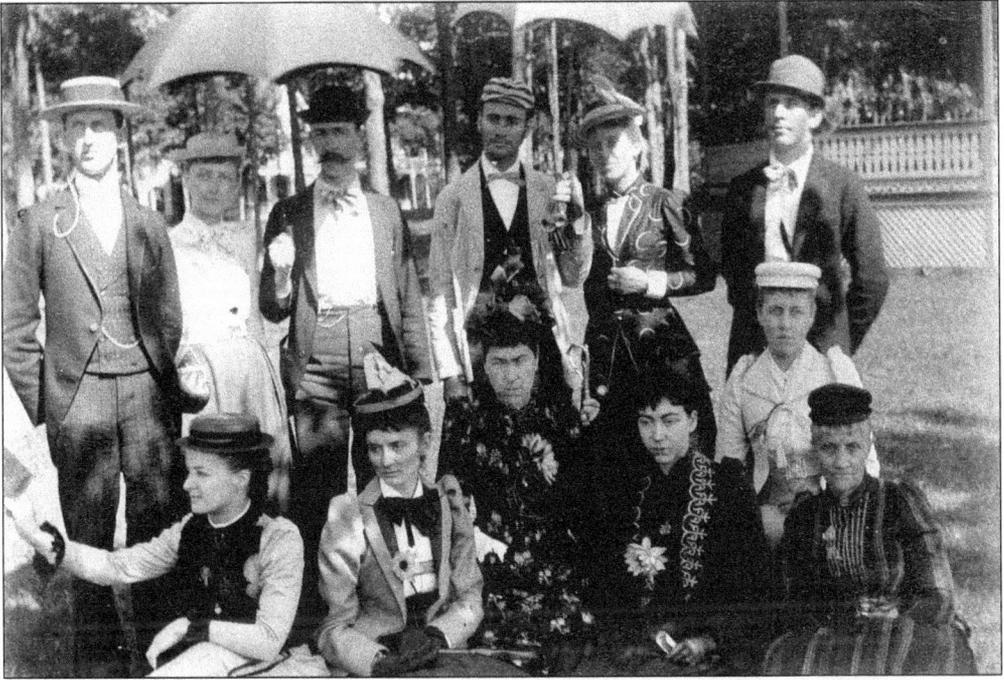

A dozen Victorians gather at Summerville Gardens on Lake Ontario to enjoy a Sunday outing during the summertime in the 1890s. Close examination reveals that the ladies are each wearing a dahlia-like flower. The group has dressed in their Sunday best. The umbrellas are protection from the sun, as tans among the ladies were not in vogue. The photograph was developed by the Rochester Optical Company.

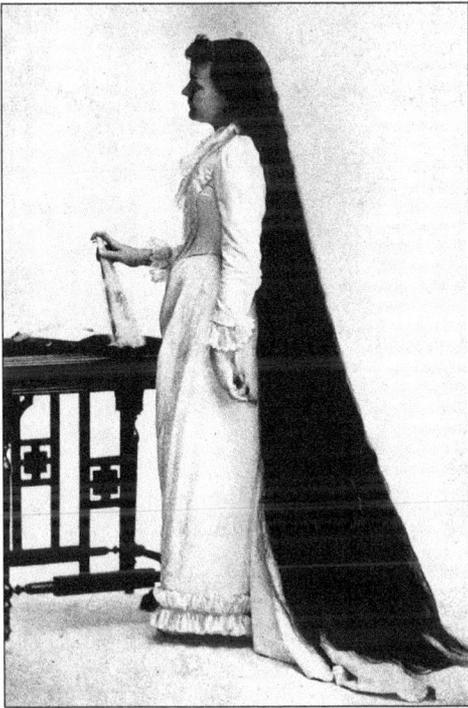

This lass with the long tresses is Martha Matilda Harper. In 1888, she opened the nation's first lady's hair dressing shop in the Powers Building. Later, she was first to start the business practice of "franchising," expanding her business to include two international manufacturing centers, (one in Rochester), five Harper Method training schools, and over 500 beauty shops around the world. (Courtesy Golden Memories.)

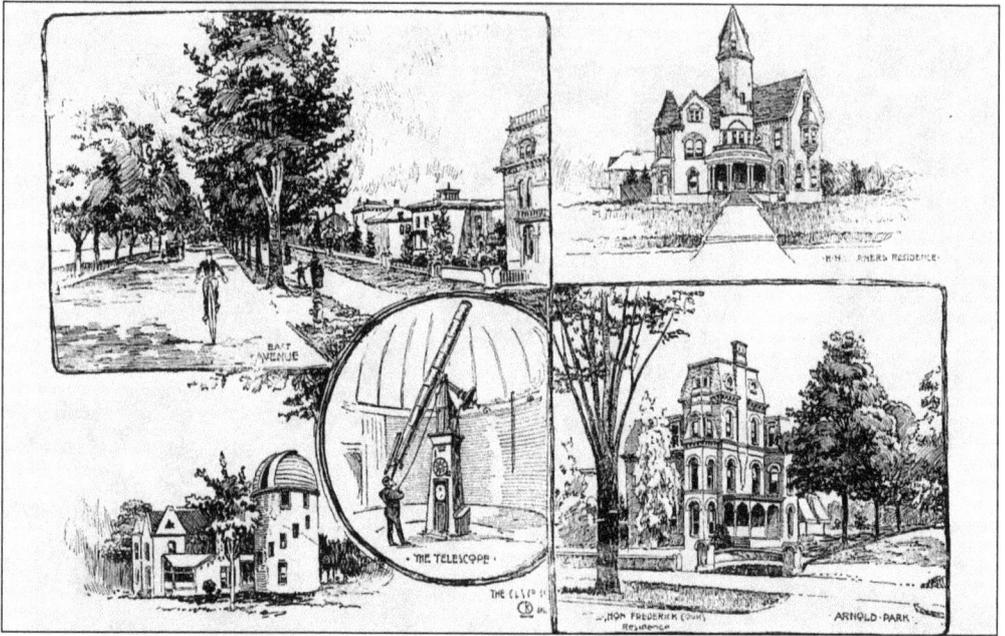

This 1888 line drawing illustrates a tree-lined East Avenue. H. H. Warner of Warner's Safe Cure, had an impressive mansion on the corner of East Avenue and Goodman Streets. He also built an observatory at East Avenue and Arnold Park. His neighbor Frederick Cook, who built Cook's Opera House, resided in a mansion at 251 East Avenue. Both were civic leaders with Warner becoming the first president of the Rochester Chamber of Commerce.

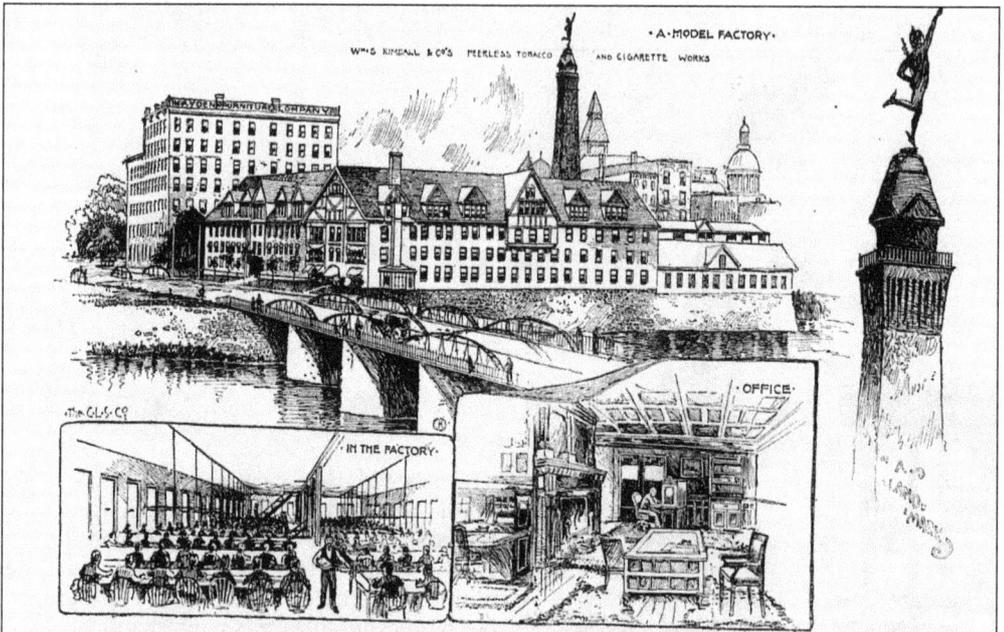

This drawing reveals a formidable Peerless Tobacco Company bordering the Genesee River at the Court Street Bridge. William S. Kimball was one of the city's leading citizens creating one of the largest cigarette manufacturing companies in the nation. He was responsible for erecting the statue of Mercury that enhances Rochester's skyline.

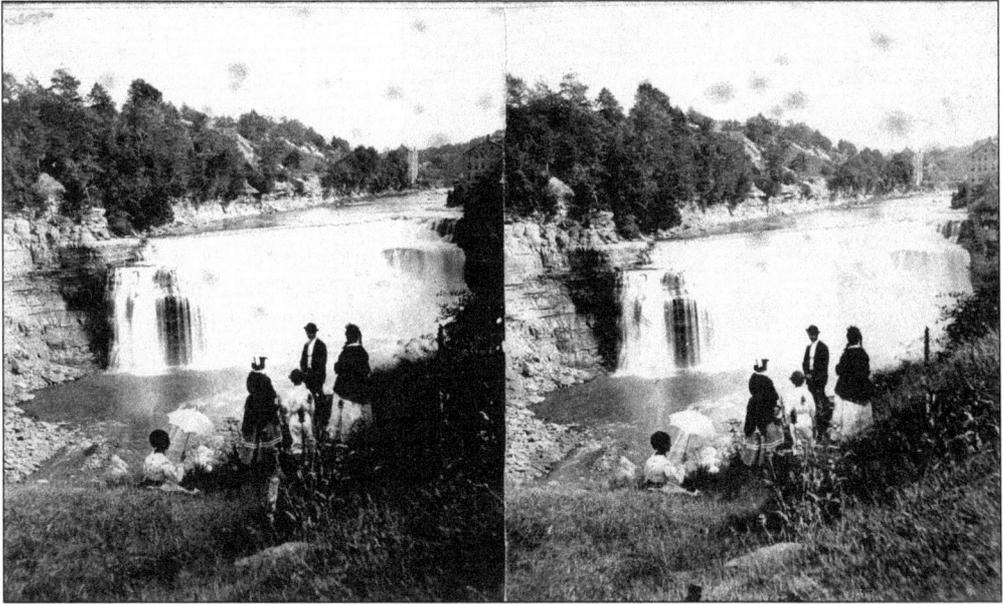

On a Sunday in the early 1880s, picnickers enjoyed viewing the surging waters of the Genesee River as they tumbled over the Lower Falls. The Driving Park Bridge had not yet been built when this stereograph was made. A flour mill is seen at the extreme right.

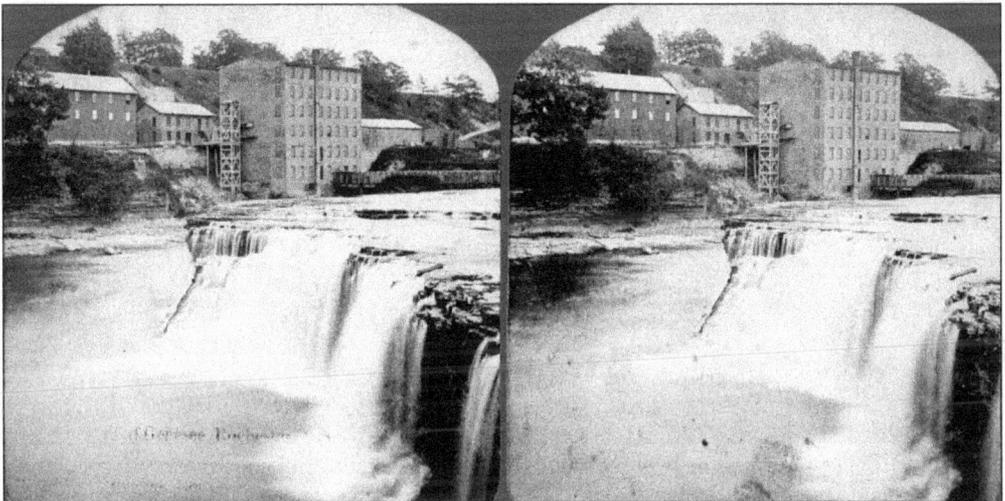

This rare *c.* 1880 stereograph was taken of the Middle Falls of the Genesee River looking south. A row of factories and a mill line the East bank.

A distinguished public servant and influential Rochester native, James Goold Cutler, was a contractor erecting the Elwood Building at West Main and State Streets, Kimball's Peerless Tobacco Company factory (now the site of the War Memorial), and other city homes. In 1884, he invented and manufactured the government approved mail chute used throughout the nation and was elected for two terms as mayor from 1904 to 1907.

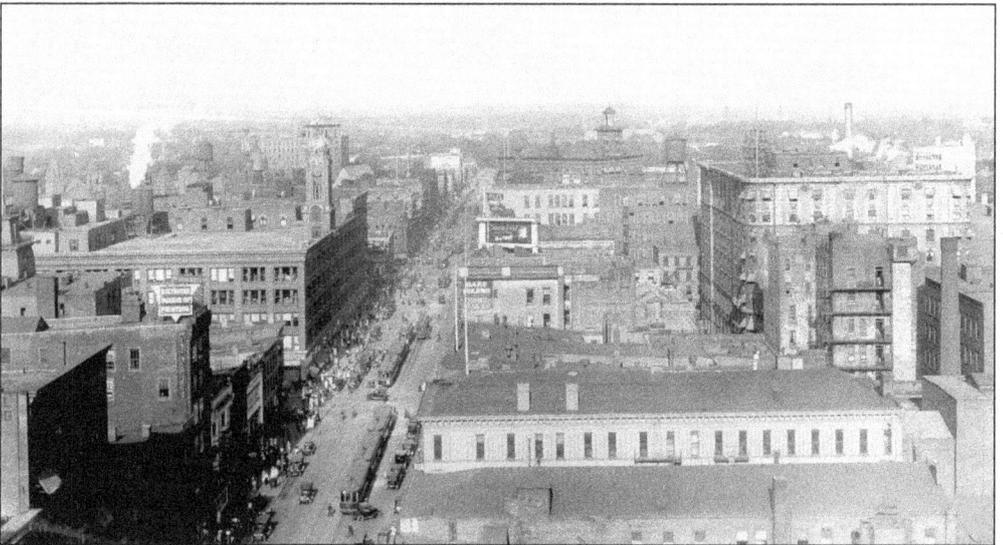

This *c.* 1920 view covers much of a trolley-lined Main Street. Sibley's appears in the center foreground. At the bottom right is a sign with letters "RIA," part of the marquee for the $75,000 Rialto Theatre at 197 East Main Street. The photo-playhouse operated from 1918 to 1924, predating the "talkies." The Morgan-Chase Bank tower fills much of that space today.

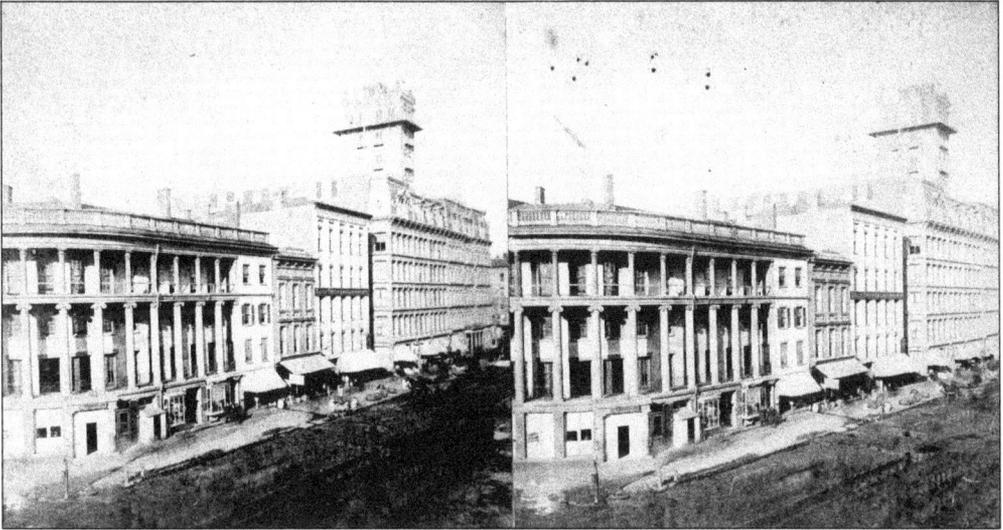

Looking northeast around 1875, the imposing National Hotel, built in Greek Revival style, once stood on the corner of West Main and North Fitzhugh Streets. Torn down in 1881, it was replaced by the Powers Hotel. To the right, the Powers Building is topped by its first tower. A taller and current tower was erected in 1890.

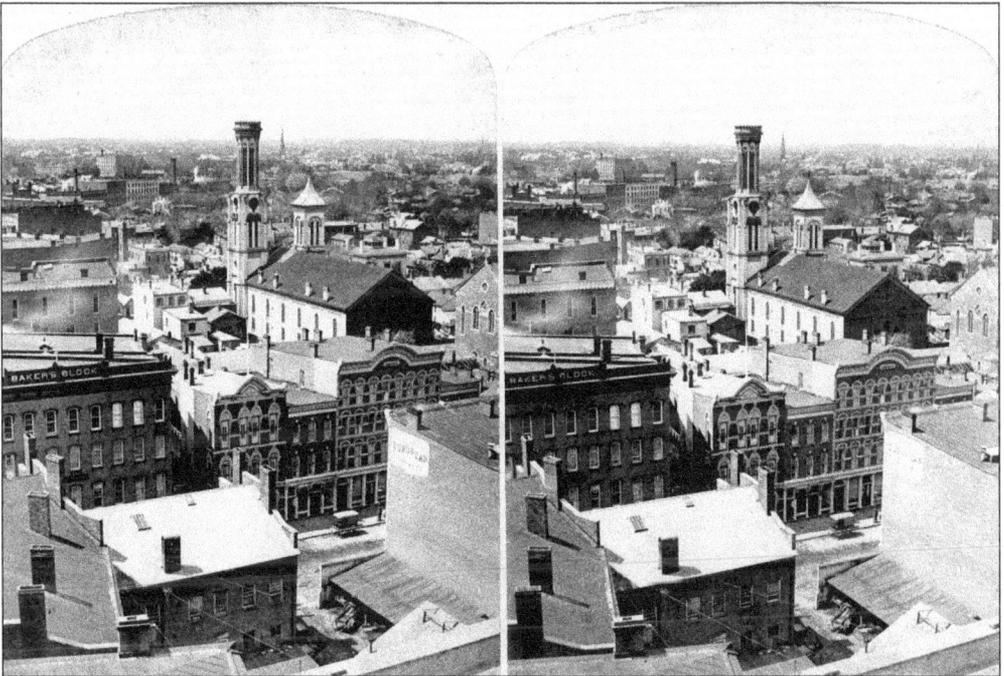

This unusual view was taken around 1885 from the tower of Daniel Powers' Building, looking west. The Brick Presbyterian Church on North Fitzhugh and Allen Streets dominates the center. The church burned on June 11, 1903, and it was rebuilt on the same site.

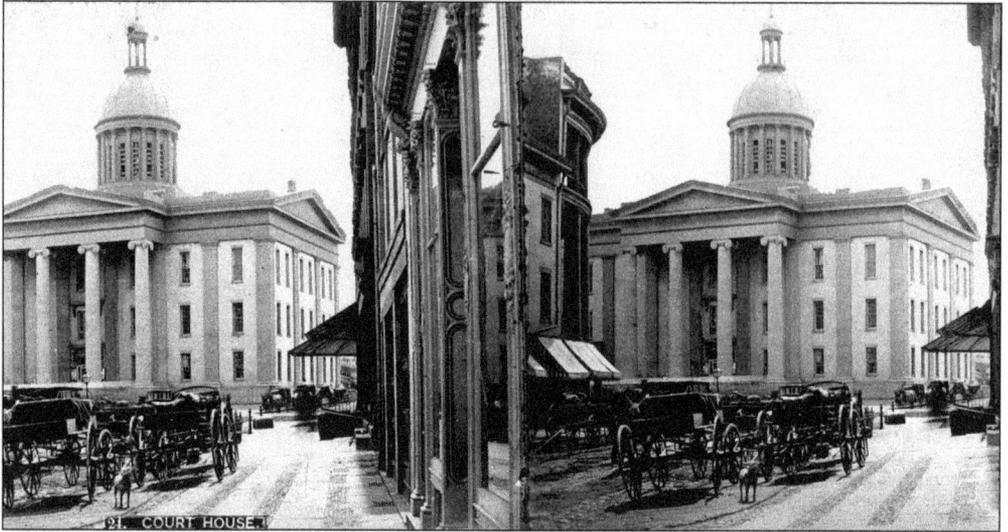

Monroe County's second county courthouse is viewed looking south from State Street *c.* 1880. Completed on June 20, 1850, the courthouse cost $60,000.

Taken with an early Kodak camera on July 4, 1894, this vintage photograph reveals the cornerstone laying ceremony for the third county courthouse, now the county office building. Costing $805,000 and designed by J. Foster Warner in Italian Renaissance style, the interior displays extensive use of Italian marble. In the background, crowds of onlookers in the Powers Building and Powers Hotel are witnessing the historic ground breaking ceremonies.

During the Great Depression, it was not uncommon to see a man leading a pony down a city street. He was a photographer who, for a very modest sum, would ask parents if they wished to have their child photographed on the pony. Clara Ryan's folks did.

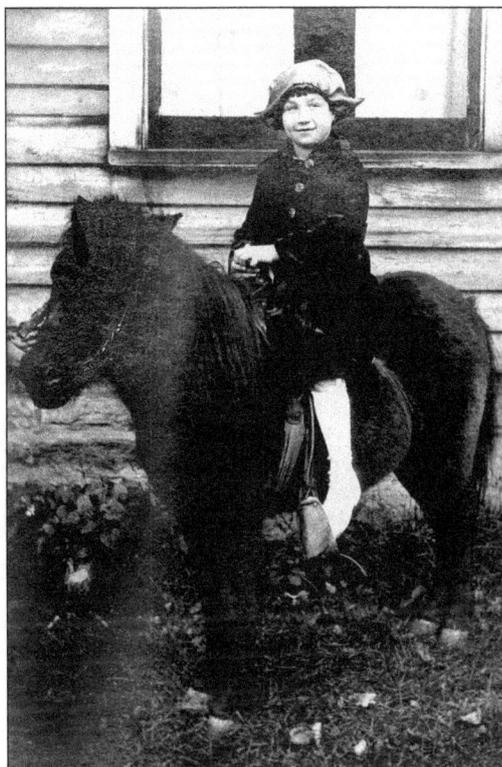

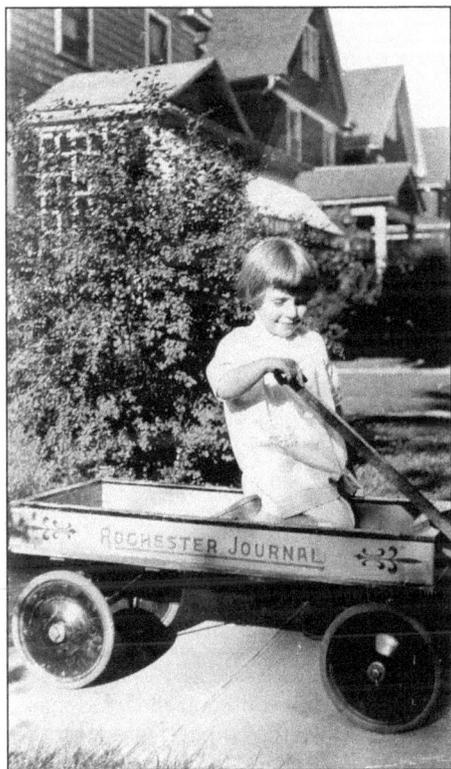

This girl was photographed around 1923 riding her wooden *Rochester Journal* wagon. The *Rochester Journal*, a Hearst-owned evening newspaper, was sold in the city from September 11, 1922, until it became the *Journal-American* around 1925. It was published in the Journal-American Building at St. Paul and Andrews Streets.

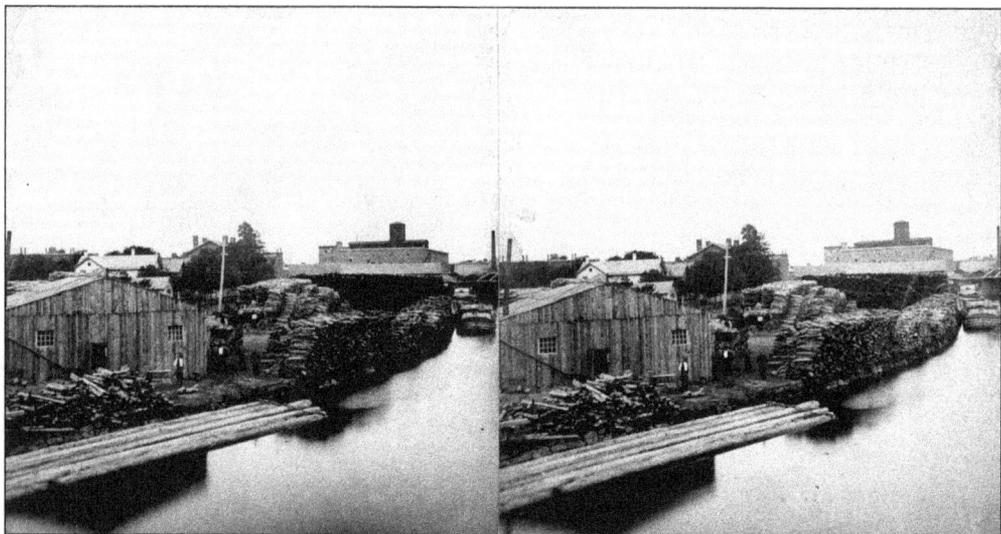

When this photograph was taken in 1870, George J. Knapp and Otto Fisher were dealers in groceries, hard, soft, stove, and kindling wood at 130 North and St. Paul Streets. They advertised, "Wood delivered to all parts of the city free of charge." Cord wood was delivered by Erie Canal freight boats to the extensive wood lot seen here. Logs lashed together made a sturdy dock for the transfer of cord wood.

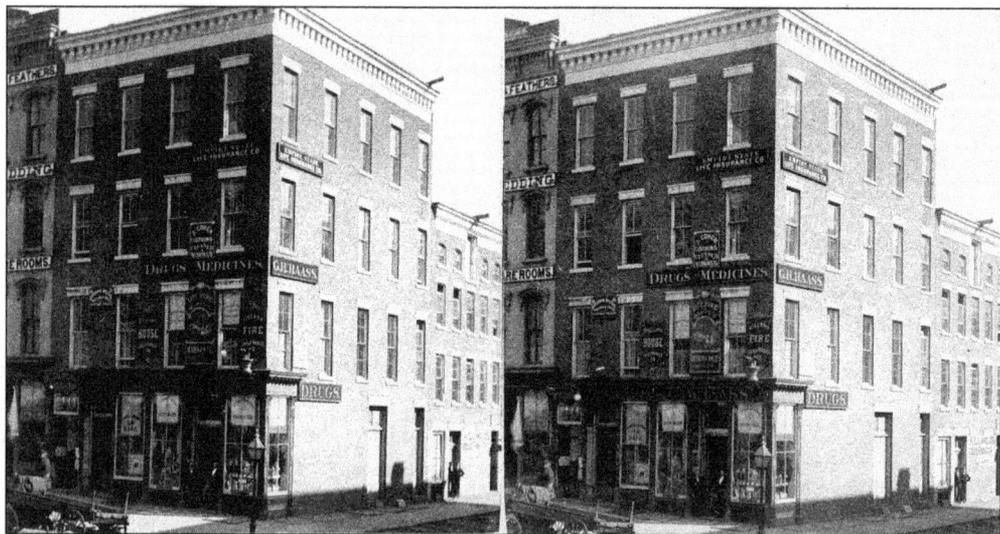

Herman G. Hass was the proprietor of the drug store at 38 Main Street around 1865. He shared the four-story building with J. Cohen, a secondhand clothing dealer, the Empire State Insurance Company, the Hibernia Fire Insurance Company, and the Dwelling House Insurance Company.

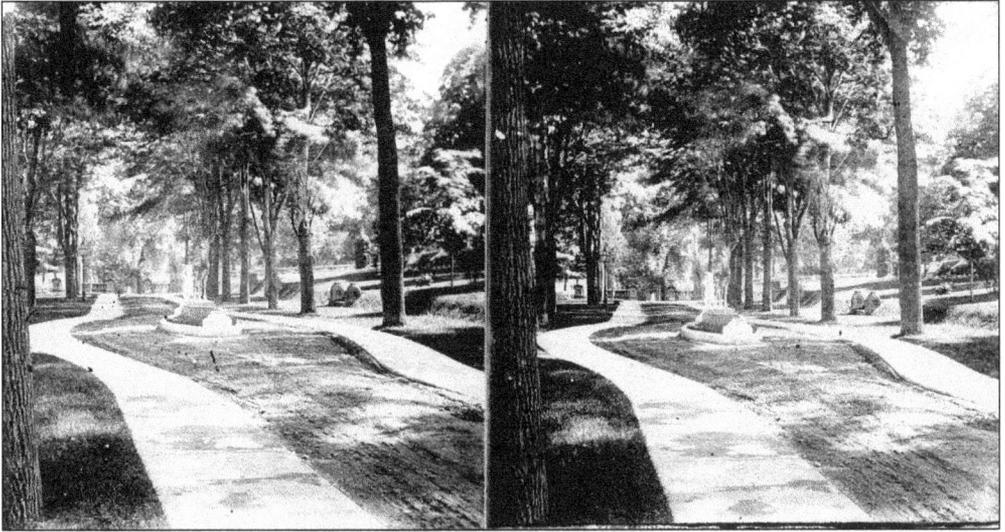

Just off Troup Street in Corn Hill was an elegant neighborhood known as Livingston Park. Ringed by a brick and wrought iron fence, it may be the first gated community. Its tree-shaded entrance is shown here around 1890. A large statue of a deer was centered between pathways leading to a row of imposing Victorian mansions.

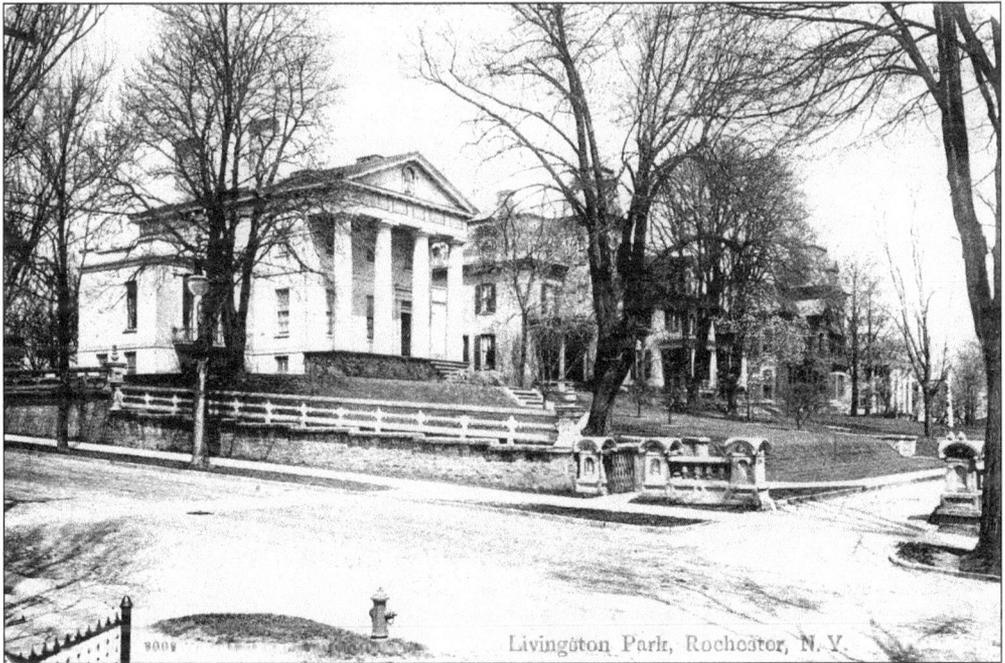

Livingston Park, Rochester, N. Y.

The first home one sees looking north into Livingston Park is the stately Greek Revival mansion built around 1838 and first owned by Hervey Ely, one of Rochester's first millers. Later owners include William Kidd, Aristarchus Champion, Jonathan Watson, Dr. Howard Osgood, and finally, the Irondequoit Chapter of the Daughters of the American Revolution. Hervey Ely is credited with planting the first shade trees in Rochester in 1816. George C. Buell, a prosperous wholesale grocer, owned the mansion seen next to the Ely home.

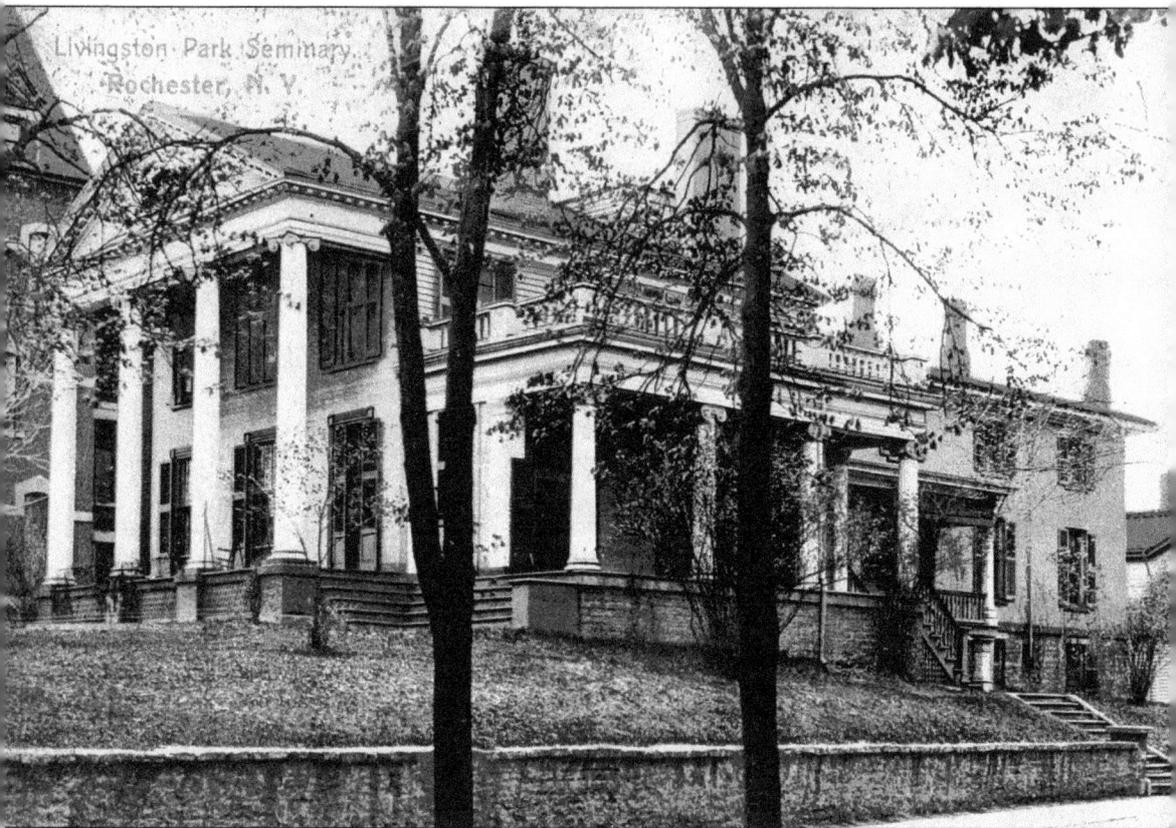

The mansion at One Livingston Park was photographed around 1907. Built in the late 1820s, it housed a girl's seminary. The house, slated for demolition and construction of the Ritter Ice Rink, was rescued in the 1950s by architect Harwood Dryer and benefactor Sibley Watson. Its parts were carefully numbered and stored until it was reconstructed as the Livingston-Backus House at the Genesee Country Museum in Mumford.

The Livingston Park Seminary was formed in 1858 by Cathro Mason Curtis as "a Family School for Young Ladies." It was the oldest private school for girls in Rochester when it closed in 1932. When the Civil War was declared in 1861, Cathro Curtis sewed an American flag, organized a ceremony, and raised the first flag in Rochester "proclaiming our loyalty to the Union."

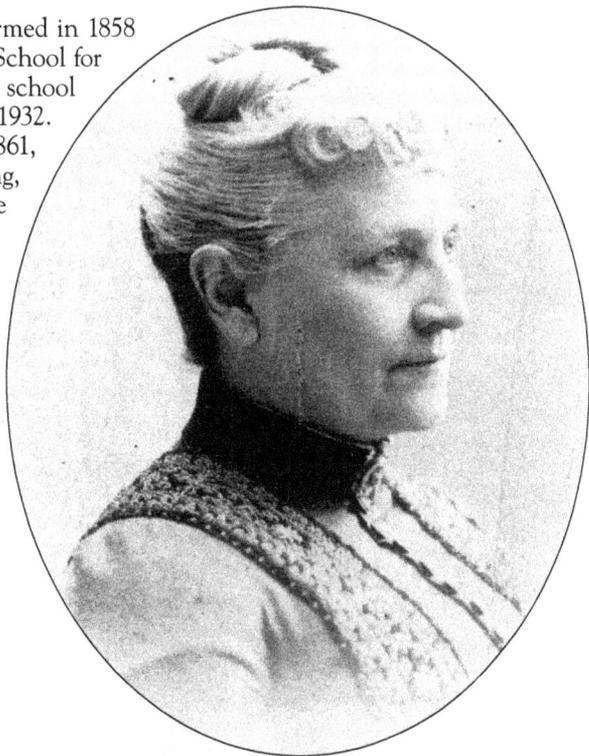

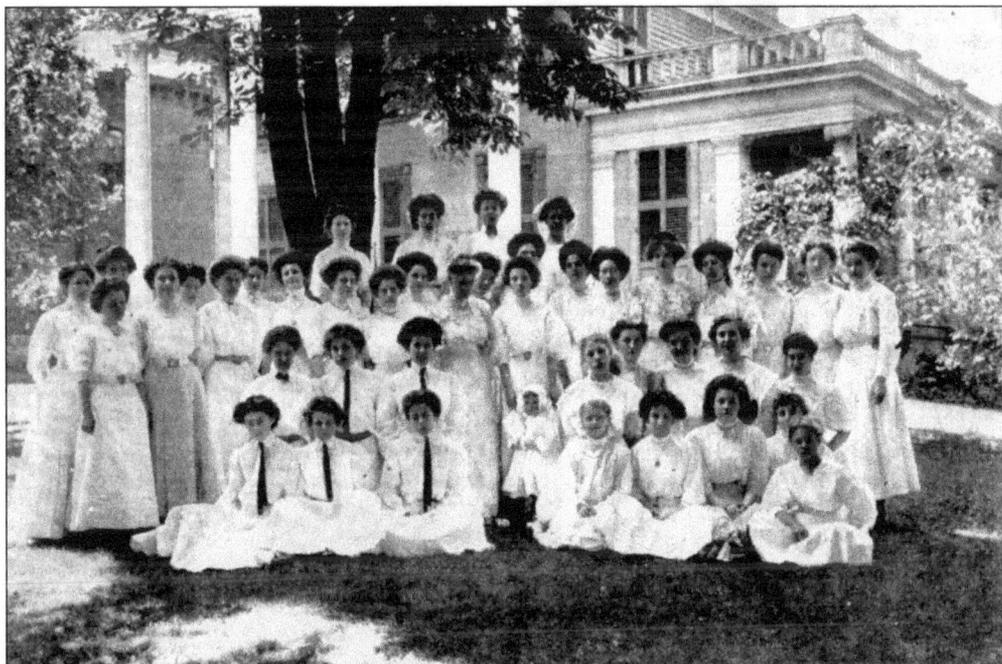

The young ladies attending the Livingston Park Seminary assembled for this photograph appearing in the *Illustrated Sunday Magazine* of the *Democrat & Chronicle* on June 25, 1908. The seminary, located at the corner of Livingston Park and Spring Street, was considered to be in "the most healthful, beautiful and retired part of the city."

The west side of North Fitzhugh Street was the location of Rochester's first public schoolhouse. The two-story building in this photograph was built in 1836, replacing an earlier frame building erected in 1813. By 1857, it had become Central High School, the city's first secondary school. It was bracketed by St. Luke's Episcopal Church on the left, an oyster and barber shop next to it, and the Rochester Savings Bank at the extreme right.

Thirteen Fitzhugh Street was the location of this four-story structure known as the Rochester Free Academy. Dedicated on March 20, 1874, its right and left arches were originally used as separate entrances for boys and girls. The center entrance was used by the superintendent of schools who was also the city's librarian. The first floor housed the city's central library and until 1980, the board of education. Gas lights, indoor plumbing, and a fresh air system made it up-to-date. Later, the lower level became Edwards Restaurant. Renovated today, the building has been adopted for office use.

The service that the noble fire horses provided for our city has almost been forgotten today. In 1926, the American Legion placed this bronze plaque on the city's main fire station as a tribute to "Our Firehorses." It was November 27, 1926, when horses were last used to pull the eight ton steam pumpers. Chubby, the last fire horse of her kind, passed away February 23, 1933. A replica of Chubby stands outside the Craft Company shop on University Avenue.

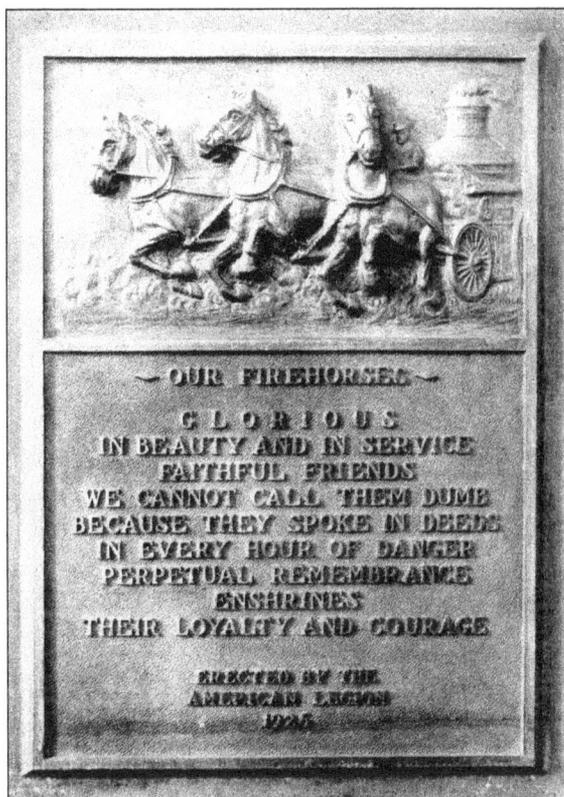

~OUR FIREHORSES~

GLORIOUS
IN BEAUTY AND IN SERVICE
FAITHFUL FRIENDS
WE CANNOT CALL THEM DUMB
BECAUSE THEY SPOKE IN DEEDS
IN EVERY HOUR OF DANGER
PERPETUAL REMEMBRANCE
ENSHRINES
THEIR LOYALTY AND COURAGE

ERECTED BY THE
AMERICAN LEGION
1926

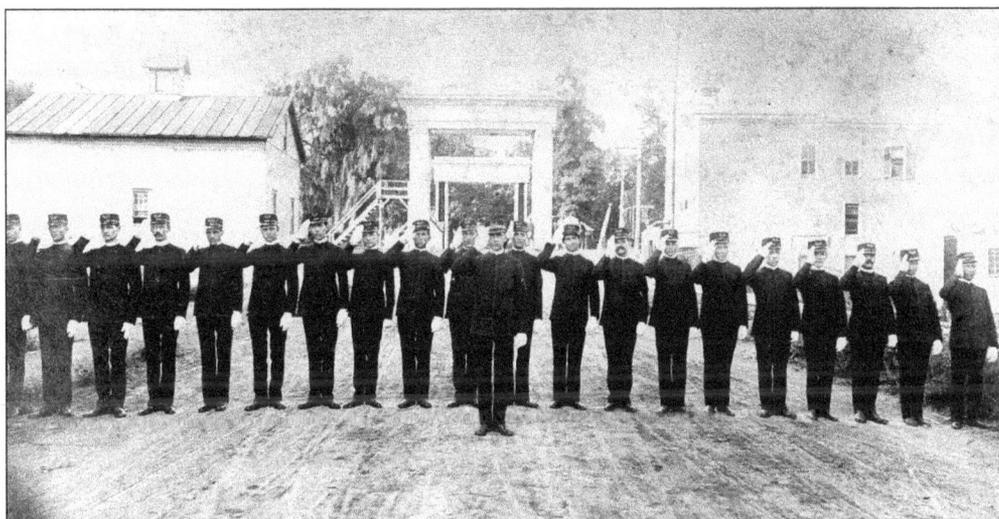

The village of Brighton was proud of its fire department. Taken around 1885, the firemen pose on an unpaved intersection of South Street (Winton Road) and East Avenue, known at the time as Caley's Corners. The lift bridge in the background allowed traffic to cross the Erie Canal.

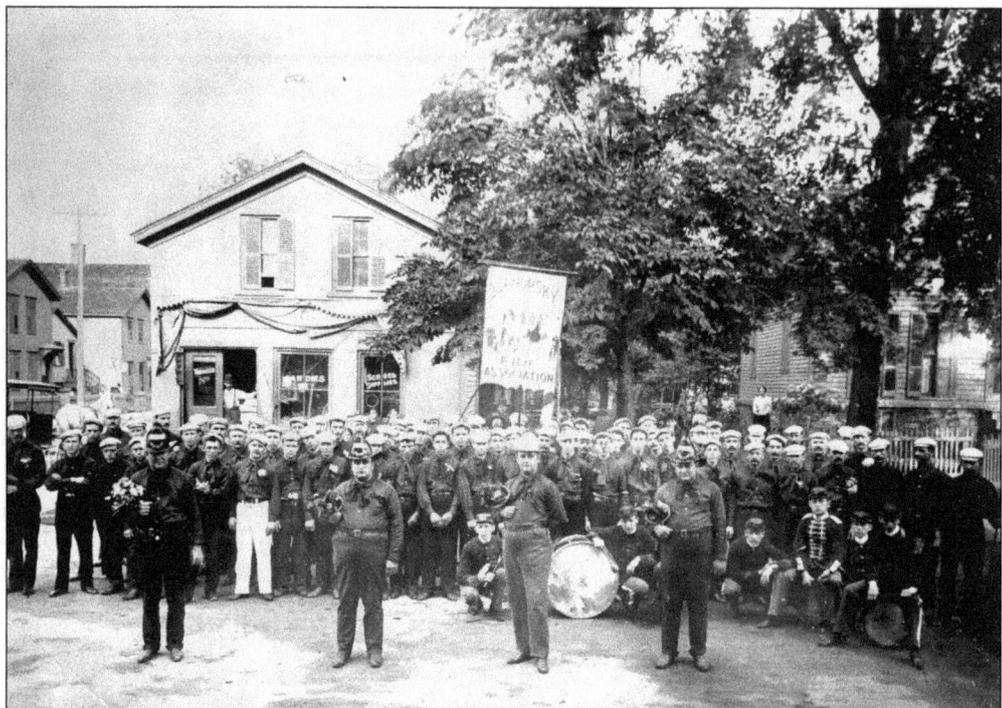

One of Rochester's more unusual firefighting organizations was the Burn-Up-Sky Fire Association. More than 75 volunteers and band members are shown proudly dressed for this *c.* 1902 photograph.

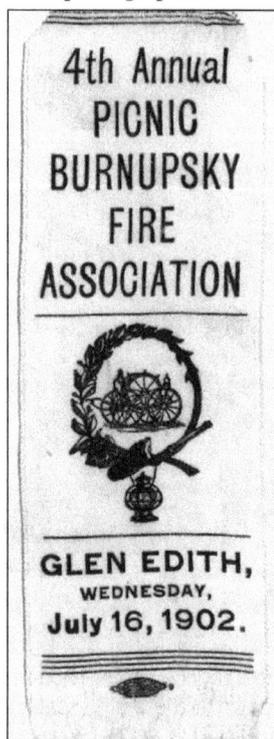

4th Annual
PICNIC
BURNUPSKY
FIRE
ASSOCIATION

GLEN EDITH,
WEDNESDAY,
July 16, 1902.

The firemen making up the Burn-Up-Sky Fire Association must have been a group of fairly brash young men. Not only did they join to fight fires, but they enjoyed the fellowship at their annual outings. On July 16, 1902, members wore this ribbon to their fourth annual picnic at Glen Edith. The ribbon belonged to William F. Janneck, who was boarding at 170 Berlin Street.

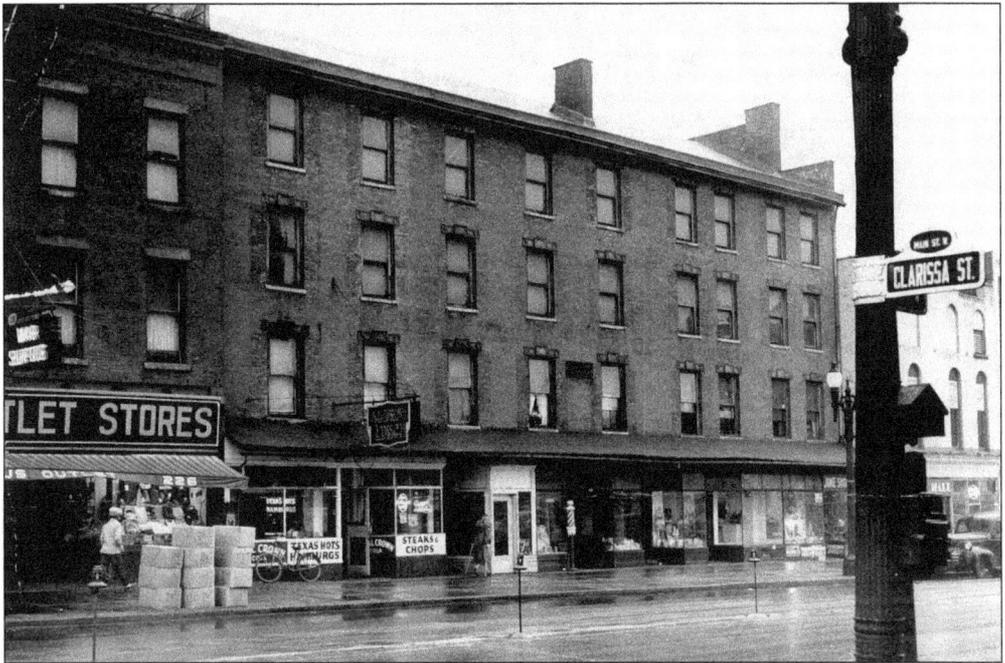

Just across West Main from Clarissa Street is the venerable building once proudly known as the United States Hotel. The four story brick structure was the humble first home of a great Rochester institution, the University of Rochester. A bronze plaque, seen between the second floor windows, attested to its origins. It is now a historical souvenir somewhere.

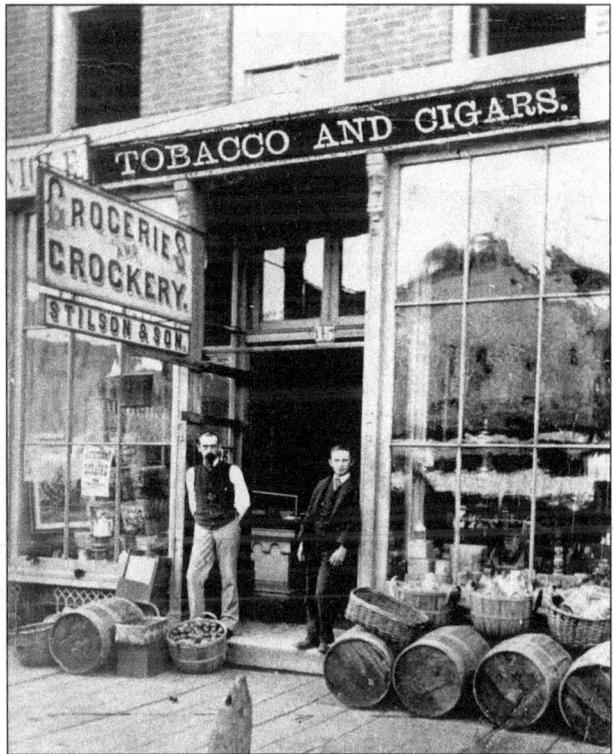

This glimpse into the past shows just one of many general stores that lined Rochester's streets in the 1890s. Charles Stilson (left) and his son, early city entrepreneurs, are awaiting customers in an era where goods were displayed and sold in baskets and barrels.

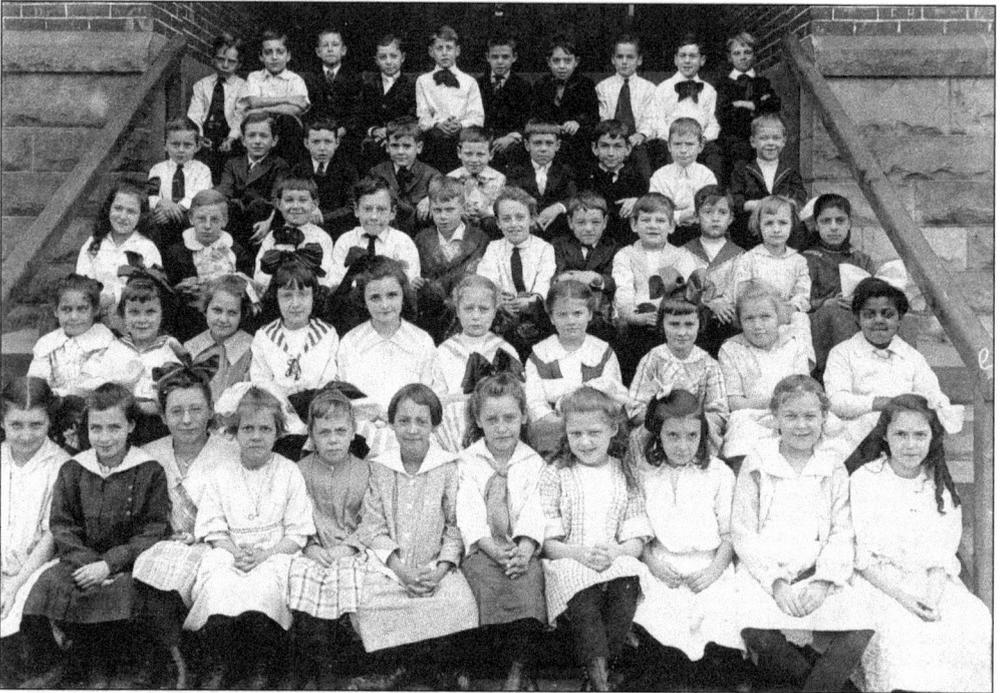

Memories of good old school days were captured in this *c.* 1905 photograph of two fourth grade classes at a city elementary school. A close study of the picture reveals carefully folded hands, smiles, and semi-serious expressions on many of the young faces. Button shoes, hair bows, and bow ties were in style.

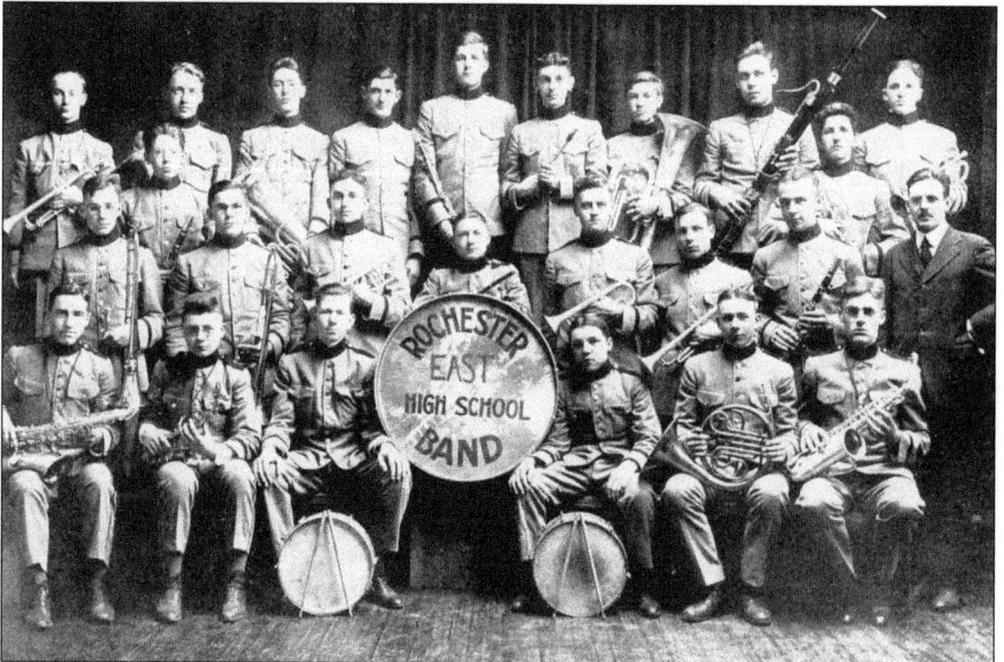

Recorded in the *Senior Log*, published in June 1920, this detailed photograph shows the 24 members of East High School's band. The school also had an orchestra directed by Jay Fay.

46

One of Rochester's senior establishments was created by Alick G. and Durbin Richardson on December 16, 1915, at 1069 Lyell Avenue. World War I was exploding in Europe. At the war's end, the firm secured veterans as salesmen for their "Maid of Honor" fruits and syrups. Their "salesmen and jobbers wanted" card appears here.

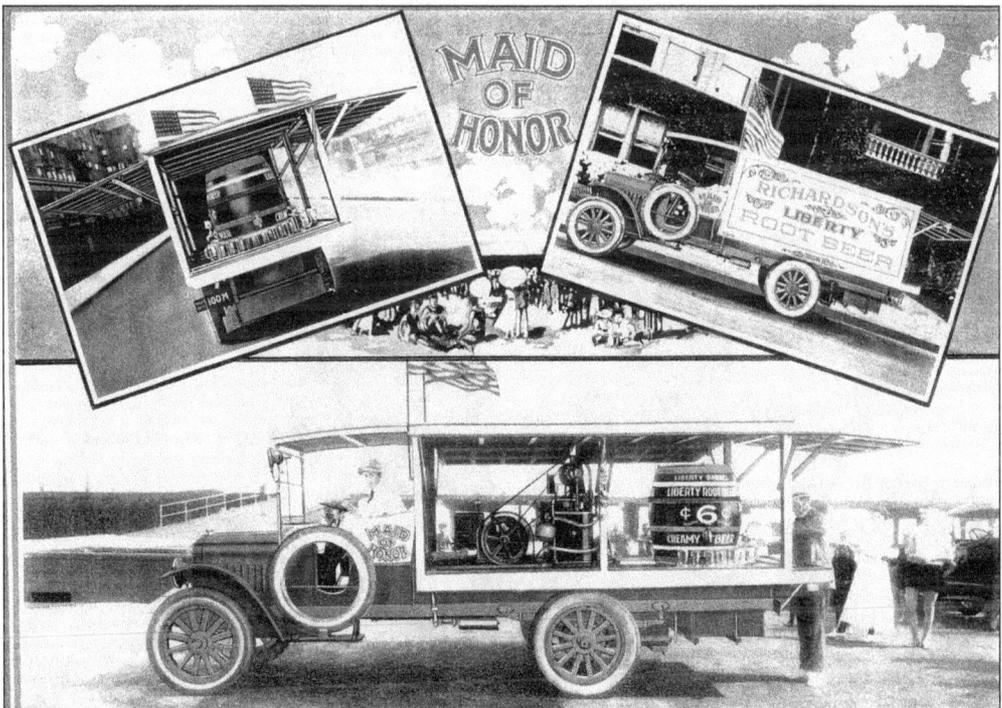

By 1919, the firm had patriotically named their newest syrup "Richardson's Liberty Root Beer." Dispensed in "Liberty Barrels," the "Creamy Beer" filled hefty glass schooners that weighed as much as their foamy contents. The firm's neat promotional vehicle visited resorts and amusement parks from New York to Michigan.

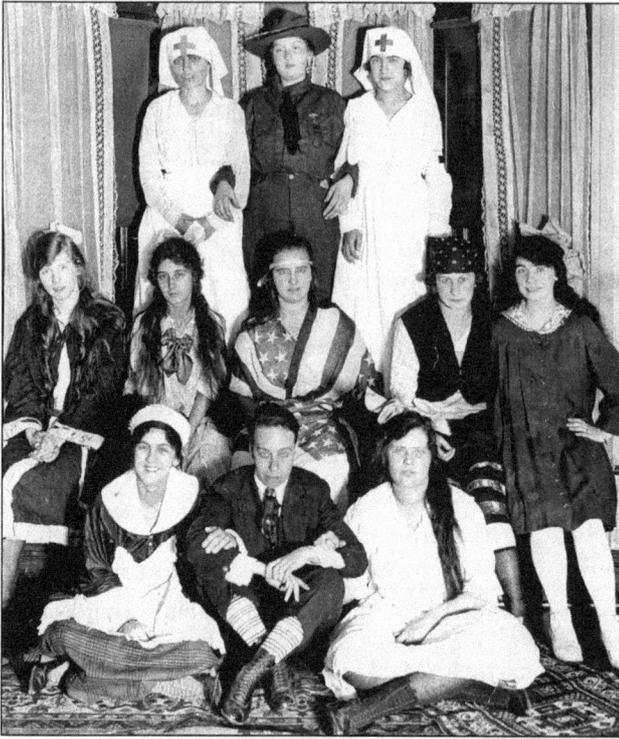

During World War I, Rochester residents supported their servicemen by purchasing war relief and victory bonds. This group of amateur thespians did their part by promoting the bond drives through presenting a number of patriotic plays. How could anyone not want to contribute after seeing these actors perform?

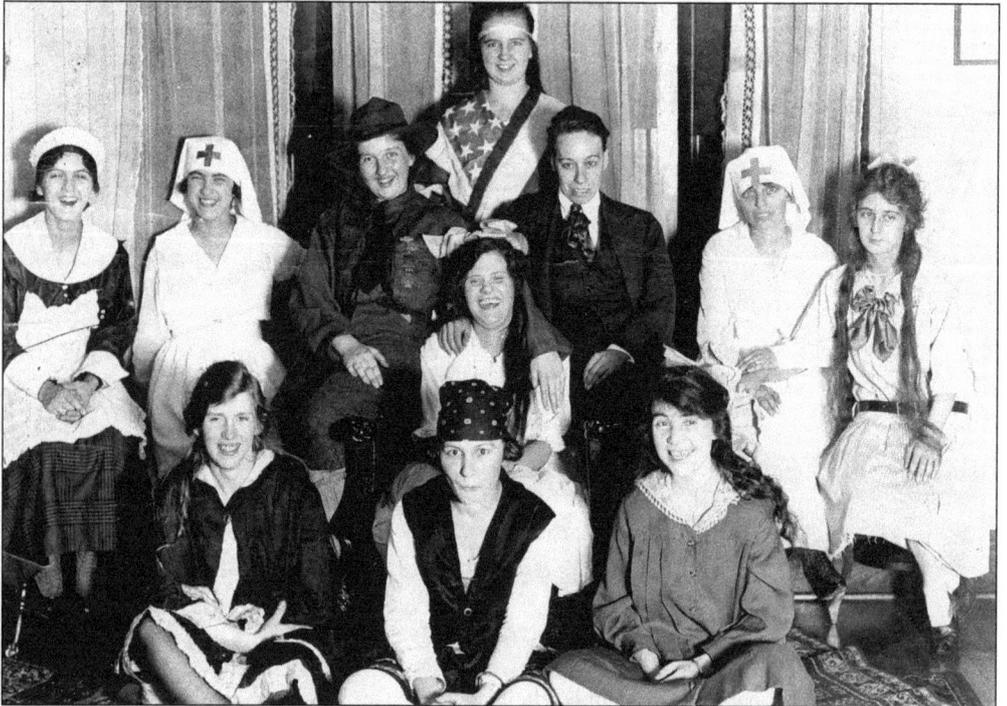

The need for bonds and war relief funds must have been great to entice these patriotically costumed Rochester residents to perform a series of skits encouraging citizens to give to the fund drives during World War I.

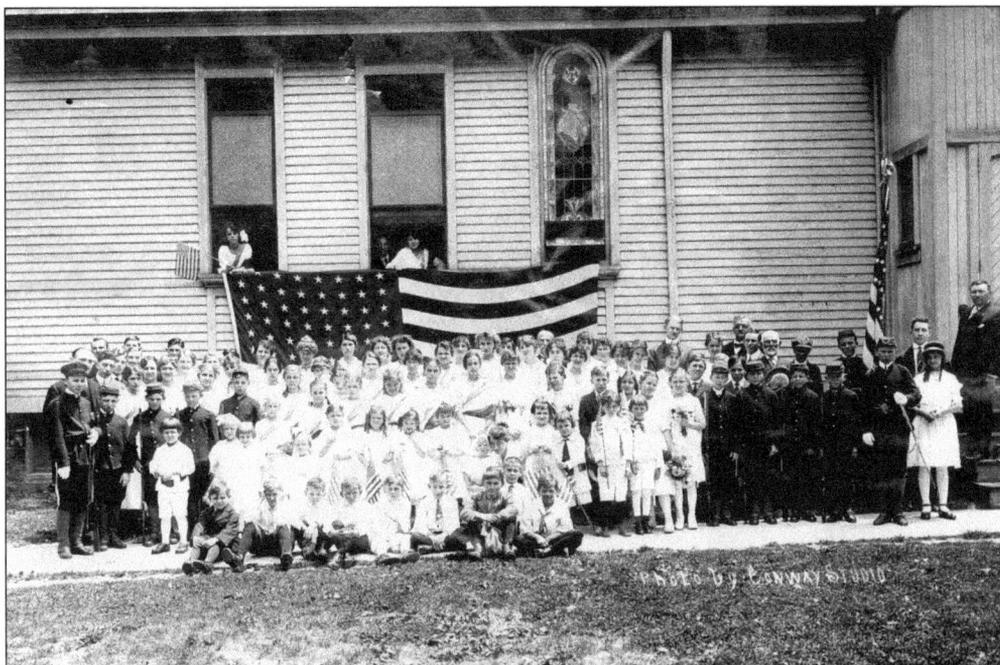

In 1917, Children's Day was celebrated by the Evangelical Lutheran Church of Peace at Caroline and Mt. Vernon Streets. Patriotic songs, hymns, and skits were sung and dramatized by the children who then posed for this unusual photograph.

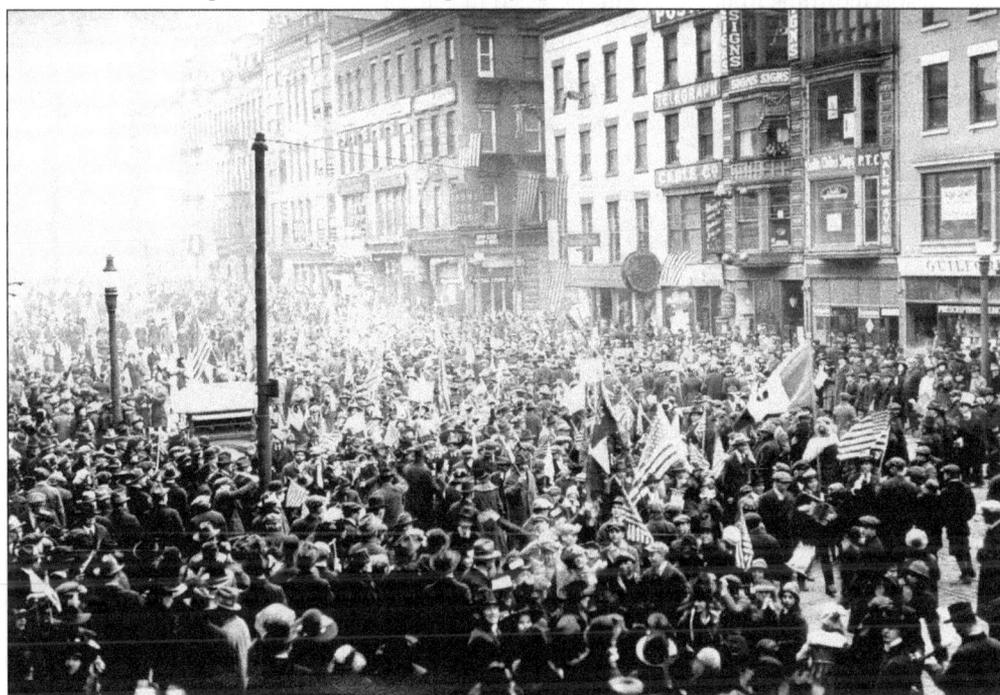

Victory bond drives brought out huge numbers of residents in 1914. This patriotic crowd rallies on West Main Street just east of Exchange Street to show its support for our Allies in France during World War I. Note that everyone is wearing a hat.

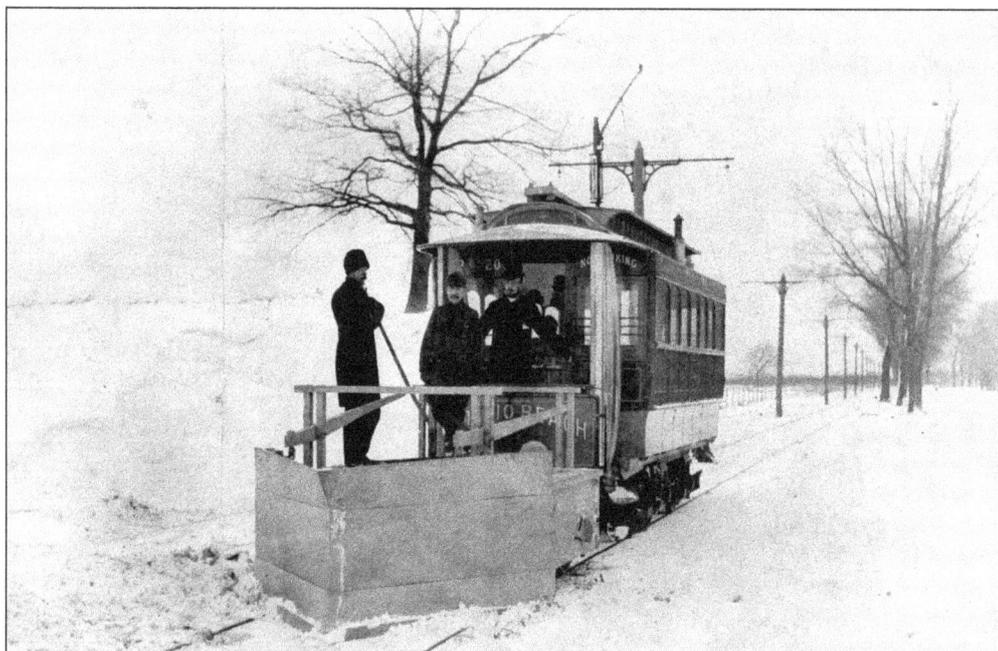

How did trolley cars cope with Rochester's winters? The company invented a trolley propelled snow plow with its own wheel set to remove snow from the rails. This photograph, taken on Lake Avenue near Winchester Street, has frozen in time a trolley car with its unique wooden plow blade. It was returning from Lake Ontario Beach in the 1890s.

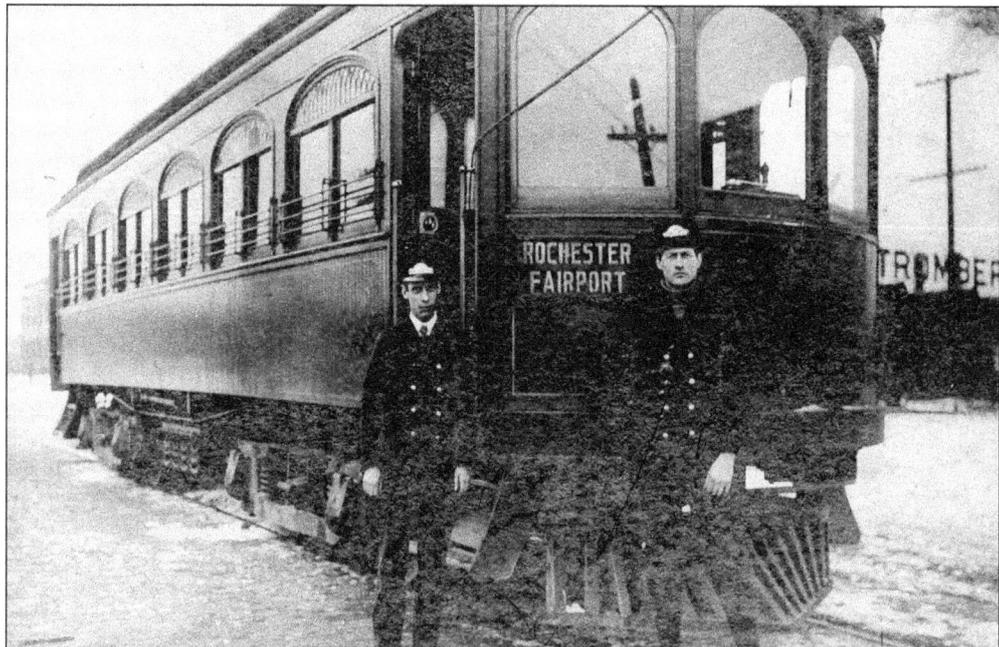

Between 1906 and 1931, the Rochester, Syracuse, and Eastern "ravelectric" whisked patrons for 87 miles between Culver Road in Rochester and Salina Street in Syracuse. The interurban trolley, photographed near the Stromberg Carlson Company, is on its way to Fairport. From 1922 to 1928, the cars shared the route of the abandoned Erie Canal bed when leaving the city.

The small wheel transmitting electricity from overhead wires to the trolley car's electric motor was called a "trolley." However, the public soon called the entire streetcar a trolley. The National Trolley Manufacturing Company was located in Rochester.

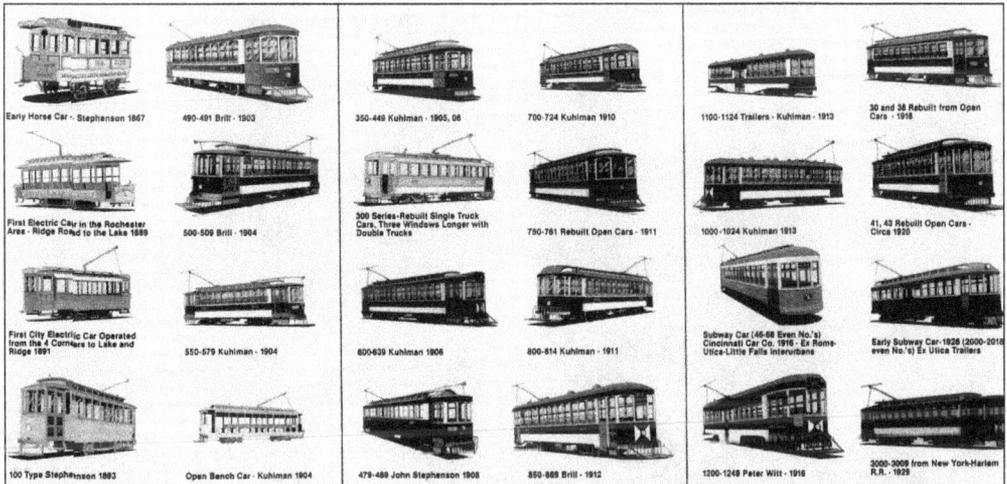

These fascinating images show the evolution of Rochester's early trolley cars from 1887 horse cars to a 1929 electric trolley. Images were drawn by veteran Rochester Transit System employee, Robert Northrup. They appeared in the 1982–1983 Rochester-Genesee Regional Transportation Authority's annual report celebrating 150 years of transit progress in Rochester. Originals may be seen at the New York Museum of Transportation on East River Road.

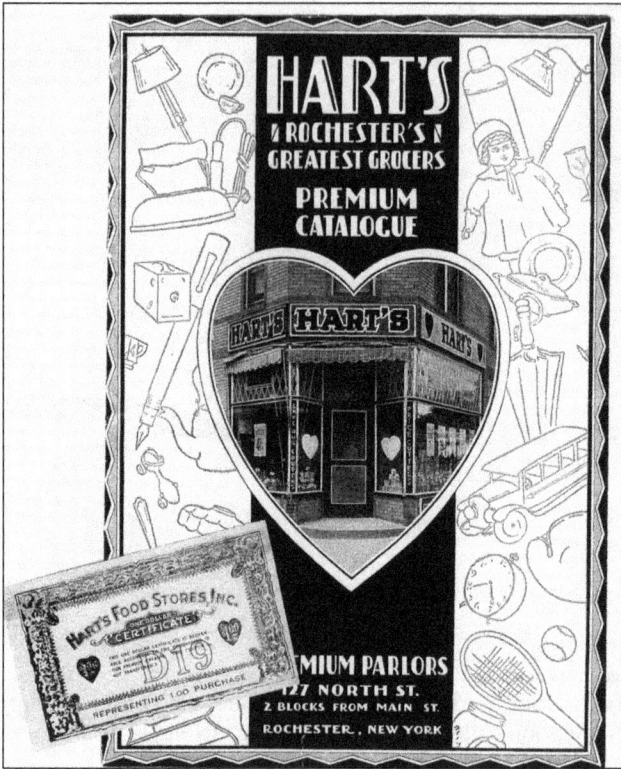

In the 1920s, Alfred Hart founded Hart's Food Store chain. He instituted the nation's first use of store-brand labels, operated a store-owned bakery, and offered coupons to his customers good for over 400 items redeemable at the chain's premium parlors. Additionally, he created the first self-service grocery market. During the 1960s, the stores became Star Supermarkets. Hart's certificates were printed in pink, green, yellow, and blue.

"The Spirit of Rochester"
is the Hart Spirit—
the Spirit of Progress and Good Will

A familiar sight on every street in every section of Rochester and vicinity.

HART'S SPIRIT OF ROCHESTER

ALL STEEL, MACHINED BEARINGS, DISC WHEELS, HEAVY RUBBER TIRES, WEIGHS 40 LBS.

Premium No. 162
200 Certificates

Thousands of these wonderful all steel orange express carts may be found on Rochester's streets. They are FREE to patrons of Hart stores merely for saving the coupons given with each purchase.

Much envied were the kids that had one of these snappy, brightly orange-painted Hart's wagons. If parents could save 200 Hart's coupons, they could acquire one at a Hart's Premium Parlor. The early carts were made of wood and later of metal.

Two

LEADERS IN MANUFACTURING AND INVENTION

The medal of Col. Nathaniel Rochester, sculpted by Alphonse Kolb, bears his likeness and represents the foremost of Rochester's great leaders. Born in 1752 and passing away in 1831, his legacy is not only the great city which carries his name, but the hundreds of products invented and manufactured here. Those early wares became known around the globe, and Rochester's products, creativity, and quality are still benchmarks of craftsmanship highly valued today.

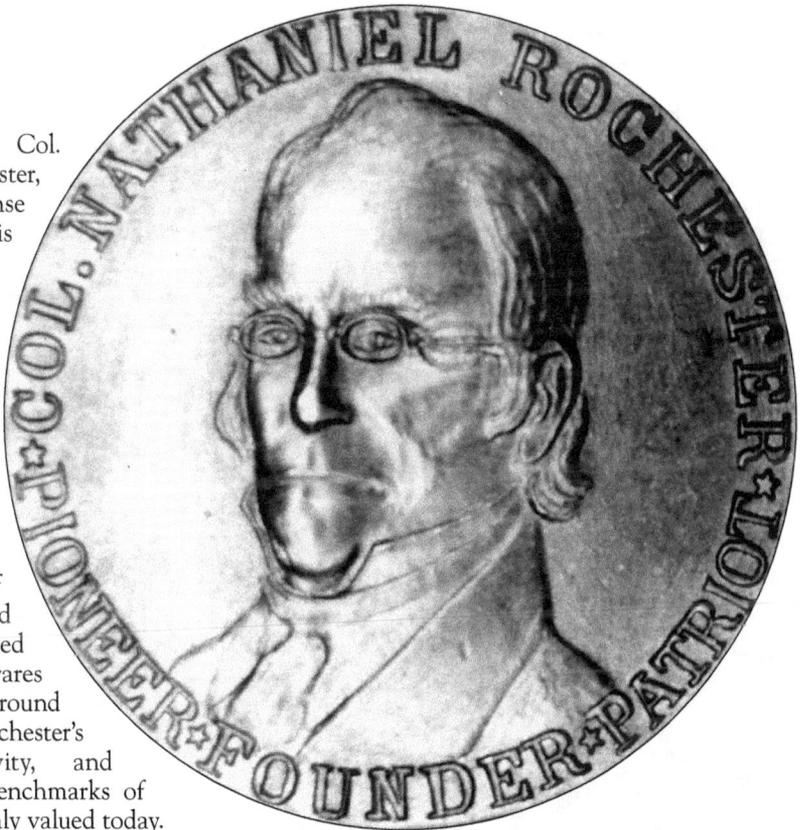

Three major foundries manufactured cast iron stoves in Rochester. The largest, the Co-Operative Foundry Company, was founded in 1867 by Nicholas Brayer and Edward W. Peck. It manufactured Red Cross stoves and ranges. Their logo, a red Gothic cross, widely promoted their product. Who could resist a second look at the comely young lady, a red cross pendent around her neck, about to finish dressing?

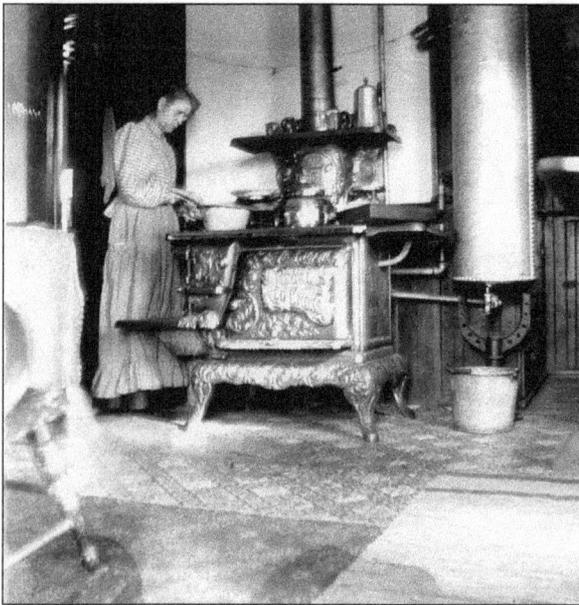

By the 1880s, the stove firm had moved to the corner of West Avenue and Lincoln Park. With 500,000 feet of floor space, the Co-Operative Foundry ranked as one of the largest in the nation. Hattie Ginegaw used her Regal Red Cross stove not only to bake delicious mince meat pies and heat the kitchen, but also to provide a ready supply of hot water.

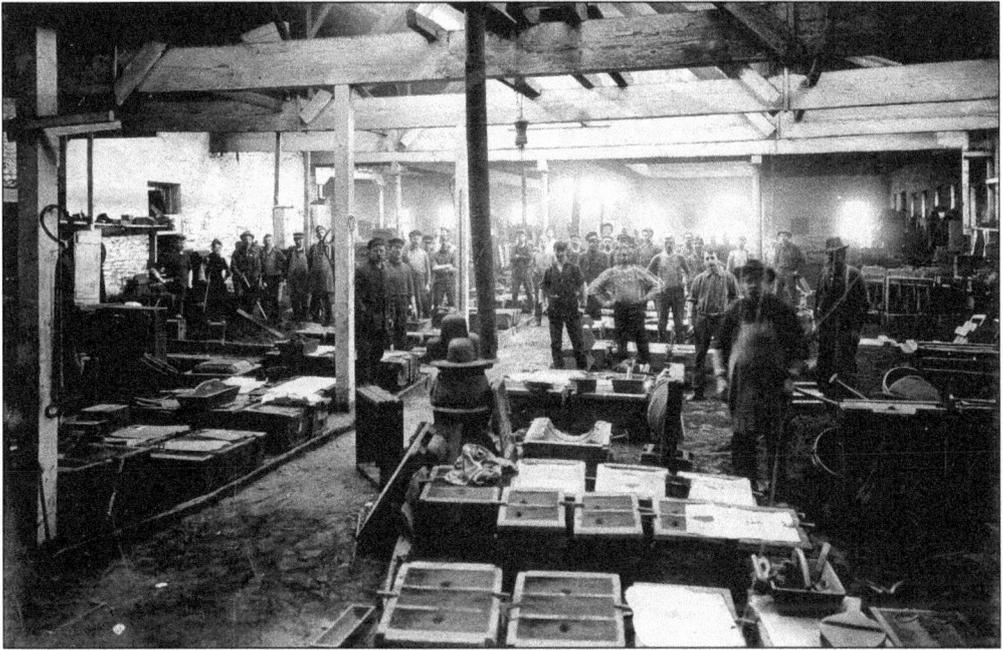

Located at 208–210 Oak Street, the Sill Stove Works, founded by Frederick Will, was another of Rochester's major industries in the early 1900s. Boxes holding sand for casting stove parts can be seen in the foreground. Enough heat was generated by the foundry so that warmth from the small parlor stove was not needed.

Brightly colored advertisements pictured a pretty girl to market the Sill Stove Work's parlor stove. The ornate model is a Sterling. The advertisement's reverse side proclaims that the Sterling is, "The most successful square heating stove ever made." It had "Three Years Of Unprecedented Success." Attention was also called to the stove's top bearing a "Handsome Bronze Figure, representing Mars, the God of War."

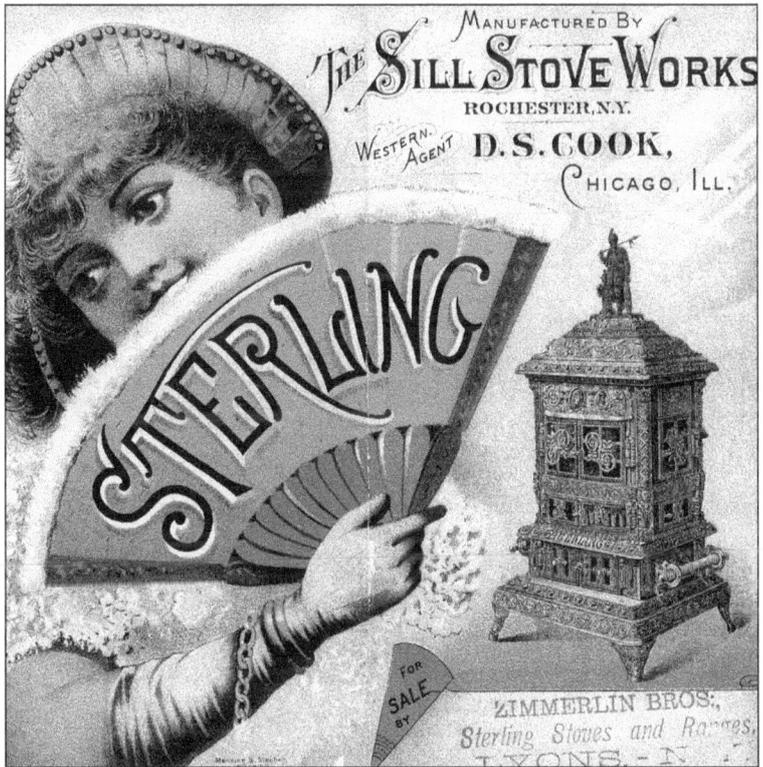

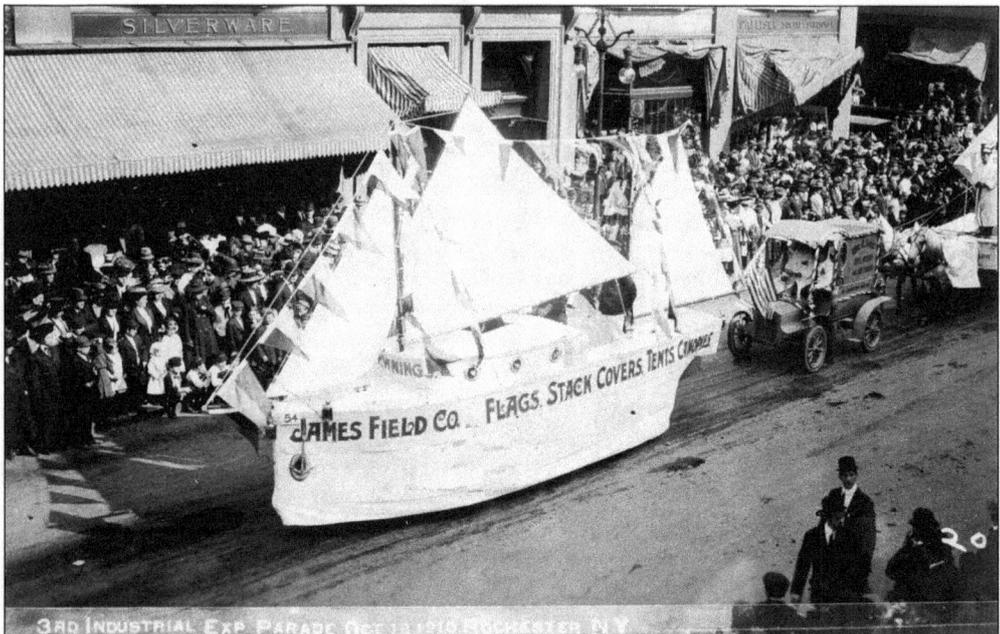

To advertise Rochester's third industrial exposition to the public, a parade was held on October 18, 1910. The James Field Company's float is seen flowing down East Main Street in the shape of a ship. This was an appropriate choice for a company that manufactured a full range of sailcloth and other nautical needs.

Established in 1843, the James Field Company furnished flags, tents, and all types of canvas for awnings and yacht sails. The firm also offered a complete line of marine and canal boat supplies from Manila and jute rope to pitch oakum and tackle blocks. Horse and wagon covers, grain bags, canal whiffletrees, and camp outfits were also available manufactured by their firm at 41–43 Exchange Street.

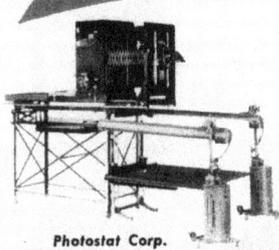

Photostat Corp.

J. Hungerford Smith Co.

Art Craft Optical Co.

Kee-Lox Manufactur

Richardson Corporation

Max Lowenthal & Sons

Tobin Packin

Clapp's Baby Food Div.
American Home Foods Inc.

Stein-Bloch
Company

Defender Div.
E. I. du Pont de Nemours & Co., Inc.

E. P. Reed
& Company

Samson United
Corporation

The
Schlegel
Mfg. Co.

Ilex Optical Company

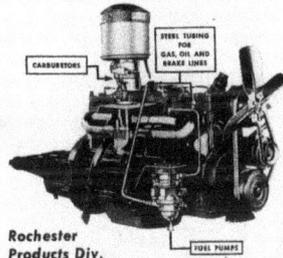

Rochester
Products Div.
General Motors Corp.

Sc
Fo

The Todd Co., Inc.

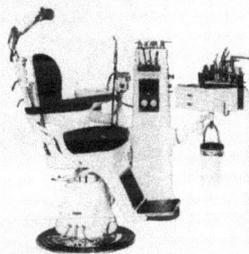

Ritter Co., Inc.

Fanny Farmer Candy
Shops Inc.

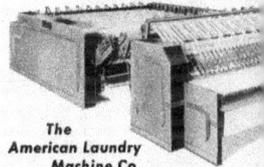

The
American Laundry
Machine Co.

Wilmot Castle
Company

General Railway
Signal Company

Beech-Nut
Coffee

STEEL CUT

Beechnut Packing
Company

Taylor

Taylor Instrument
Companies

Levy Brothers &
Adler-Rochester,
Inc.

NUNQUAM RETRORSUM

The Anstice
Company,
Inc.

Shown here are more than 50 of the many manufacturing firms that called Rochester home
in 1947. Company logos help to identify their origins. Rochester prided itself on being a major
inventive and manufacturing center at the time.

ND
LOTHES

ores, Incorporated

FULL COLOR Lithography by STECHER-TRAUNG

Stecher-Traung Lithograph Corp.

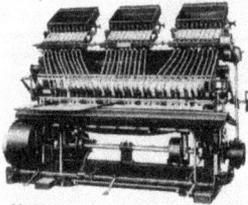

Kellogg Div. American Brake Shoe and Foundry Company

Hickey-Freema CUSTOMIZED CLOTHE

BROS. CO.

Morgan Machine Co., Inc.

Delco Appliance Div. General Motors Corp.

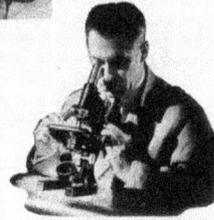

Bausch & Lomb Optical Co.

Stromberg-Carlson Company

Hickok Mfg. Company, Inc.

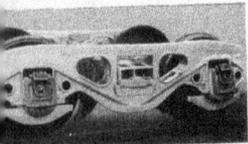

F. A. Smith Mfg. Co., Inc.

balanced TIMELY CLOTHES tailoring

Wollensak Optical Co.

Graflex Inc.

he Symington-Gould Corp.

Curtice Bros. Co.

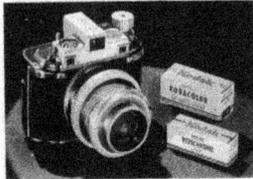

Shuron Optical Co., Inc.

Eastman Kodak Co.

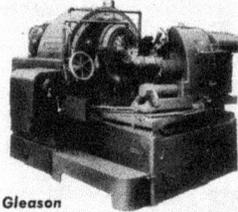

Gleason Works

Commercial Controls Corporation

The R. T. French Co.

Justowriter Corporation

J. G. Menihan Corporation

FASHION PARK CLOTHIERS

Yawman & Erbe Manufacturing Co.

Michaels Stern & Company, Inc.

Distillation Products Inc.

In 1946, "more than 800 manufacturers employed more than 140,000 workers in Rochester." Clothing, food, and manufactured goods were major items produced in Rochester. These images represent the larger concerns; many lesser firms could also be listed.

William Gleason, founder of the Gleason Works, saw a better way of fabricating bevel gears. In 1874, he invented the bevel gear planer. At the beginning of the 20th century, he gave up tool making to concentrate on bevel gear machinery. Today, Gleason products are sold throughout the world.

To the left is part of the Kidd Iron Foundry. In 1876, William Gleason became sole owner of the foundry at Brown's Race. In 1865, an early camera recorded the foundry-men and their products—cast iron gears and trolley wheels. The foremen have donned their high hats for the photograph. In 1890, the firm, known as the Gleason Tool Company, sold its first bevel gear planner to a company in England.

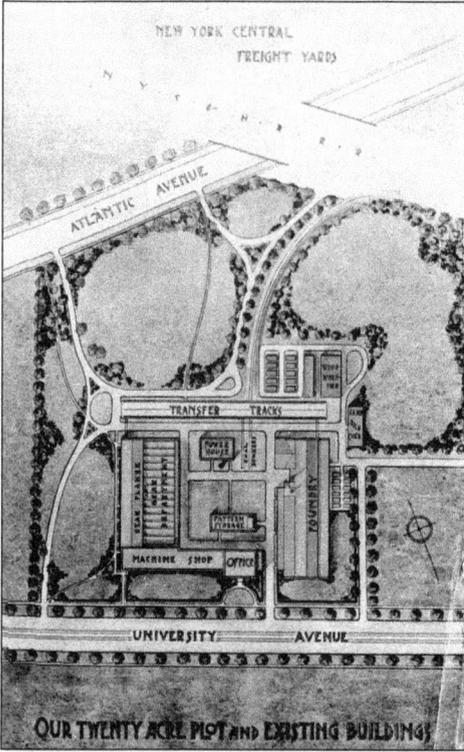

OUR TWENTY ACRE PLOT AND EXISTING BUILDINGS

By 1911, the Gleason Works complex had moved to 1000 University Avenue. Kate Gleason, William Gleason's daughter, chose impressive neoclassical lines for the firm's main entrance based on the Pan-American Building in Washington D.C. Located on University Avenue in the "backyard" of George Eastman's estate, the company exhibits a strong pride and sensitivity to its neighborhood.

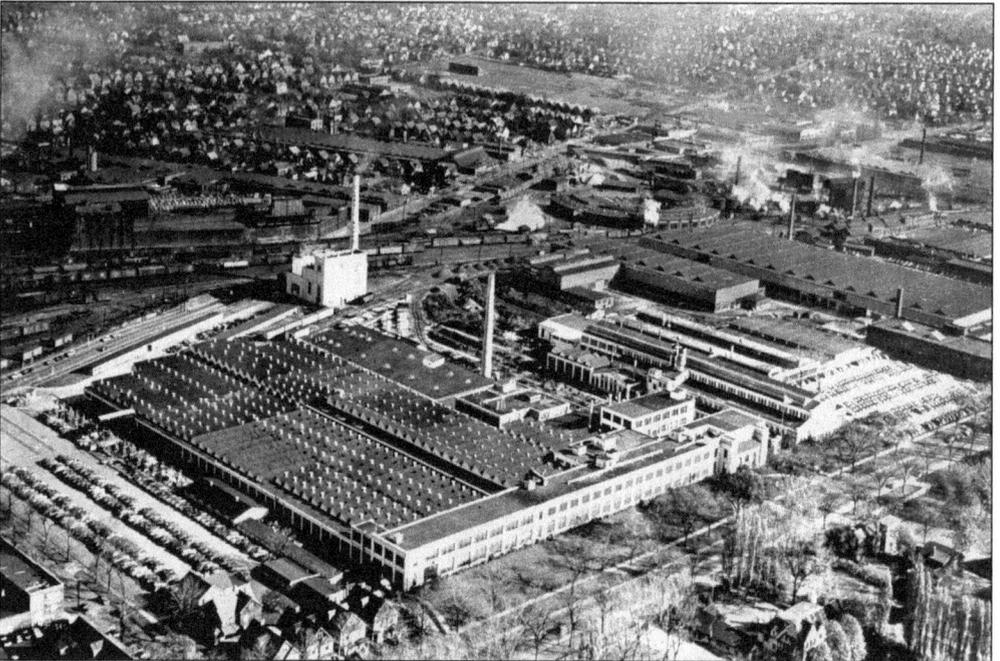

This aerial view shows the Gleason Works Factory at 1000 University Avenue. Its one of Rochester's oldest pioneering industrial firms. It continues to make gear cutting machines, expanding to 500,000 square feet of floor space covering 24 acres as seen in this 1950 photograph. In the distance in the center are the Atlantic Avenue rail yards and roundhouse.

On January 1, 1881, George Eastman and Henry Strong formed a partnership called the Eastman Dry Plate Company, and the rest is history. An avid tinkerer, he put his Yankee inventiveness to work creating flexible film. Thus, he gave rise to popular photography and the motion picture industry. Eastman gave us the Eastman School of Medicine and Dentistry, Eastman Theatre, Eastman School of Music, and Durand-Eastman Park. He also founded the radio station WHAM and the Community Chest, today's United Way of Greater Rochester.

This lovely young Victorian maiden became the "Kodak girl." The May 11, 1903, issue of the *Democrat & Chronicle* headlined an article stating, "A Maid To Adore Is The Kodak Girl, But Men by the Score With Their Heads Awhirl Have Tried in Vain to Learn Her Name." Lewis B. Jones, then Kodak publicity bureau head, also refused to name her.

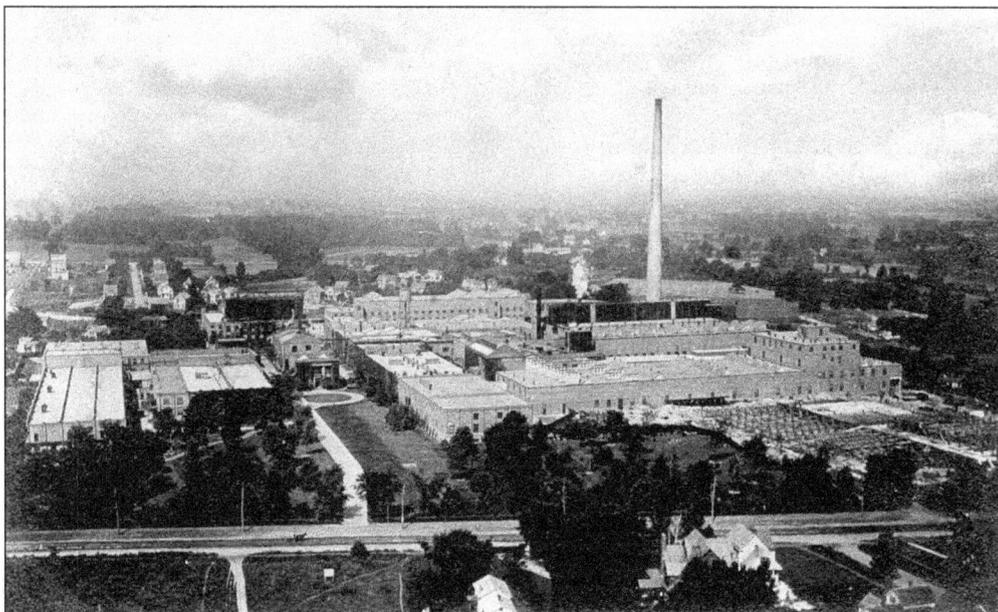

KITE PHOTOGRAPH OF KODAK PARK.

One of the earliest attempts at aerial photography took place when a Kodak camera, using Kodak film, was fastened to a kite and sent aloft. The result was this sharp image recorded in 1910 and sold as a postcard at the Kodak Company exhibit during the Rochester Industrial Exposition that year. The postcard was signed by Avery Allen Ashdown.

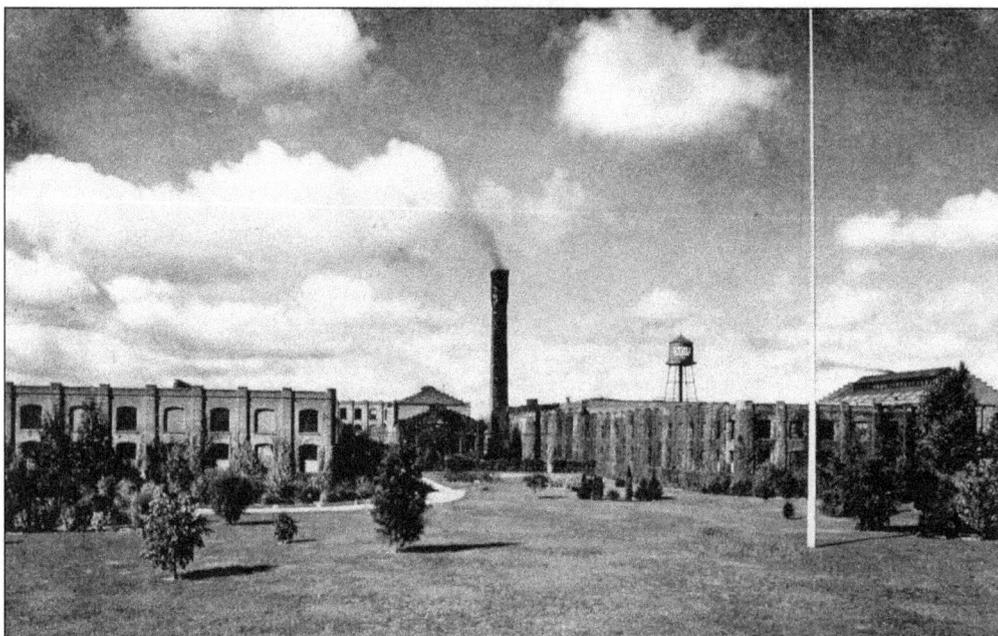

On 15 park-like acres along Lake Avenue, then city outskirts, these buildings became the initial segment of the Kodak Park Division in 1891. Growing to 195 buildings, it covered 1,300 acres with two fire stations and 17 miles of railroad track. Over 200,000 people have been employed at Kodak over its existence, making film, cameras, and other photographic products.

62

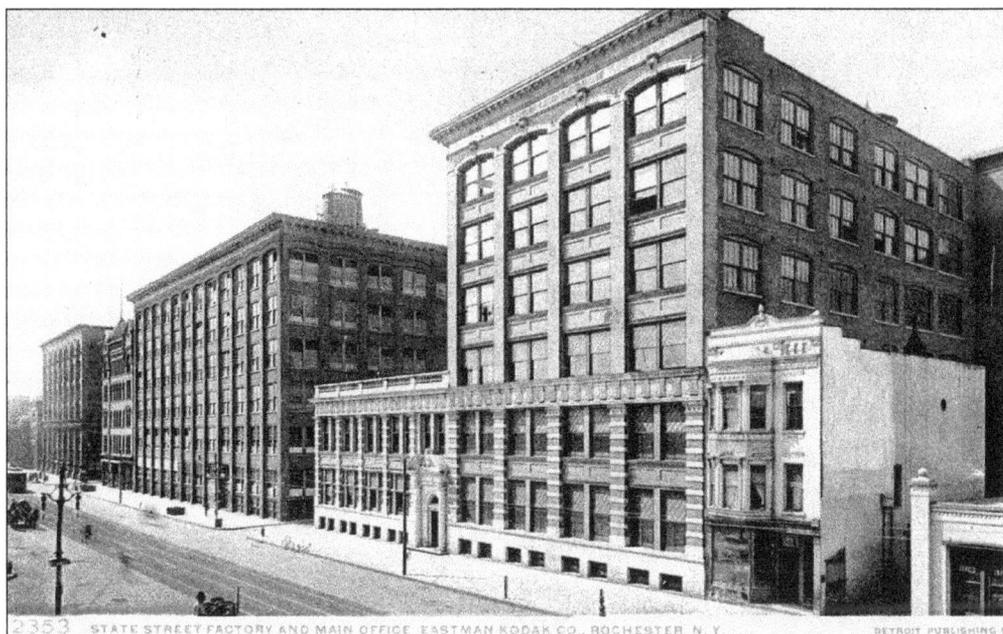

In 1909, the Eastman Kodak Office Building complex at 343 State Street appeared somewhat different than today. Kodak's main offices are to the left, and the factory can be seen to the right.

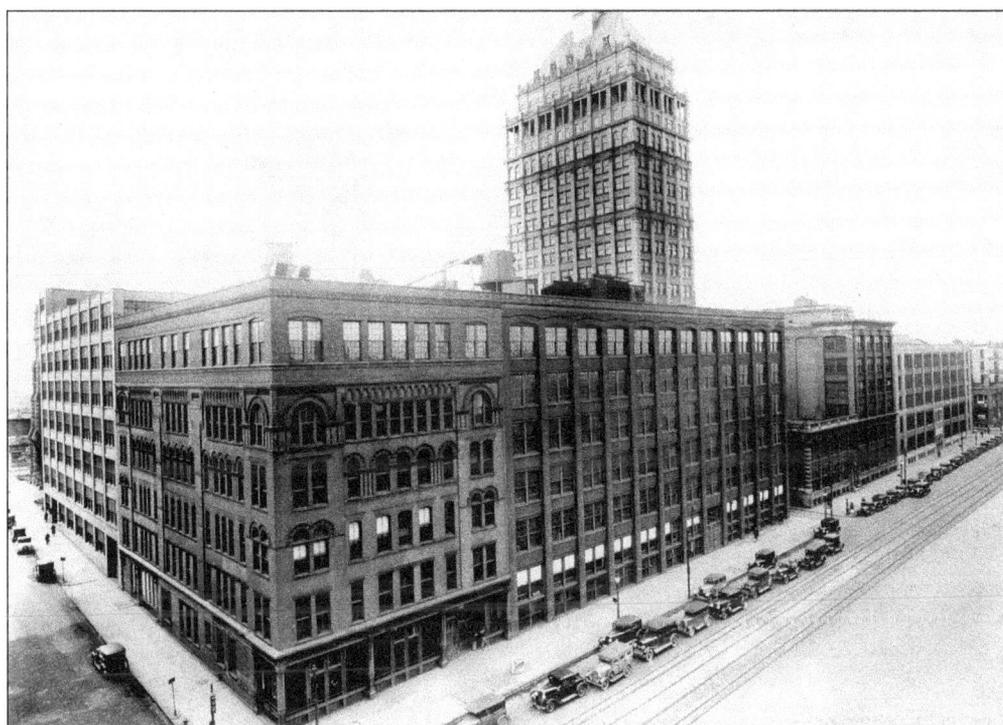

A later photograph, taken around 1920, shows the Eastman Kodak offices to the left and the Camera Works to the right. Now, the 19 story Kodak Tower looms over the complex. To the extreme left on Platt Street, a thin portion of St. Patrick's Cathedral can be seen.

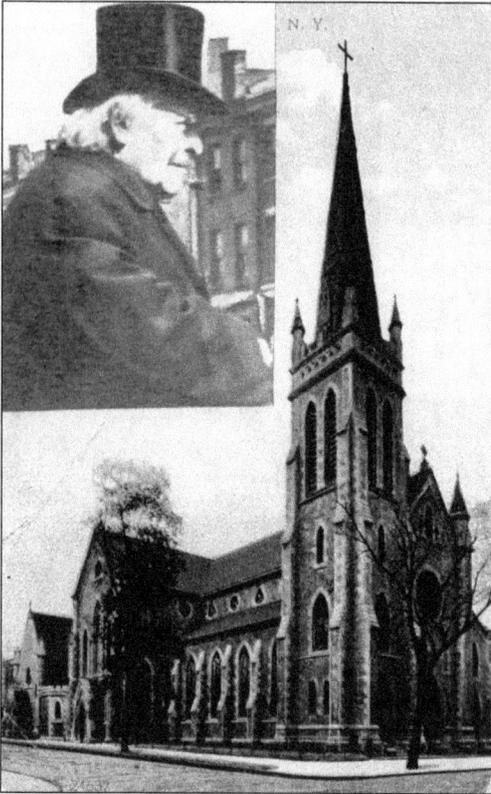

Built in 1869, St. Patrick's Cathedral stood on the northeast corner of Plymouth Avenue and Platt Street. Built in 1823, this is the original site of the city's first Roman Catholic church. The inset is a photograph of Bernard J. McQuaid, bishop of Rochester from 1868 till his passing in 1909.

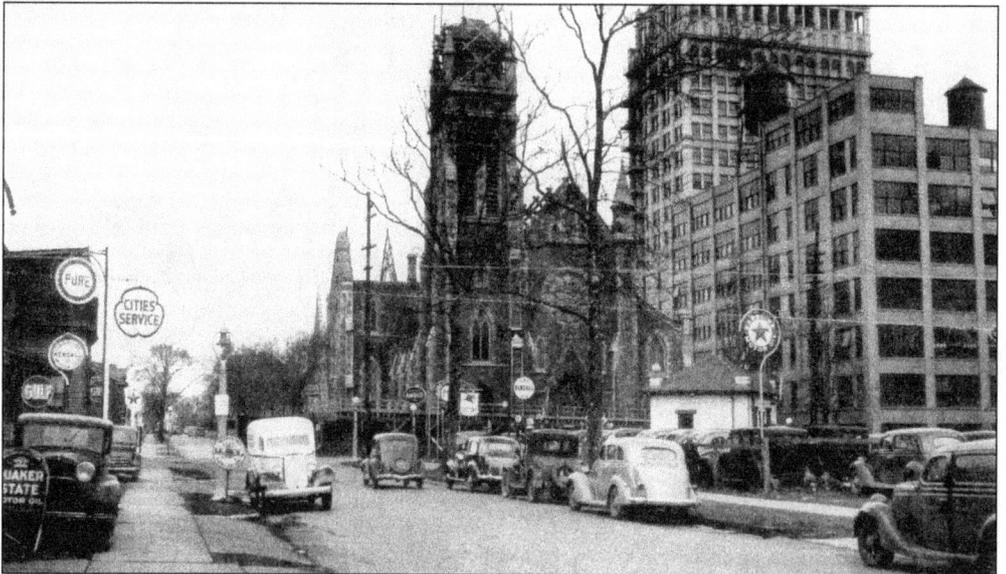

Few fans attending events at Frontier Field may realize that St. Patrick's Cathedral once occupied the nearby site on Platt Street and Plymouth Avenue where a "new" six story Camera Works was built along Plymouth Avenue in 1945. Demolition of the cathedral began in the fall of 1938, as seen in this picture taken that year. (Original photograph appeared in a December issue of *Kodakery*.)

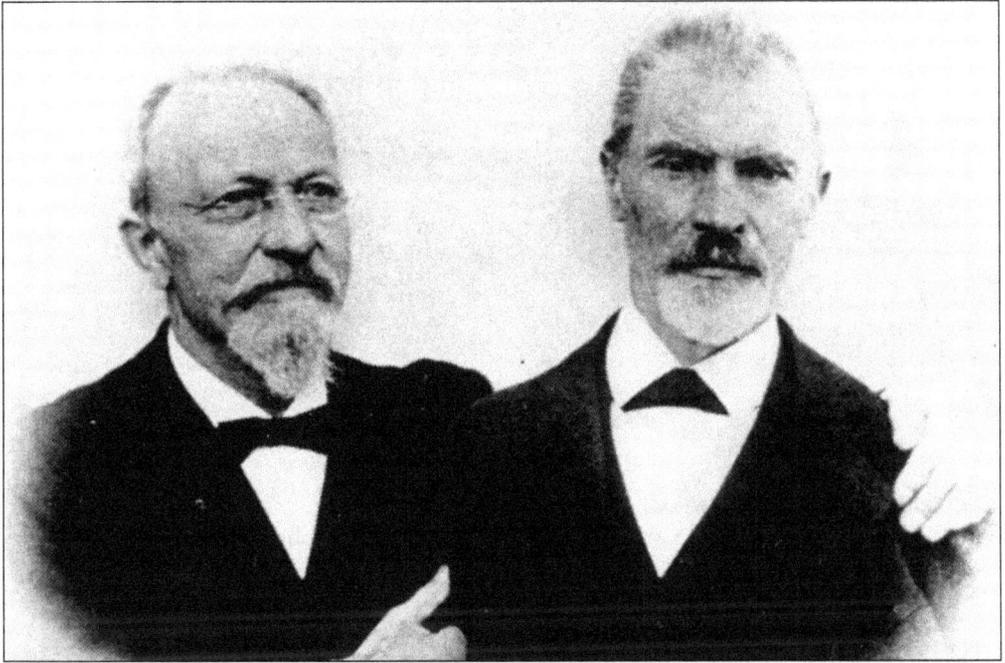

John Jacob Bausch, a German immigrant, borrowed $60 from his good friend, Henry Lomb. The result was a partnership formed in 1853 that grew into the world famous Bausch & Lomb Optical Company. John Bausch is on the left, and Henry Lomb is on the right.

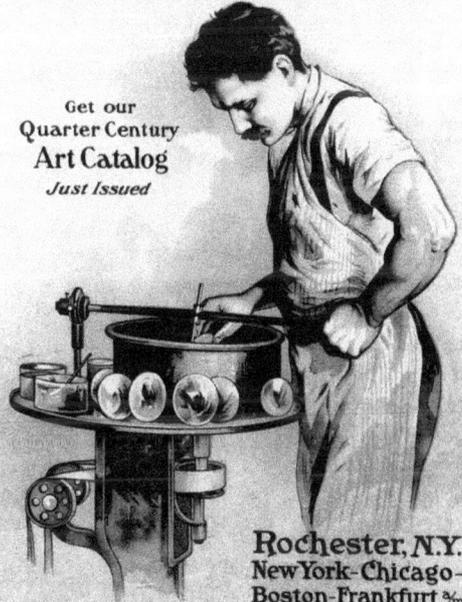

The quarter century *Art Catalog* was issued just prior to the last century. It recorded Bausch & Lomb's many products in the optical field. The workman in the illustration is grinding optical lenses. The firm produced the first optical quality glass in America.

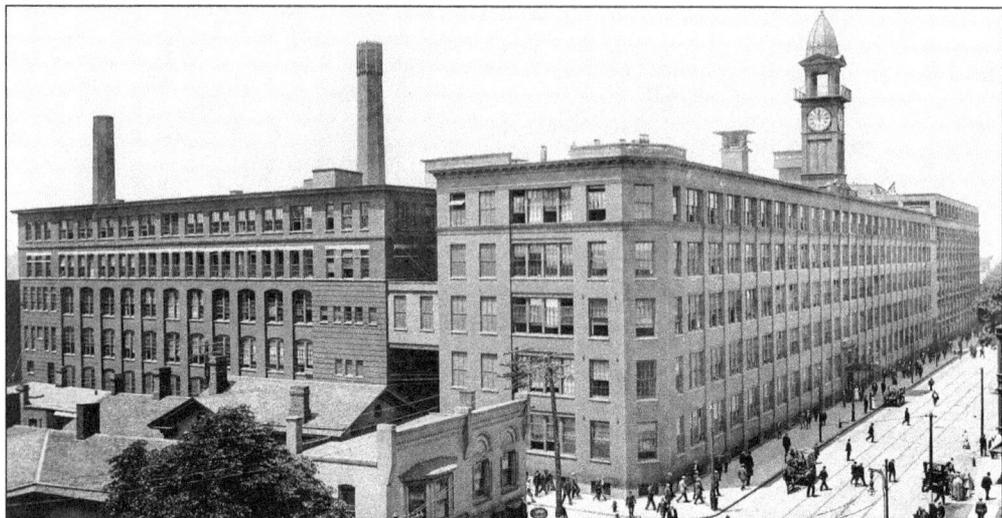

The Bausch & Lomb Optical Company was formed in 1853 by John Jacob Bausch and Henry Lomb. The firm, seen in this c. 1920 photograph, was once located on St. Paul Boulevard. Growing into the world's largest optical company, it ranked as one of the largest city employers. Today, its products are sold throughout the world.

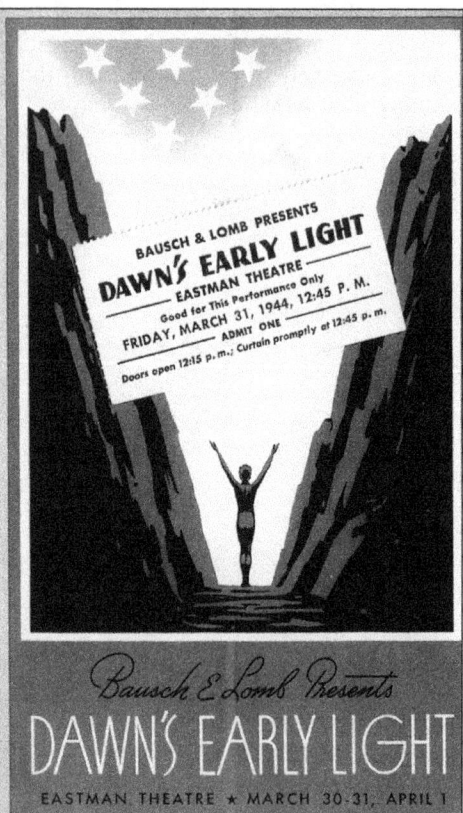

Seen here is the cover of a brochure given to the audience in 1944 at the Eastman Theatre. It documents Bausch & Lomb's patriot presentation "Dawn's Early Light." It was a tribute to the memory of their employees who made the supreme sacrifice in World War II.

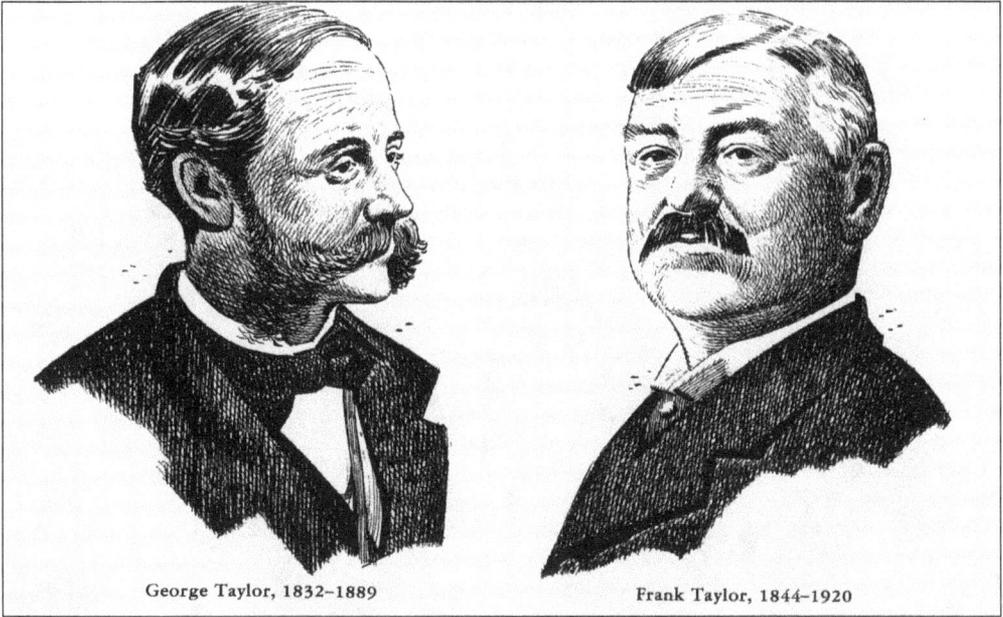

George Taylor, 1832–1889 Frank Taylor, 1844–1920

The Taylor Instrument Company was formed in 1851 by David Kendall and George Taylor at the Rochester Novelty Works. In 1866, Frank, George's younger brother, joined the firm, which began by manufacturing mercury thermometers.

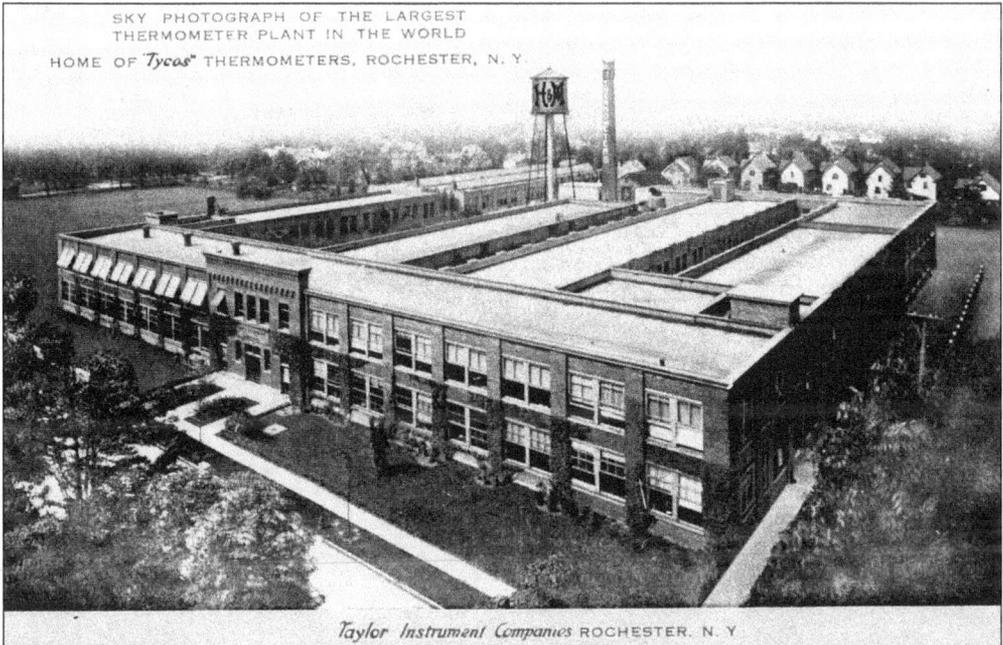

SKY PHOTOGRAPH OF THE LARGEST
THERMOMETER PLANT IN THE WORLD

HOME OF "Tycos" THERMOMETERS, ROCHESTER, N. Y.

Taylor Instrument Companies ROCHESTER. N. Y.

By 1905, the Taylor Instrument Company erected this plant on Ames Street, soon becoming the world's largest producers of thermometers. By 1951, the company's centennial year, the Taylor Instrument Company had sales offices throughout the United States and manufacturing subsidiaries in London, Toronto, Tulsa, and San Francisco.

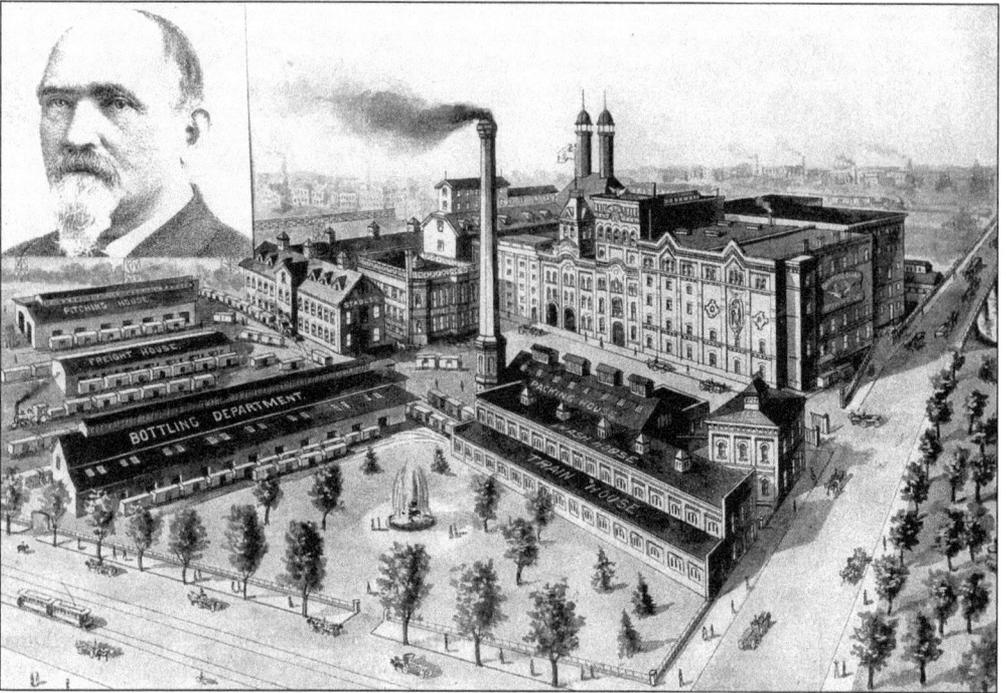

This 1900 lithograph illustrates the area covered by the Bartholomay Brewing Company on St. Paul Street at the beginning of the 20th century. Henry Bartholomay started the first large brewery in Rochester. By 1874, it had grown to be worth a quarter of a million dollars.

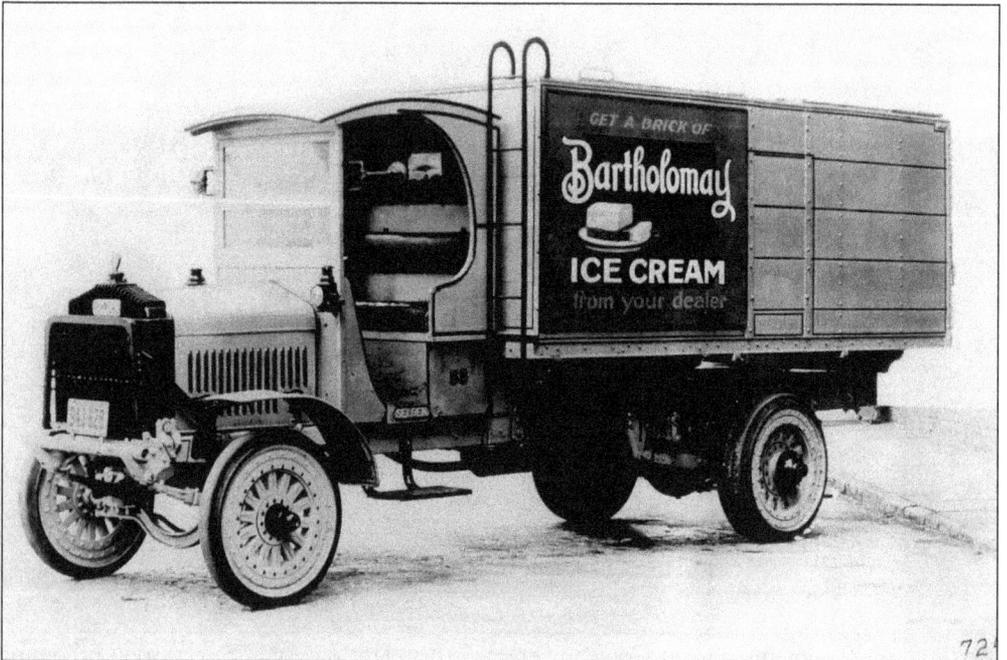

Following prohibition, the Bartholomay Brewery turned to marketing milk and ice cream. In the 1920s, Rochester-made Selden trucks (note sign above door step) took the place of the old horse drawn beer wagons that once made deliveries along city streets.

E. E. Fairchild products were shipped around the world. Formed in 1900, the corporation began manufacturing paper boxes. For years they were leaders in designing boxes and novelty containers for candy, especially for another Rochester company, the Fanny Farmer Candy Company. They were still making them in 1948 when this photograph was taken.

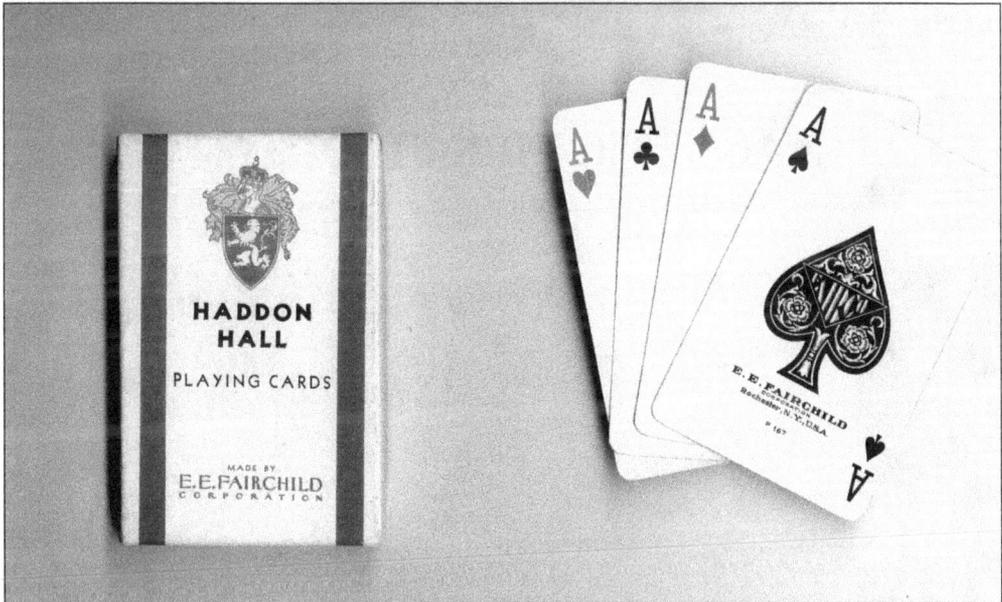

During the World War II, Elmer E. Fairchild headed the firm located at 367 Orchard Street. At this time, the armed forces and the American Red Cross spread Fairchild playing cards to every battle field. In peace time their cards were sold in 30 foreign countries. Fairchild's children's games such as Fairco and Genesee puzzles, old maid, bingo, and authors were also sold in retail stores throughout the country.

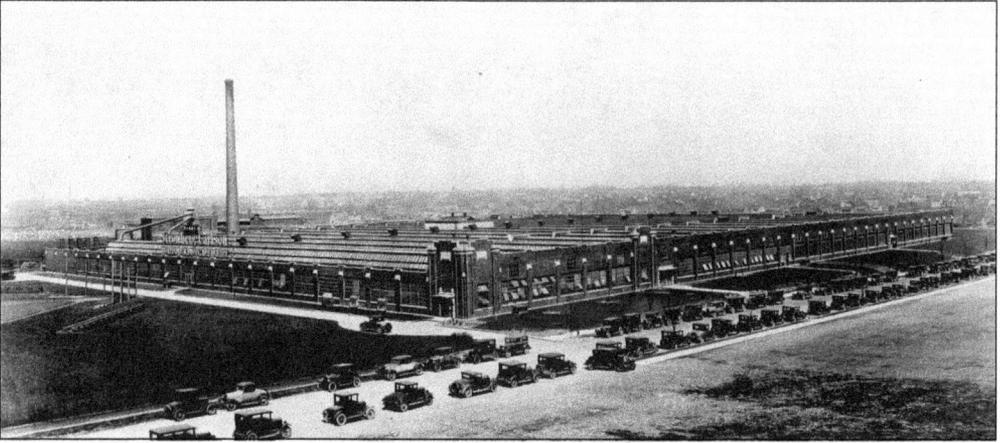

The Stromberg-Carlson Manufacturing Company moved to Rochester in 1902. Its plant eventually covered 7.24 acres. When this photograph was taken in 1925, it was the largest independent telephone manufacturing establishment in the United States. It also owned and operated the 50,000 watt radio station, WHAM.

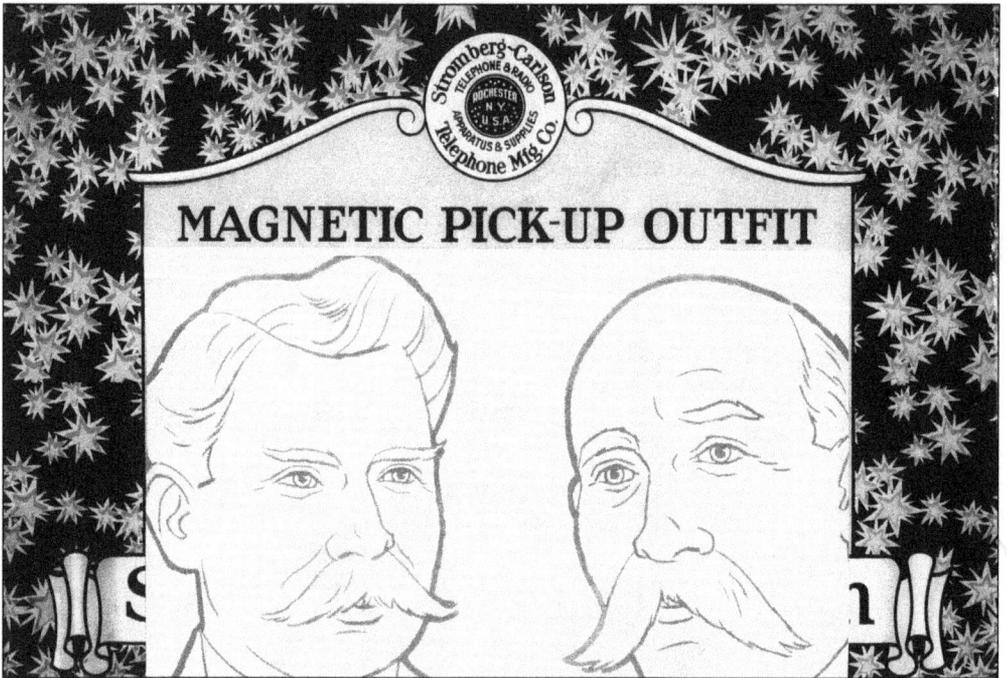

The fancy lid from a box once containing a "magnetic pick-up outfit," is an example of the many early products produced by the Stromberg-Carlson Company when radio was young. To the left is the image of inventor Alfred Carlson, and Androv Carlson is seen on the right. Their firm manufactured telephones and exchanges, early radio receivers, and pioneering television sets in handsomely crafted wooden cabinets. The first automobile radio was Stromberg-Carlson set.

Three

ENTREPRENEURS
AND ENTERTAINERS

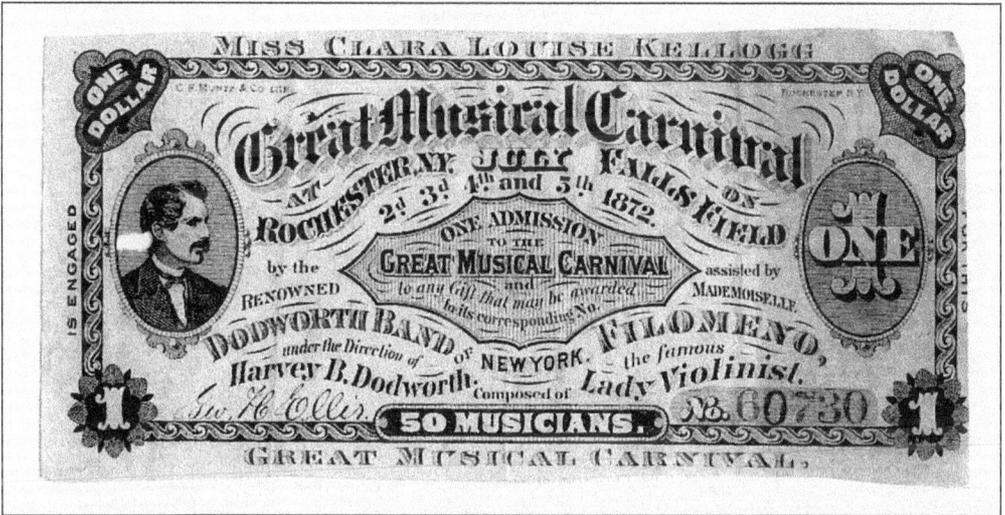

The good citizens of Rochester have been entertained by musical programs over many, many years. Here is a one dollar ticket to the Great Musical Carnival held at Falls Field on the east bank of the Genesee River, July 2–5, 1872. The rare and elaborate memento advertises the renowned Dodworth Band of New York composed of "50 Musicians and assisted by Mademoiselle Filomeno, the famous Lady Violinist."

The detailed Grand Musical Festival program's cover identifies another of Rochester's early musical attractions. Held at the Washington Rink at the southwest corner of South Fitzhugh Street and the Erie Canal (Broad Street), the band was accompanied by canon, anvils, and a 150 voice "grand chorus." The program's publisher, J. D. Scott, was noted for his scenic Lake Ontario and Irondequoit Bay boat excursions.

72

Built in 1888, the Lyceum Theatre was the preeminent theater in the city. The theatre on South Clinton Avenue (now Midtown Mall) greatly outranked the city's other four playhouses. Shakespearian plays, the Barrymores, John Drew, Maude Adams, Joseph Jefferson, and a host of other famous stage stars of yesterday entertained Rochester play-goers there for 46 years. The theatre was demolished in 1934 to become the site for the B. F. Foreman Company. This photograph was taken around 1920.

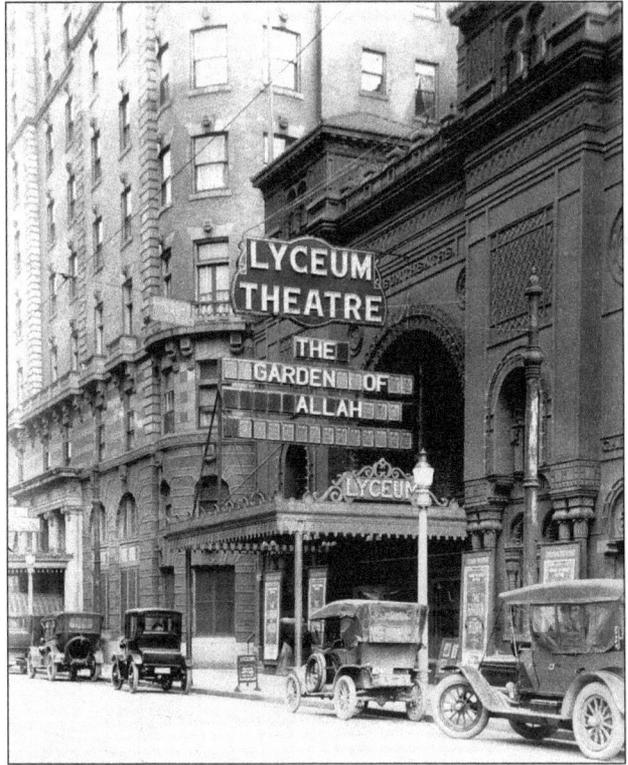

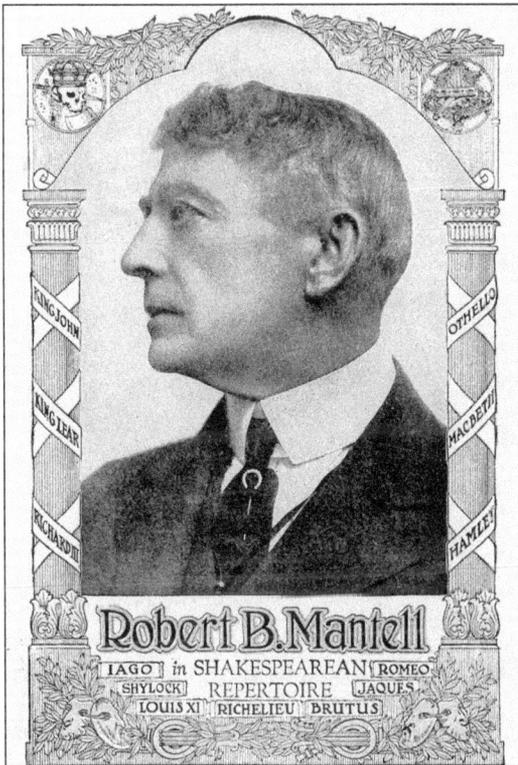

A versatile actor of his day, and a Rochester favorite, was stage idol Robert B. Mantell. He played Richard III, Macbeth, Hamlet, Iago, and King Lear. This c. 1910 playbill dramatically depicts his three night appearance at the Lyceum Theatre as the leading character in four Shakespearean plays.

LYCEUM THEATRE

Monday Ev'g, Oct. 23,
ONE NIGHT ONLY.

LIQUID AIR

THE LATEST MARVEL OF SCIENCE.

Startling Experiments and Demonstrations by

Prof. William Clarke Peckham

Professor of Physics in Adelphi College, Brooklyn.

Only authorized demonstrator of the General Liquid Air Co. of New York.

The Temperature of the Theatre will be cooled to any
degree desired, even Zero or below, with Liquid Air
by Prof. Peckham in ten seconds time.

Over two hours occupied giving marvelous demonstrations and explana-
tions of this newly discovered wonderful force.

Liquid Air 400 times more powerful than steam.

344 degrees colder than ice.

Seats on sale Thursday, October 19th.

Dated October 23, 1899, this advertisement in the Lyceum playbill indicates that the good citizens of Rochester were in for a cool treat. Professor Peckhan may have used several blocks of dry ice (solid carbon dioxide) for his "startling experiments and demonstrations." To those attending in 1899, "liquid air" was likely used, as the program suggests, "the latest marvel of science."

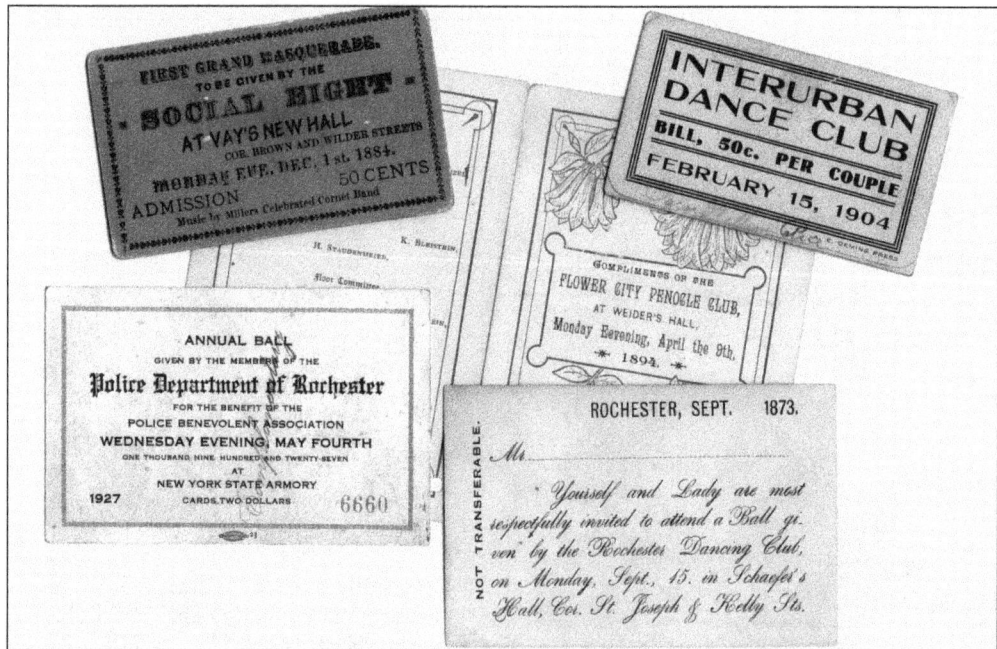

Dancing has always been a pleasant way to enjoy an evening in Rochester. Tickets to the Rochester Dancing Club were good on September 15, 1873. The Interurban Dance Club ticket was used by a couple riding the interurban trolley to a Rochester dance on February 15, 1904. The annual policemen's ball and the Flower City "Penocle" Club's dinner-dance were annual parts of Rochester's party scene.

74

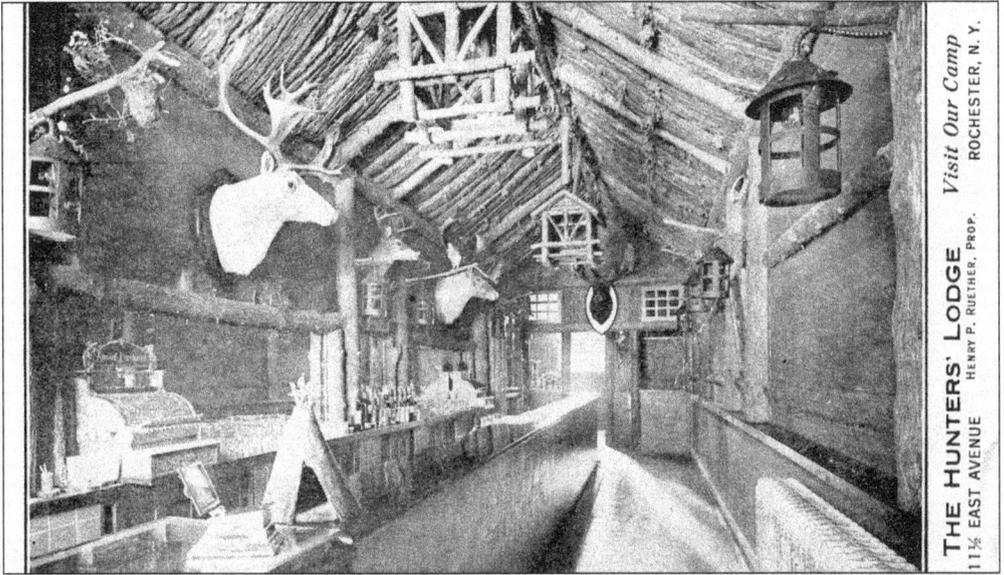

Another form of entertainment was enjoyed at this rustic saloon pictured around 1910. Once located at 11.5 East Avenue, it was known as the Hunters' Lodge with decorations appealing to very masculine tastes. It is hard to imagine such a provincial emporium on Rochester's proud East Avenue.

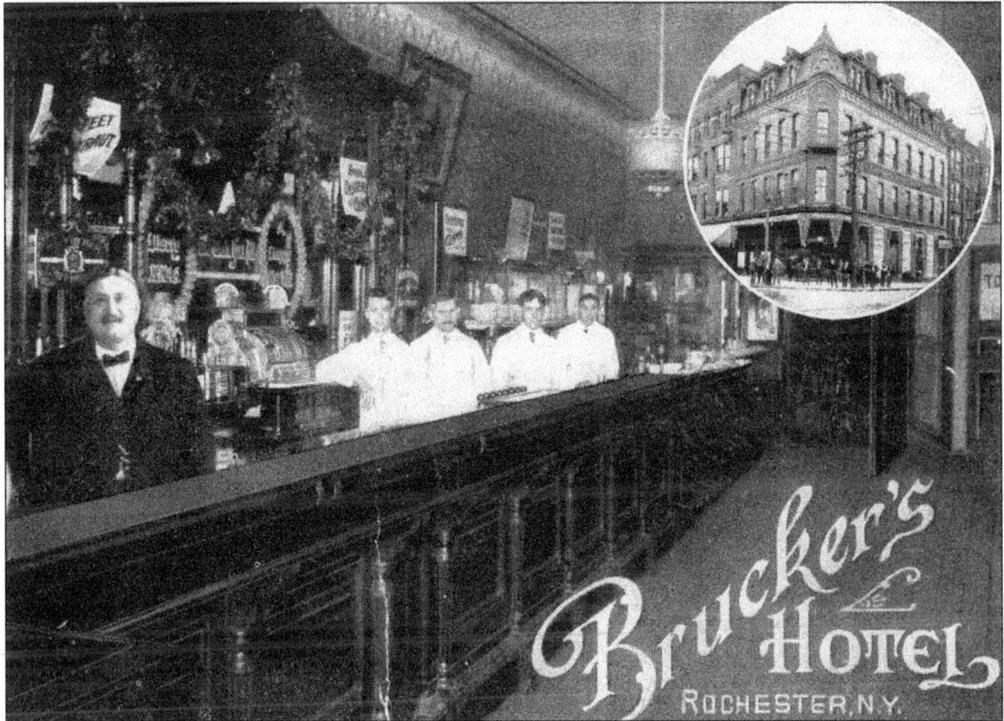

Brucker's Hotel was another favorite haunt for salesmen and those traveling by train. Its location at the intersection of North Clinton Street and Central Avenue made it a most convenient and refreshing stop after a long train ride. The hotel's motto stated that it was, "the home for strangers."

One of Rochester's most prominent entrepreneurs was Daniel Powers. Born in 1818, he became a successful banker, civic leader, and art collector. The Powers business block was erected from 1870 to 1890 and the Powers Fireproof Hotel in 1883. For a score of years, Powers added floors and reshaped the tower to retain the record as the city's tallest building.

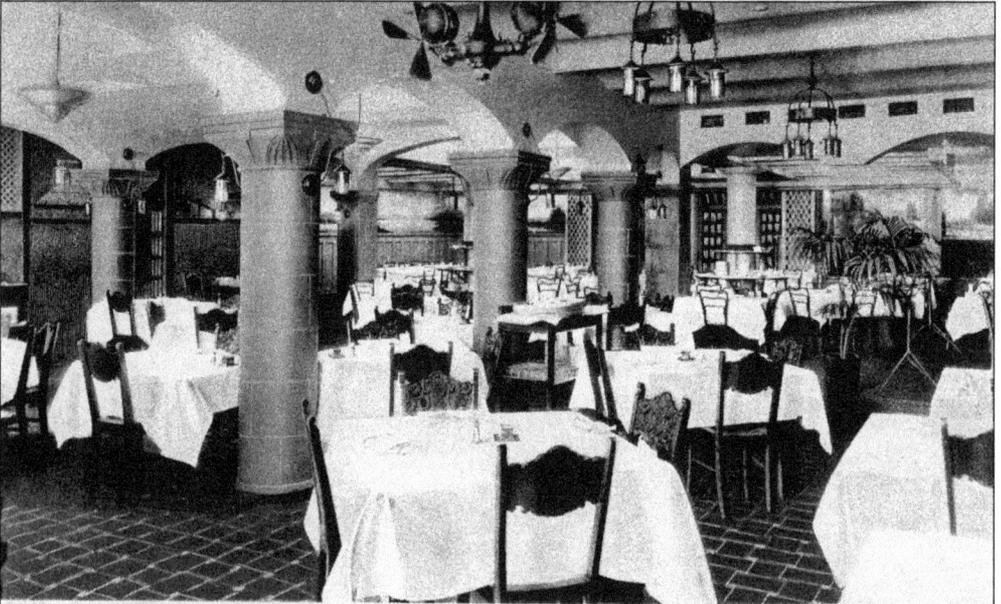

NO BETTER PLACE TO TAKE YOUR MEALS—POWER'S HOTEL, ROCHESTER, N. Y.

This 1921 postcard provides a view of the interior of the Powers Hotel Restaurant on West Main and Fitzhugh Streets. It was touted as a place "where quiet dignity makes dining a pleasure." From its opening until its closing in 1967, the popular downtown eatery was variously known as the Arbor Room, Rathskeller, and later, Cafe D'Or.

Frederick J. Odenbach ran the renowned Hofbrauhaus at 14 South Avenue, opening the German-style restaurant in 1890. It served rich German specialties accompanied by live entertainment for 47 years before closing its doors on June 4, 1937.

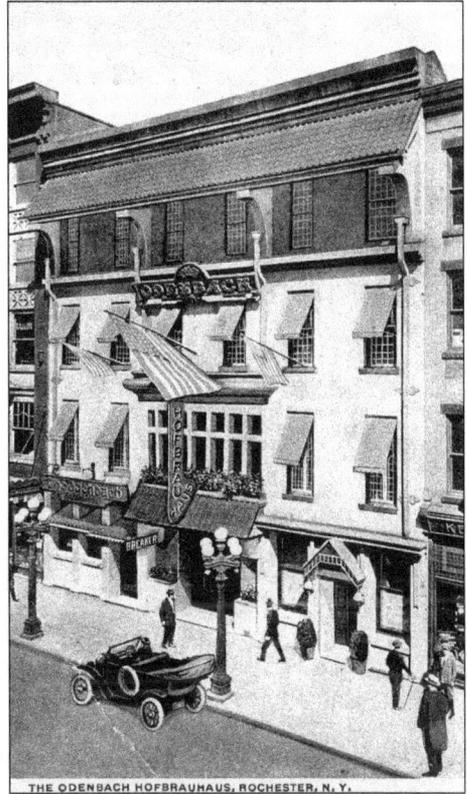

THE ODENBACH HOFBRAUHAUS, ROCHESTER, N. Y.

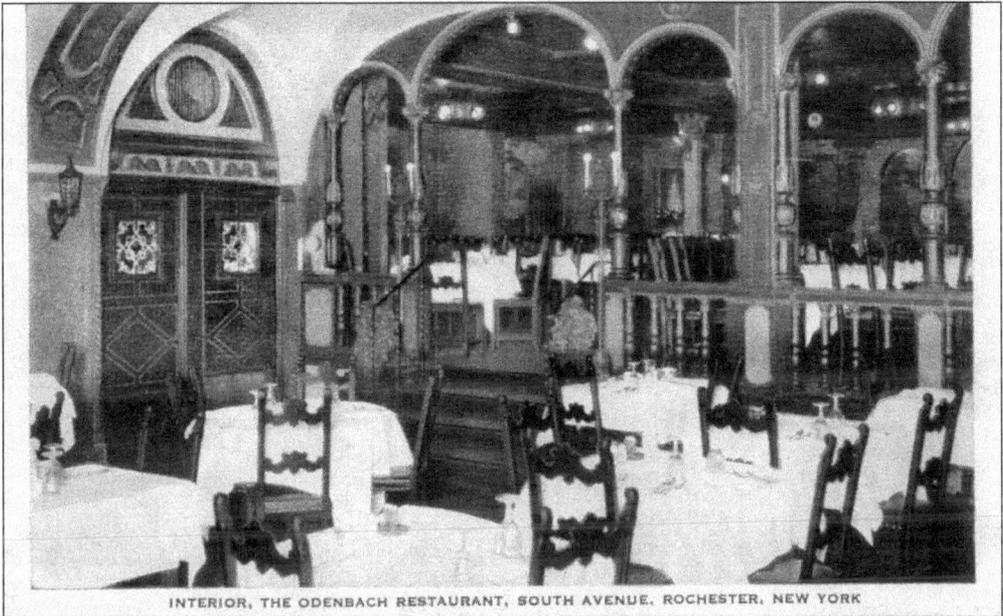

INTERIOR, THE ODENBACH RESTAURANT, SOUTH AVENUE, ROCHESTER, NEW YORK

Located directly across South Avenue from the Cook Opera House, the Hofbrauhaus served the after theatre trade evenings and downtown shoppers during the day. The eating establishment offered white linen tablecloths and napkins, an appropriate Teutonic interior, plus music and song performed by a wide variety of entertainers.

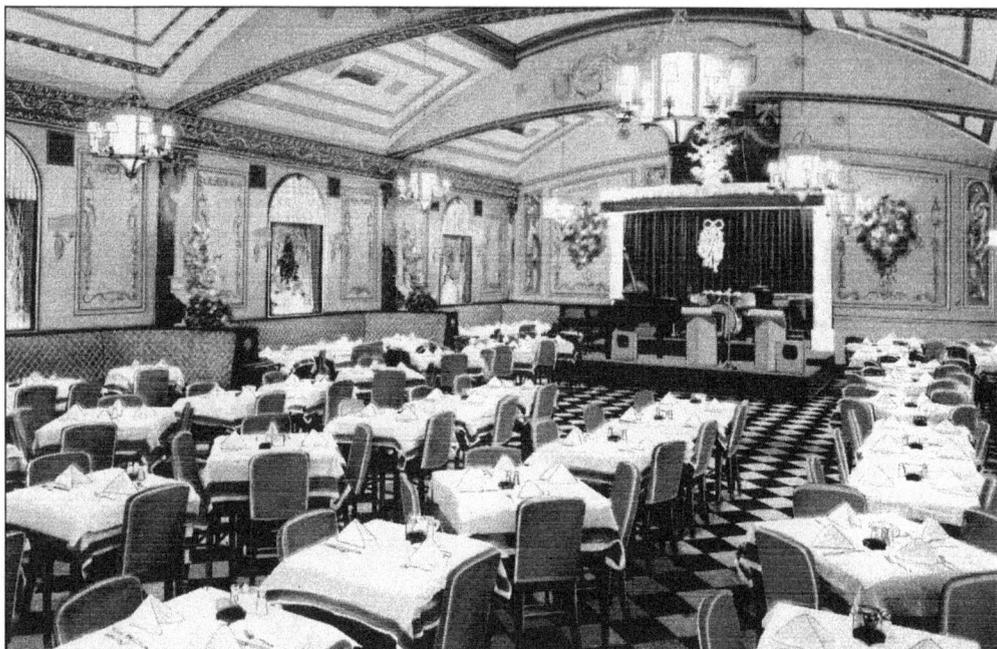

Called the Peacock Room, the main dining room of the Odenbach Restaurant was located in the former Whitcomb House lobby around 1921. Compare the photograph below with this image to see how the Odenbach brothers–Frederick, Matthew, Charles and John–transformed the former Whitcomb House lobby into "a glittering showpiece," opening for dinner and dancing on August 3, 1923.

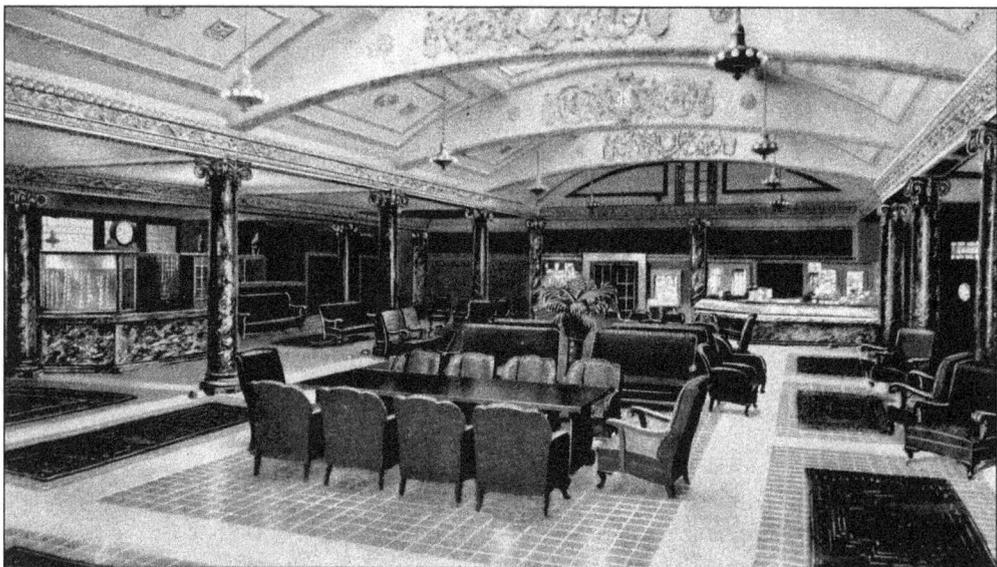

WHITCOMB HOUSE SERIES NO. 1. WHITCOMB HOUSE (LOBBY)
ROCHESTER, N. Y.

In 1909, the Whitcomb House was a prominent downtown hotel in Rochester. The lobby was unique with its wide ceiling supported by decorated cast iron arches. Located on East Main Street where the Morgan-Chase Bank now stands, it was a favorite accommodation for city visitors, actors, actresses, and traveling salesmen.

The passport photograph of Frederick J. Odenbach was taken in 1926 when Frederick and his wife embarked on a European tour as guests of the International Hotel Alliance in England, Scotland, and Belgium. Frederick and his brothers purchased the Hotel Haywood on South Clinton Avenue in 1921. Part of the former hotel became the popular Odenbach Coffee Shoppe, and the remainder of the main floor led to an impressive restaurant.

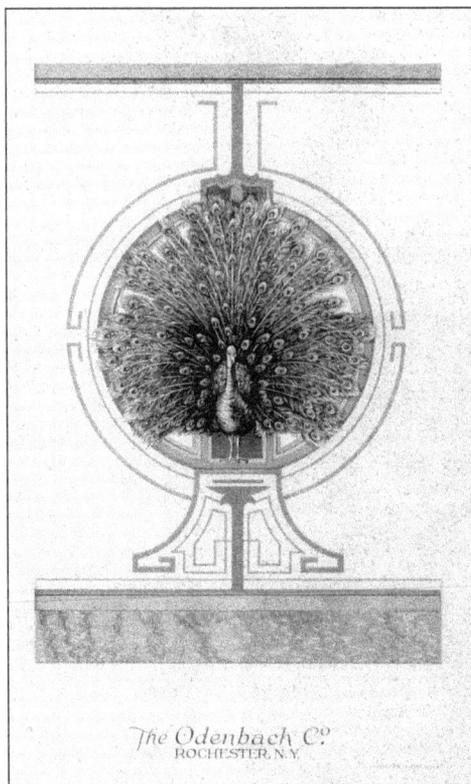

The Odenbach Co.
ROCHESTER, N.Y.

Attractive and colorful menus were provided to diners at Odenbach's famous Peacock Room. The fashionable restaurant soon became the finest place to dine and dance in town. The dining area was modeled in part on the famous Peacock Alley in New York City's old Waldorf-Astoria Hotel. Irene Gedney, Sally Goodwin, and a host of other live entertainers and dance bands made the night spot the special place for a gentleman to take his best girl.

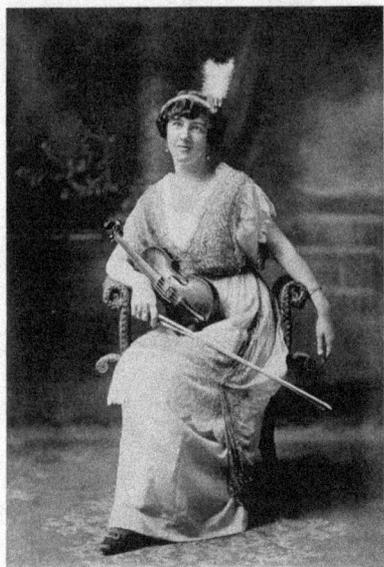

SUSAN TOMPKINS
VIOLINISTE
SOLOIST with SOUSA'S BAND

Concert Director, Jonathan H. C. Modrow
77 Joslyn Place, Rochester, N.Y.

CONCERTS
MUSICALES
RECITALS

Among Rochester's many talented entertainers was Susan Tompkins, who gained fame as a soloist with John Philip Sousa's band for four seasons beginning in the summer of 1914. Most unusual in a brass band was her appearance as a violinist. She received ovations and many encores at her performances. One newspaper review stated, "Her violin seemed charged with elves and sprites, each scampering away with some sweet sound."

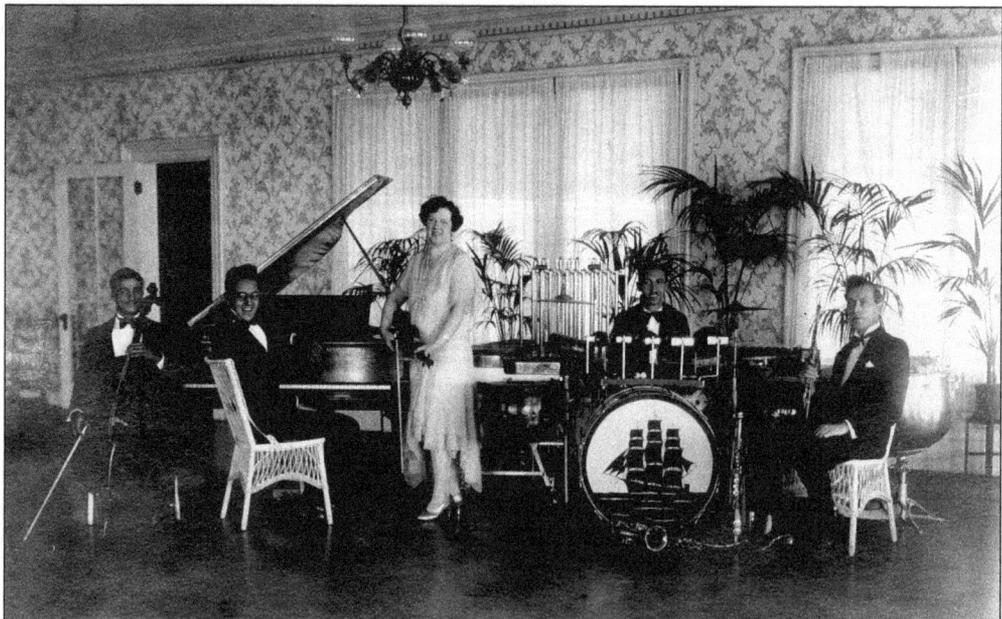

Following her debut with Sousa's band, Susan Thompkins formed her own orchestra performing at concerts, musicals, and numerous social functions. She also appeared as a soloist at the Genesee Valley Club, for the Rochester Park Band and at major vaudeville houses during the 1920s and 1930s.

David Hochstein was a contemporary of Susan Thompkins. Born in Rochester on February 16, 1892, he studied violin in the city and in Europe. Returning to the city, he won great popularity by those who realized he was "gifted beyond many of his generation." Serving as a second lieutenant during World War I in France, he was killed in action on October 8, 1918, in the Meuse-Argonne campaign at the age of 26. His memory is honored through the Hochstein School of Music, which bears his name. His eulogy expressed, "He has moved a little nearer To the Master of all music."

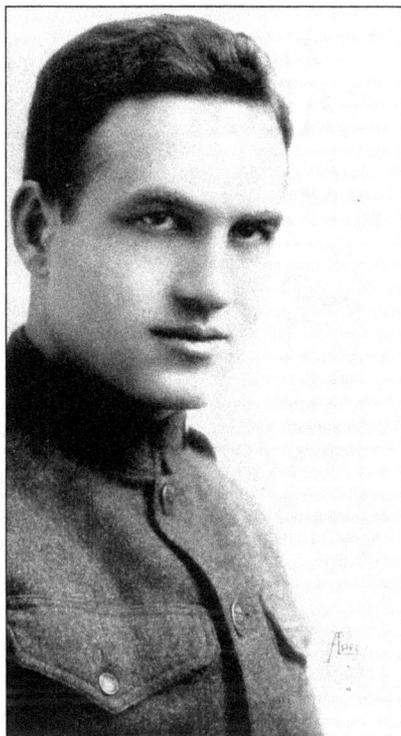

Many musical events were held in 1917 and 1918 at Rochester's Convention Hall, now Geva Theatre on Woodbury Boulevard. This ticket strip admitted one to a variety of events sponsored by the Tuesday Musicale Chorus, which was created in 1897. As musicale presidents, Jessie Danforth and Mrs. John Harry Stedman endorsed many worthy musical projects in Rochester. The Tuesday Musicale Chorus became the Rochester Festival Chorus, directed by Gareissen and later by Dr. Howard Hanson and Richard Halliday.

THURSDAY EVENING
MARCH 28

Extra!
Extra!

**Continuous
DANCING**
From 8 P. M.
until ?

**Dance to Your
Favorite
Orchestra!**

Who ?
Will Be
Rochester's
Champion
Orchestra
? ? ? ? ?

The Hottest and
Jazziest Musical
Battle You Have
Ever Seen.

ELSIE MYERSON "Queen of Jazz"

HERE THEY ARE

**Famous
Kings of Jazz**

Jerry Arms
All Star Band

Californians
Famous Girls Band

**New York
Night Hawks**

**Joe
Alexander's**
Syncopators

King Sims
and His Creoles

**Harrison's
Ginger Snaps**

ARCADIA BALL ROOM
90 CLINTON AVENUE

Sponsored by Midwest Club

Tickets 50c Boy! What a Nite!

Rochester swingers in the roaring 1920s did not miss dancing at the Arcadia Ball Room at 90 Clinton Avenue, which featured lots of jazz and Elsie Myerson "Queen of Jazz." This was, as the advertisement states, "The Hottest and Jazziest Musical Battle You Have Ever Seen. Boy! What a Nite!" As seen here, Rochester's entertainment varied with the times.

TED BROWN'S ORCHESTRA

HUGH BROWN, Sax and Clarinet Soloist TED BROWN, Banjo Soloist and Director GEORGE BROWN, Violin Saxophone and Manager

PATRONS
Are Assured of
Complete Musical
Satisfaction

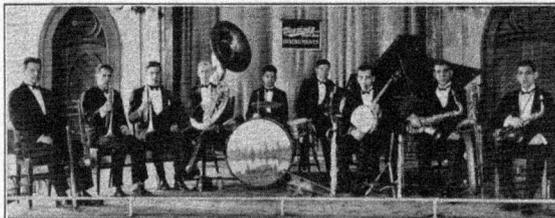

OFFICE:
6 Pansy St.
Rochester, New York
Phone Culver 1624

WHEN IN NEED OF GOOD MUSIC THINK OF TED BROWN'S ORCHESTRA

In the 1920s, Ted Brown's Orchestra appeared on the scene. The snappy eight piece orchestra (three of the members were brothers) assured its patrons of "complete musical satisfaction."

It was a snowy day in February 1936 when an amateur photographer snapped this picture of the Clinton Theater. Will Rogers and Lionel Barrymore were stars in the double-feature films.

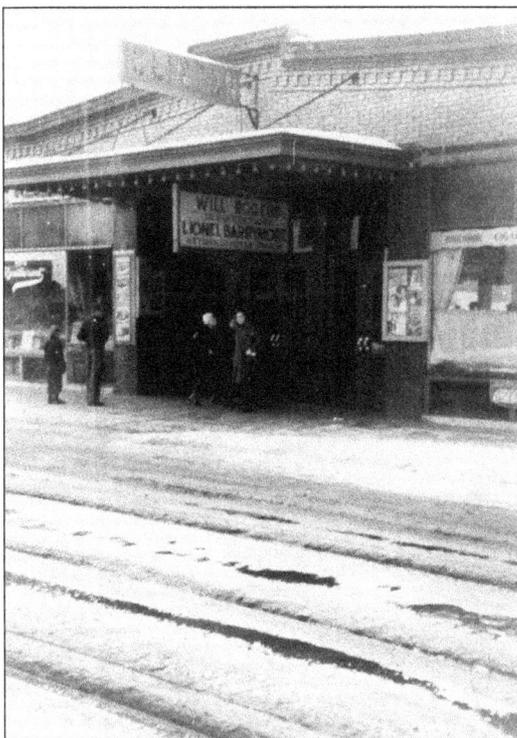

The coming attractions playbill was mailed to city dwellers in 1948 by the Clinton Theatre at 953 South Clinton at Goodman Street. The playhouse started in 1916. Cowboy movies and murder mystery films were popular at the time. Today, the Cinema Theatre occupies that same location.

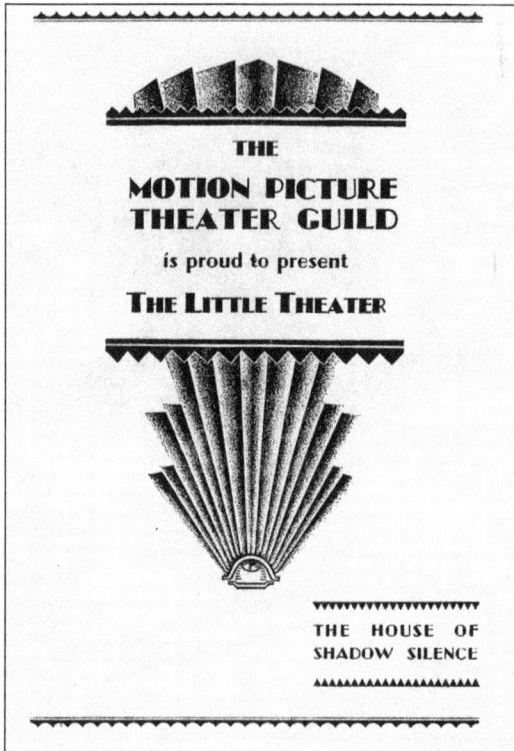

THE

**MOTION PICTURE
THEATER GUILD**

is proud to present

THE LITTLE THEATER

THE HOUSE OF
SHADOW SILENCE

For over 75 years, Rochester residents have been entertained by films at the Little Theatre, located at 240 East Avenue. It opened on October 17, 1929, with the silent film *Cyrano de Bergerac*. A three-piece orchestra provided the accompaniment for the film. Calling itself "the House of Shadow-Silence," it was unlike most commercial movie houses presenting only "art films that appeal to the intelligent and sophisticated."

In 1949, the Little Theatre celebrated its 20th anniversary. Starting in 1931, it was under the management of Florence Fenyvessy Belinson who had gained experience as a theater manager working for her father, Albert A. Fenyvessy. She organized the Civic Cinema Association that suggested films and raised money through ticket sales for worthy causes.

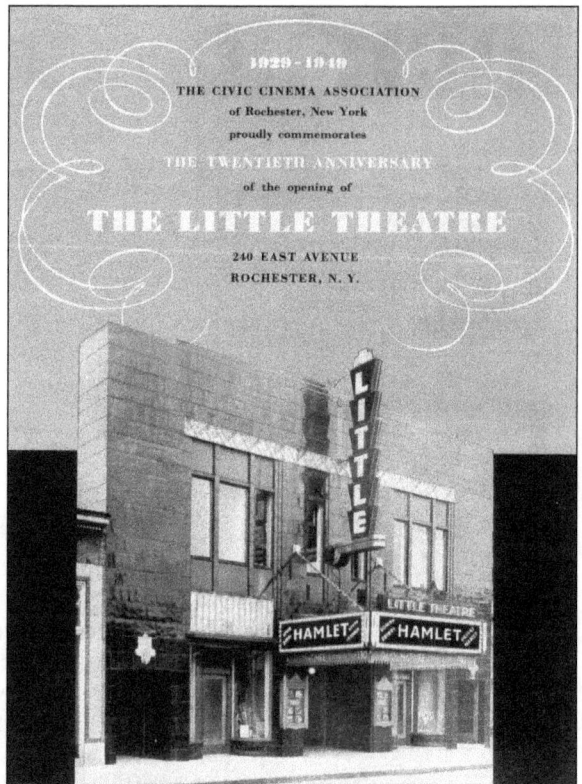

1929 - 1949
THE CIVIC CINEMA ASSOCIATION
of Rochester, New York
proudly commemorates
THE TWENTIETH ANNIVERSARY
of the opening of
THE LITTLE THEATRE
240 EAST AVENUE
ROCHESTER, N.Y.

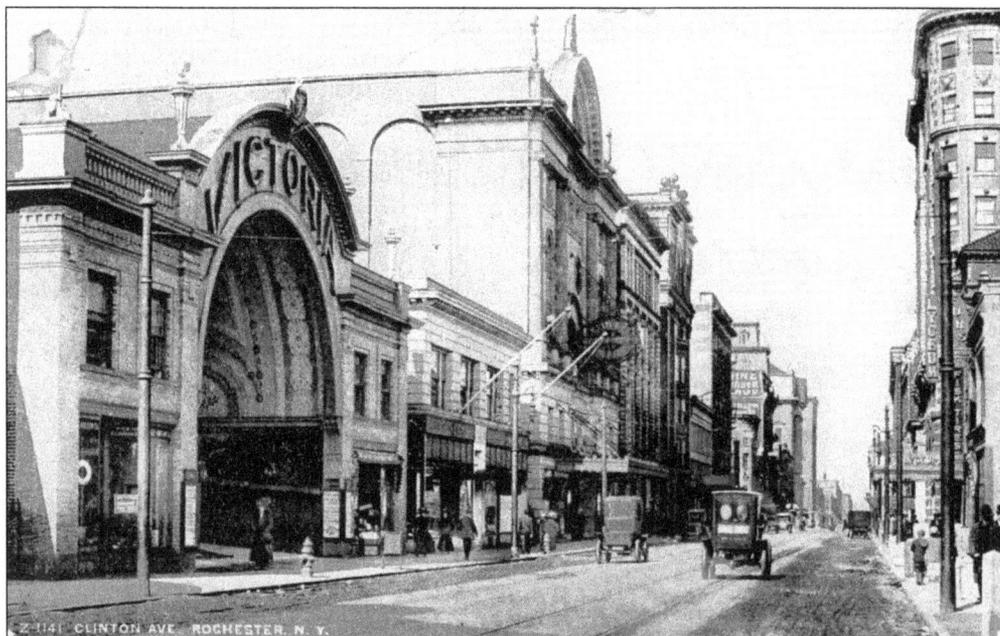

The Victoria Theatre entertained patrons during both the eras of vaudeville and the silent film. Operating at 41 South Clinton Avenue, it attracted hundreds of patrons between 1912 and 1930. It was then razed for a parking lot. Its manager was Pat Farren.

The cover of the 1923 *Eastman Theatre Magazine* advises patrons that Clara Bow, the "It" girl, can be seen in her newest silent film *Hula* at the theatre. George Eastman's purpose for the 3,100-seat theater was "for the enrichment of community life . . his goal to bring refined entertainment to the masses by developing motion pictures as an art and creating therewith an appreciation of the best music."

"THE BIG PARADE" IS COMING!

EASTMAN THEATRE MAGAZINE

VOL. II ROCHESTER, N. Y., AUG. 28-SEPT. 3 No. 43

THE "IT" GIRL BACK AGAIN NEXT WEEK

CLARA BOW will be the guest of honor (on the screen) at the Eastman's big birthday party next week. She's bringing her newest picture, "Hula," in which she plays a Hawaiian flapper who dances through life with a grass skirt.

NOW PLAYING—"THE CAT AND THE CANARY"

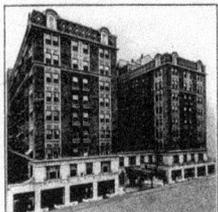

The Sagamore, John C. Graham, Mgr.

Rochester's Finest

MAIN DINING ROOM
COFFEE SHOPPE
COCKTAIL ROOM

Rates
SINGLE ROOM $3.00 UP
DOUBLE ROOM $4.00 UP
TWIN BEDS $6.00 AND $7.00

Home of
AUTOMOBILE CLUB and STATION WHAM
COUNCIL OF CIVIC CLUBS

Gracing 111 East Avenue is the building once known as the Sagamore Hotel. When the 350-room hotel opened around 1930, it soon became the place to dine and dance. Its top floor ballroom had its own orchestra where many social functions and college proms were held. It advertised itself as "the Garden Spot of Rochester," a hotel of "charm and restful beauty."

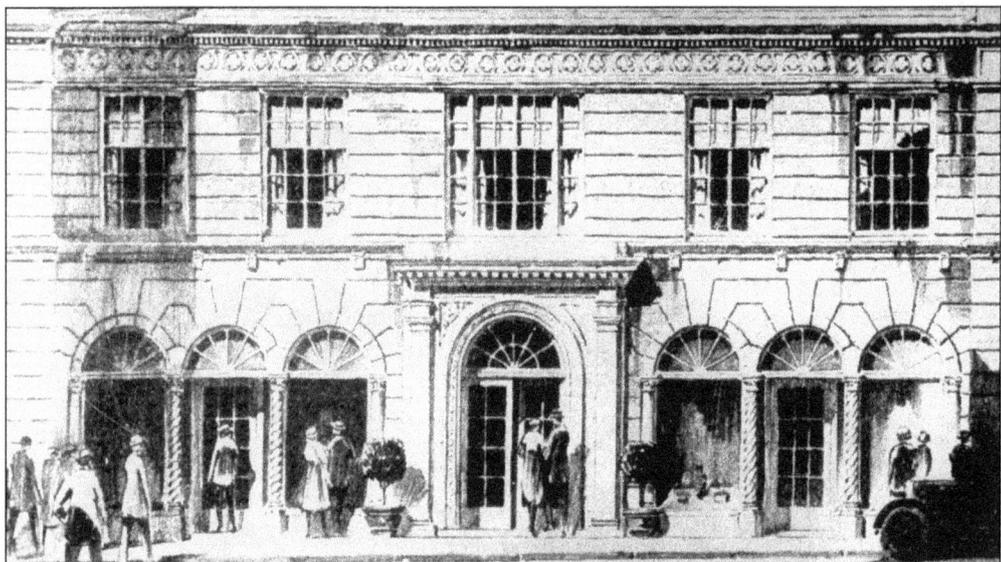

The Sagamore, which later became the Sheraton Hotel around 1940, was the new home for Rochester's premier radio station WHAM. The hotel was a shining addition to the already prestigious East Avenue.

Four

NURSERYMEN AND SEEDSMEN

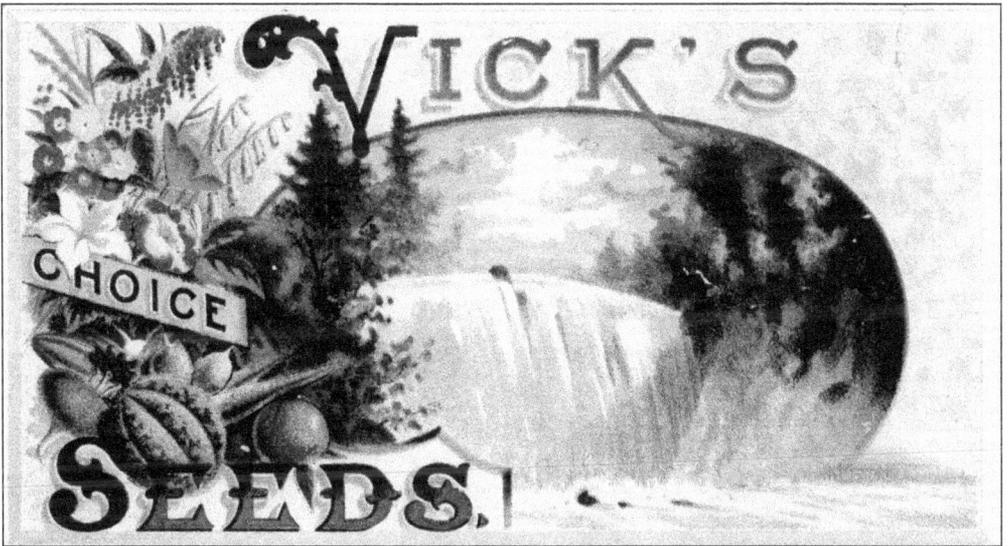

The James Vick Seed Company had perhaps the largest seed house in America, helping Rochester become known as the Flower City between 1840 and 1900. The 1886 city directory listed 38 nurserymen and seedsmen. Today, their descendant flowering plants continue to brighten all corners of America.

JAMES VICK, SEEDSMAN.

Grounds, East Ave. and near Lake Ontario; Warehouse, East Ave. and Floral St.—Frank H. Vick, President; Charles H. Vick, Secretary; James Vick, Treasurer.

Born in Hampshire, England, in 1813, James Vick settled in Rochester, edited the *New Genesee Farmer* in 1850, and purchased the national publication the *Horticulturist* in 1853. Entering the seed business in 1866, he bought 35 acres along East Avenue from Joseph Hall, operator of the Union Tavern and racetrack. His seed gardens paralleled East Avenue. From 1870 to 1873, he transformed his racetrack into a residence park called Vick Park A and Vick Park B.

The billhead, dated October 3, 1888, illustrates James Vick's mammoth seed house and one of his Irondequoit flower-seed farms. Built in 1880, Vick's four story seed house on East Avenue sent seed packets throughout the world, paying an annual postage of $50,000. Vick made the aster Rochester's official flower, and in 1918, on his Manitou Road farm, he grew 136 acres of Heart of France asters.

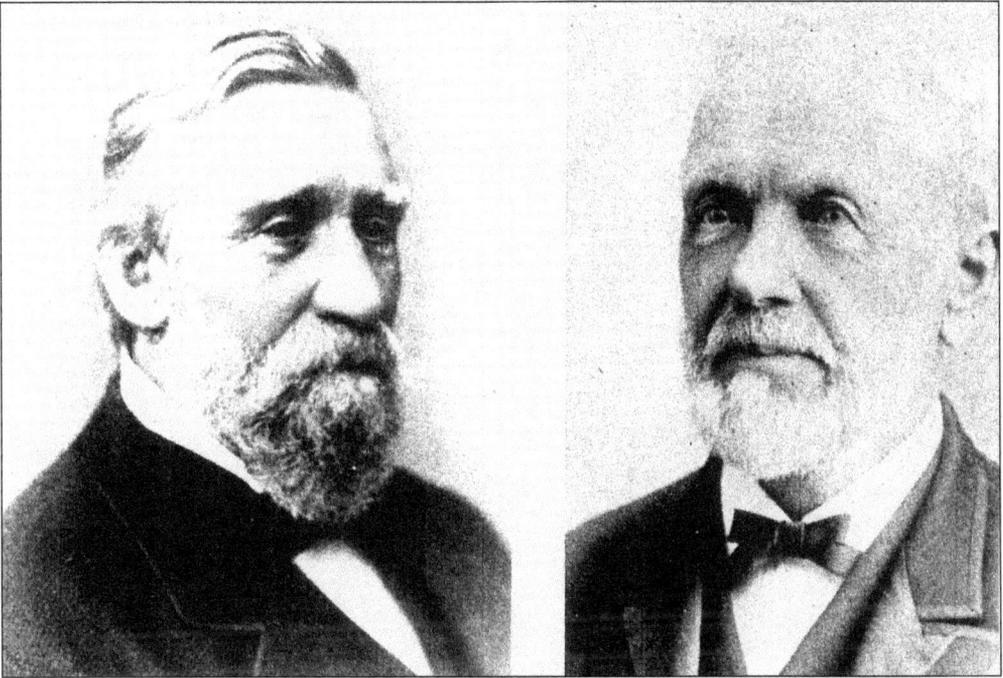

The men initiating Rochester's growth as the Flower City were German born George Ellwanger and Irish born Patrick Barry, who established their nursery on Mount Hope Avenue around 1838. The nurserymen were also prominent in creating the first horsecar line, the Glen House resort at the Genesee River's Lower Falls, donating the land for Highland Park, and erecting the park's magnificent, three story Children's Pavilion, which has since been demolished.

As the Rochester publication *Technical Educator and Inventor* of January 1911 indicates, the Ellwanger and Barry nursery was "the Beginning of a Great Industry." The nursery's botanical and pomological gardens was also known as Mount Hope Nursery. Containing thousands of fruit trees and ornamental trees, the nursery filled 650 acres and was the largest in the world at that time.

Charles W. Briggs and his brothers Hamlet S. and John T. were pioneer seedsmen, selling flower, garden and field seeds. This January catalog was mailed with this artistic catalog cover promotes the firm's "Illustrated Floral Work for 1876." Charles W. Briggs became mayor of Rochester in 1871.

Competition was strong among the city's nursery industries with more than 55 nurseries listed in Monroe County in 1893. The attractive cover of Charles A. Green's catalog illustrates his "Fruit Instructor." Established in 1877, the firm became a leading city nursery with offices located on Highland Avenue and its nursery farm in the town of Chili.

Hiram Sibley (1807–1888) became the successor to the Briggs Brothers Nursery. His nursery stock was grown both in New York and Ohio. On April 4, 1856, Sibley with Ezra Cornell consolidated several telegraph companies to form Western Union. The firm built a 1,400 mile telegraph line between St. Joseph, Missouri, and Sacramento, California, putting the Pony Express out of business. He also established the Sibley Music Library.

Almost as a second career, Hiram Sibley became a gentleman farmer with his Hiram Sibley Company, having offices for his seed business in Rochester and Chicago. It became well known across the country. His Rochester office was in a three story, Second Empire-style building on the north side of East Avenue and Stilson Street.

Circling Rochester were scores of flower beds, such as these, where the William S. Little Nursery and others grew flowers for seeds. Little's 200 acres in stock, plus other nurseries, brought beauty and fragrance to the entire countryside during the summer growing season. The seed firm, also known as the Commercial Nurseries, was established in 1830.

This 1902 photograph shows the office of the William S. Little Nursery. In 1896, the office was located at the corner of North Culver and Clifford Streets, the former location of the Donuts Delight Bakery. That may be Little standing in the porch entrance.

Five

BUILDERS OF ROCHESTER DEPARTMENT STORES

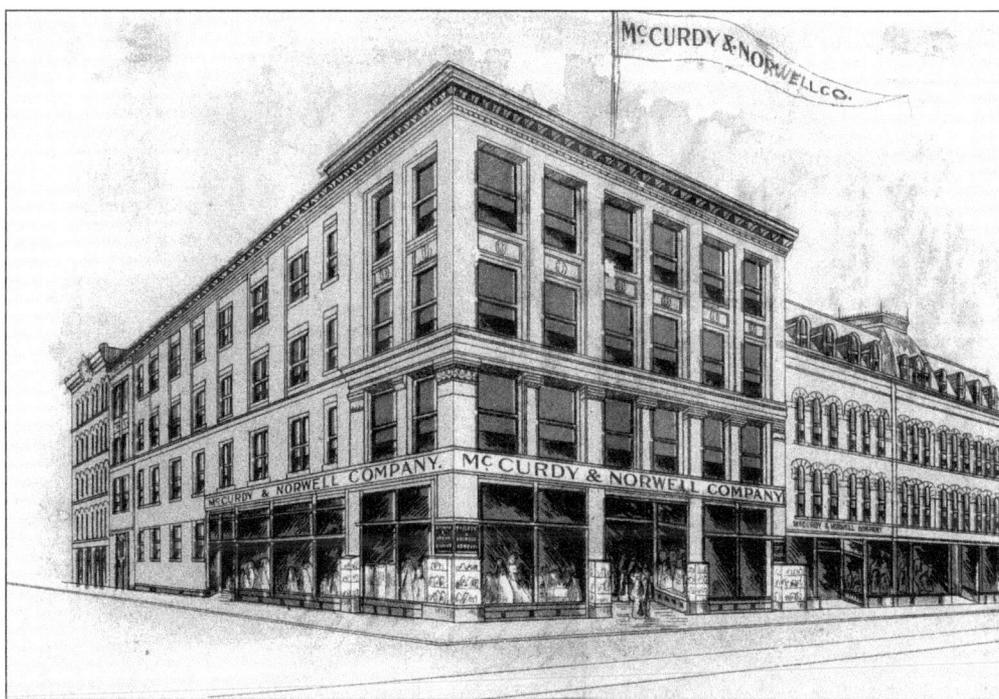

It was March 20, 1901, when John Cooke McCurdy, born on the "Shamrock shores of Northern Ireland," opened his new store. He left his neighborhood store in Philadelphia, selecting Rochester to create an "establishment for the sale of quality dry goods." Some said "The location is too far uptown. Why, there were trees all over the place at the corner of East Avenue and Main Street, and up and down Elm Street. McCurdy's store was in the country!" (Courtesy *Life at McCurdys*.)

McCURDY & NORWELL COMPANY

Have decided on MARCH THE TWENTIETH as the Date of the opening of their

NEW DEPARTMENT STORE,

Main Street East, corner of Elm Street ("The Seven Corners.")

On that day the portals will swing open on an entirely reconstructed and renovated establishment—materially different in every particular to that heretofore conducted in the building; different in fact from any that the residents of Rochester and vicinage have been accustomed to.

You are cordially invited to call, to behold the accommodations provided for your comfort, to inspect the varied assortments of highly desirable and crisply new merchandise and to purchase if you wish.

BUT YOU WILL NOT BE IMPORTUNED TO BUY.

The store is yours to enjoy according to your inclinations. You'll accept our invitation to be present next Wednesday, the 20th? Thanks.

McCURDY & NORWELL CO.

This advertisement, printed in the March 1901 issue of the *Rochester Herald*, invited Rochester residents to a new dry goods store known as the McCurdy and Norwell Company.

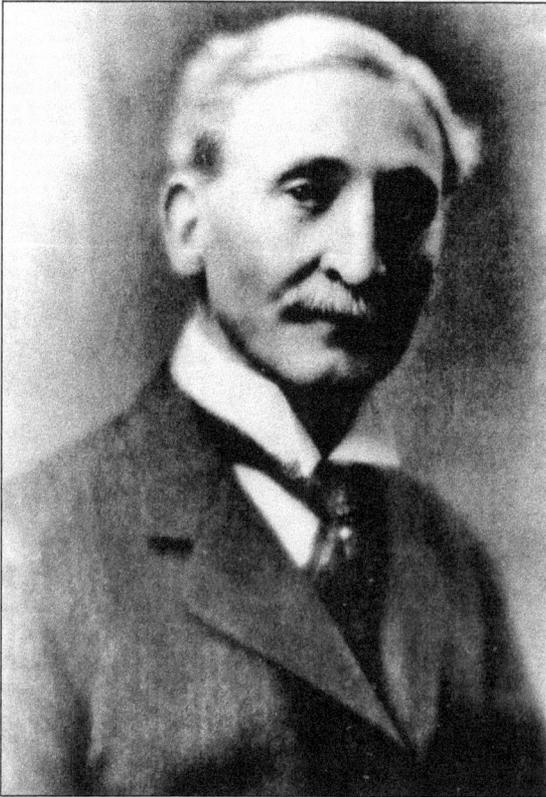

John Cooke McCurdy retired in 1899 at age 49. He later came out of retirement to found a new uptown store in Rochester. It gave him great pride to witness shoppers flock to his 50,000 square foot, four-story building on the southwest corner of Elm and East Main Streets.

McCurdy and Norwell Co.

Main St. East, Corner of Elm St. Thursday, May 23. Many Stores Combined.

If You Are Fond of Dainty Confectionery, Try TROWBRIDGE'S ORIGINAL CHOCOLATE CHIPS, Just Pure Molasses and Sugar Coated With Chocolate. Samples Given Out in the Candy Store—BASEMENT.

SILK WAISTS Reduced a Third

The Second Floor's Greatest Occasion to Begin This Morning.

All of the Silk Waists that have been used for show purposes here, or that have formed a part of our regular stock, come under the ban of to-day's rigid price-cut. Read a little further and you'll warm up to the interest of this store news.

Beginning this morning, the Waists you prized most, but did not buy because of the prices, (which really were little enough) are brought nearer to you—as near as is possible if we are to give any consideration whatever to their cost and worth.

Buy the silk to make them, along with the trimmings; hie yourself to a dressmaker who commands style, and you'll spend double or more for waists of equal merit. And even then, there will be an absence of the grace and nattiness, the smart effects that characterize these ready-to-wear garments.

Along with those we already possessed, we have taken over all the same maker had in stock—one or two of a kind he made up from short lengths of silks. Taken all in all, there are

$2,500.00 Worth of Silk Waists to be Sold for $1,667.00.

Not so much when you read it quickly, but it represents more than two hundred and fifty of the choicest confections that apt hands ever fashioned or style ever knew. Waists like which you have seen no copies hereabouts and which have turned the tide of buying this Spring, right home here, to the "Seven Corners."

At $3.70: One hundred and twenty one finest taffeta and louisiene Silk Waists all hemstitched and trimmed with clusters of fine plaits, front and back; L'Aiglon or straight collars and Bishop sleeves. Rose, green, light blue, lavender, royal, castor, grey and white. Just a third under price.

At $4.90: Fifty seven exquisite Silk Taffeta Waists in every color that is new and pretty. Made in vest and Bolero effects, with wide box plaiting. Some are all-over hemstitched, others lace trimmed. Newest sleeve effects. Just a third under price.

At $7.60: Forty nine very handsome Waists of Crepe de Chine and taffeta, tucked all over and trimmed with chiffon and lace. Very dressy and stylish. Light blue, pink, nile and white. Some trimmed with black velvet ribbon and have fancy sticks. Just a third under price.
SECOND FLOOR.

McCURDY AND NORWELL CO.

This advertisement, which appeared in the *Rochester Herald* on May 23, 1901, shows a glamorously attired Victorian woman with her silk parasol.

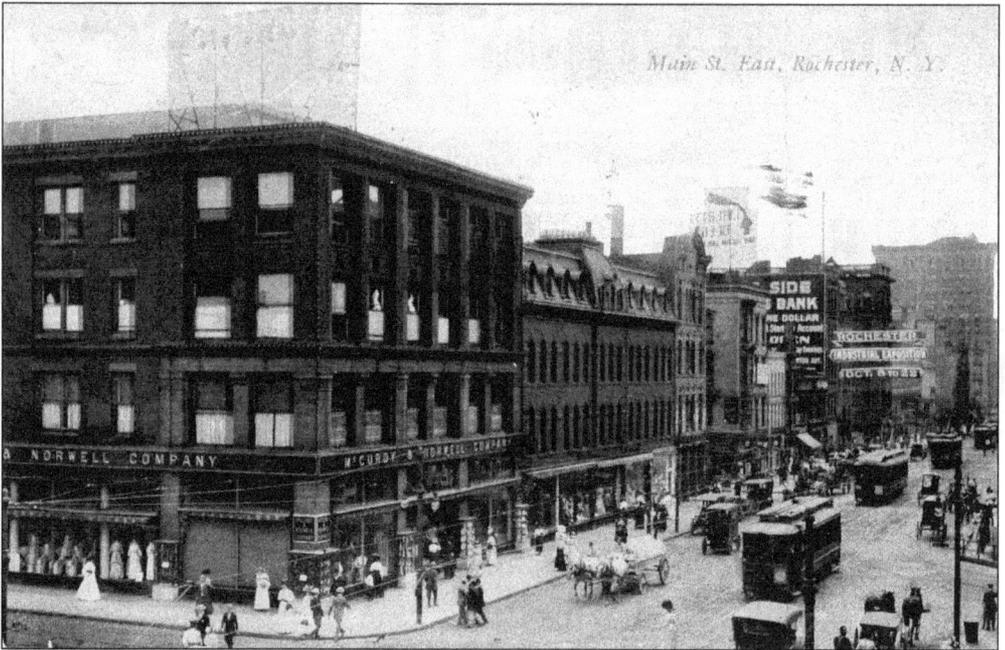

In 1913, the McCurdy and Norwell Company became the McCurdy and Robinson Company. This view looks west on East Main Street. The chamber of commerce building is to the extreme right. The banner announces Rochester's Industrial Exhibition in October 1912.

The new building is finished

Grand "opening" sale, May 10th to 17th

Rochester's most modern and handsomest shopping center will be opened Saturday, May 10. Value-giving on an extraordinary scale, in every department, will celebrate the event, from May 10 to 17. Plan your shopping trip accordingly.

McCurdy & Norwell Co.

Order by Mail (Parcel Post Service) Rocheste

Spring flowers greeted the shoppers attending the grand opening of the McCurdy and Norwell Company's new six-story addition on May 10 to 17, 1913. The advertisement appeared on May 7, 1913.

Gilbert J. C. McCurdy, son of McCurdy's founder, joined the firm in 1919 following service in World War I. Soon afterward, the store's name was changed simply to McCurdy and Company. In 1923, a six-floor wing was added to the south, and in 1928, two stories were added to the corner building with six elevators in operation. Escalators took patrons from the basement to the fifth floor in 1946.

THE FRIENDLY STORE

When you are in haste—
This is that store which takes care of phone orders when one has not the time to shop in person.

When you have plenty of time—
This is that store which is glad to show and to serve until the customer brings the transaction to a conclusion.

Art Needlework	Girls' Apparel	Phonographs
Babywear	Gloves	Pictures
Beauty Shop	Handkerchiefs	Radios
Birds	Hosiery	Sewing Machines
Blankets and Bedding	Housewares	Silks and Velvets
Boys' Apparel	Infants' Wear	Silverware
Cafeteria	Jewelry	Stationery
Children's Apparel	Lace and Embroidery	Sweaters
China and Glassware	Lamps	Tecla Pearls
Corsets	Leather Goods	Toilet Articles
Domestics	Linens	Trimmings
Draperies	Linings	Umbrellas
Dress Goods	Luggage	Underwear
Dressmaking	Men's Furnishings	Vacuum Cleaners
Floor Coverings	Millinery	Wall Paper
Footwear	Neckwear	Wash Fabrics
Frigidaire	Negligees	Washing Machines
Furniture	Notions	Women's and Misses'
Furs	Patterns	Apparel
Gifts		

McCurdy & Co.

ROCHESTER, N. Y.

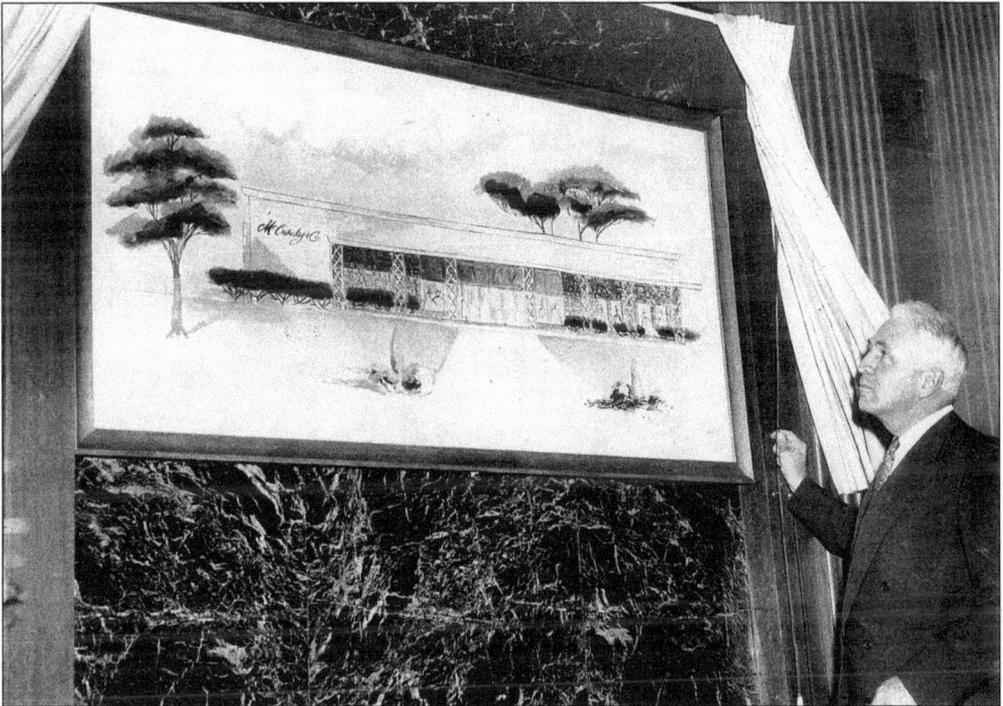

Gilbert J. C. McCurdy is seen unveiling the architect's rendering of a new suburban McCurdy's that was planned to open between Britton and Denise Roads in Greece. The event was part of a profit sharing dinner for employees at the Rochester Chamber of Commerce on April 14, 1953. (Courtesy History Division, Rochester Public Library.)

97

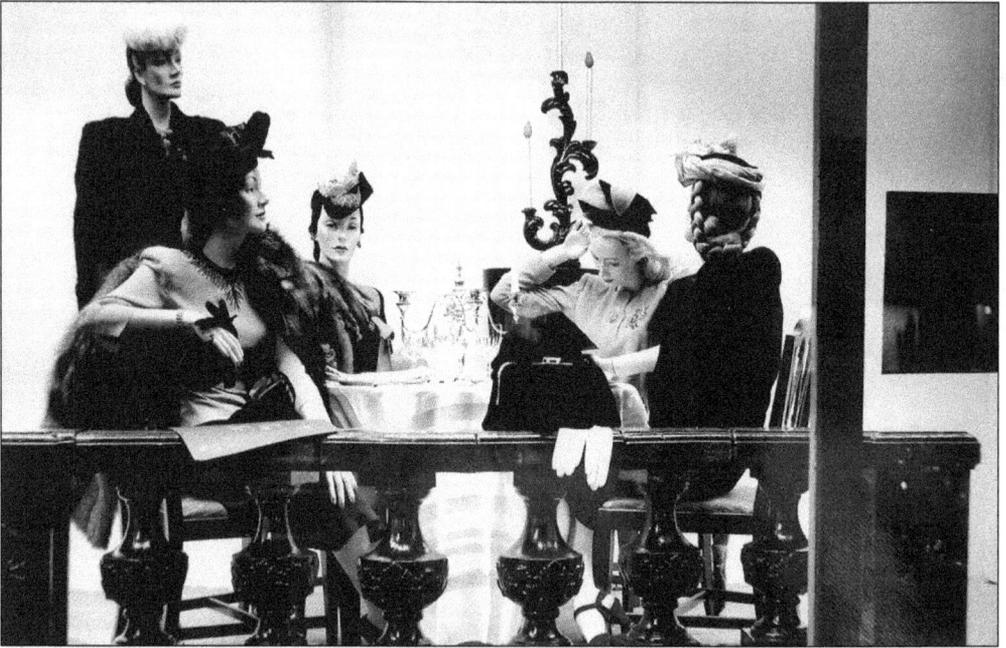

Five fashionably dressed mannequins sit around a table complete with stemmed goblets and a candelabra. McCurdy's window display was created in the early 1940s.

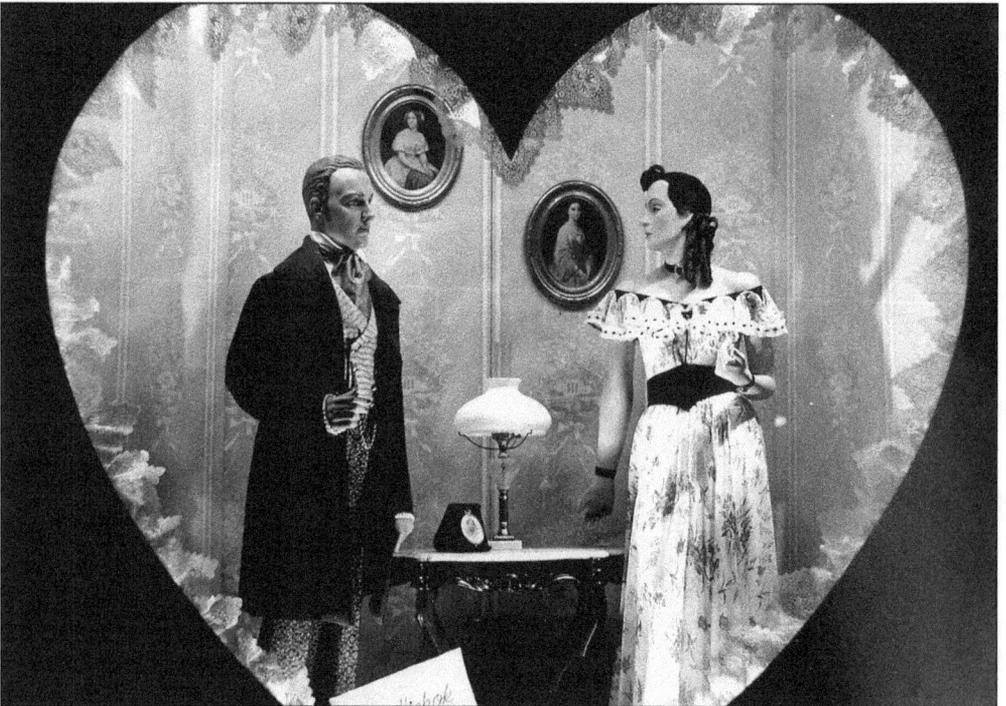

A valentine-shaped window display shares a presentation of Hickok men's accessories and a Victorian scene based on the film *Gone With the Wind*. Such frequently changed window displays made window shopping downtown a happy pastime for many patrons. (Courtesy History Division, Rochester Public Library.)

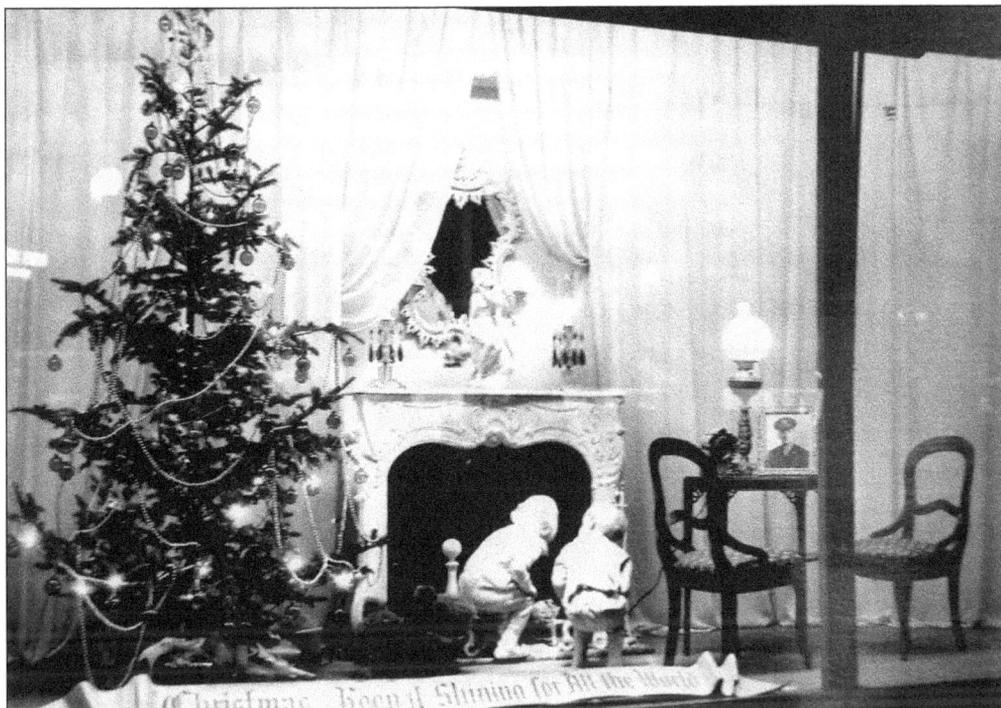

The holiday season in the 1940s had Christmas trees minus the icicles. The metal was needed for wartime uses. In this McCurdy's store window display, two youngsters await a visit from St. Nicholas. Note the framed photograph of the serviceman on the table. (Courtesy History Division, Rochester Public Library.)

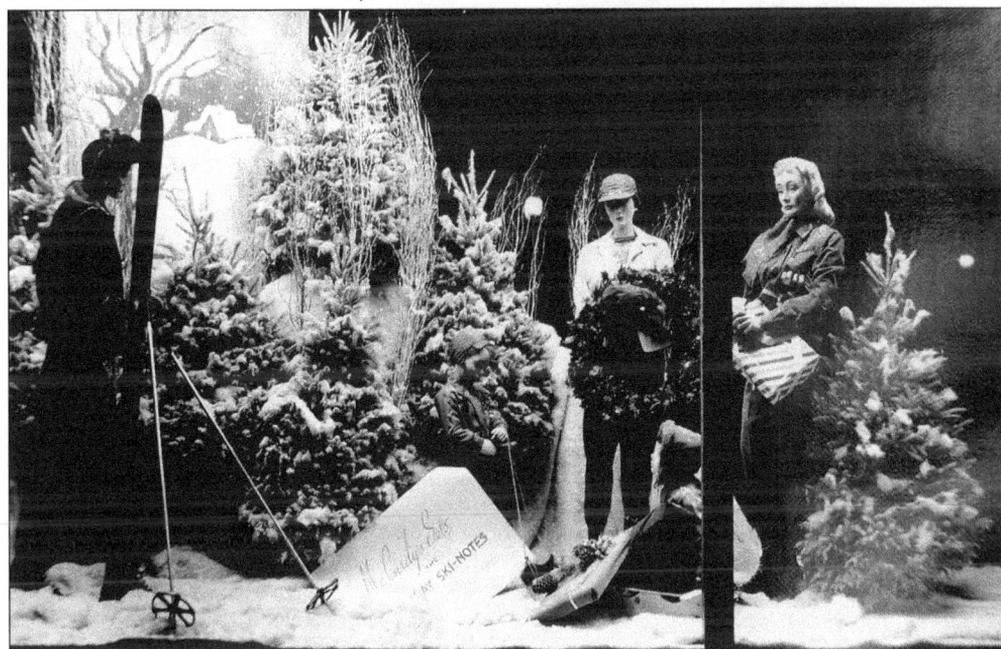

Getting ready for both Christmas and a skiing holiday seems to be the message delivered by this c. 1940s window display. (Courtesy History Division, Rochester Public Library.)

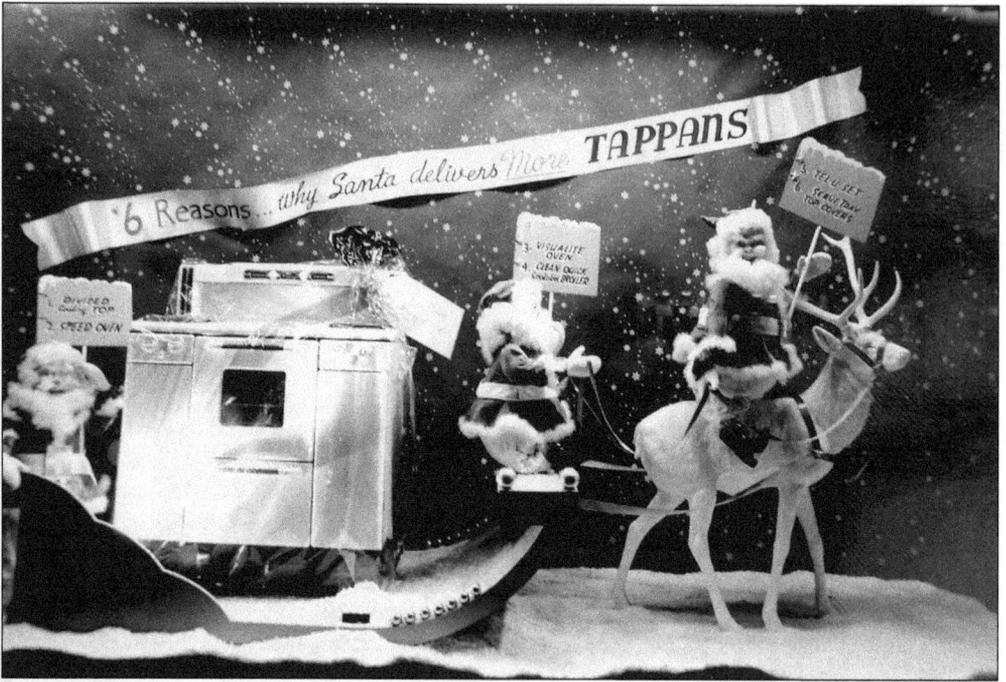

Santa's elves use reindeer power to deliver a brand new Tappan gas range to some lucky family for a Christmas present in the 1940s. (Courtesy History Division, Rochester Public Library.)

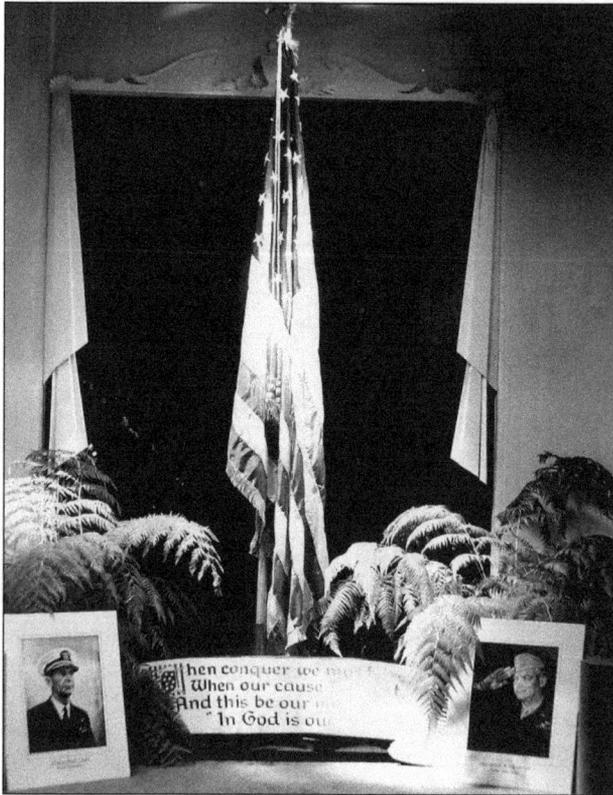

During wartime in the early 1940s, the McCurdy store provided reminders of those overseas. Portraits of Gen. Dwight D. Eisenhower and Adm. Ernest J. King were part of a patriotic window tribute on Memorial Day. (Courtesy History Division, Rochester Public Library.)

One of McCurdy's elevators was furnished with a unique interior on September 2, 1938. Jay Niver operates the unusual elevator, giving Anne Marie Whalen an express lift to the home furnishing department. In 1931, Gilbert J. C. McCurdy became store president. (Courtesy History Division, Rochester Public Library.)

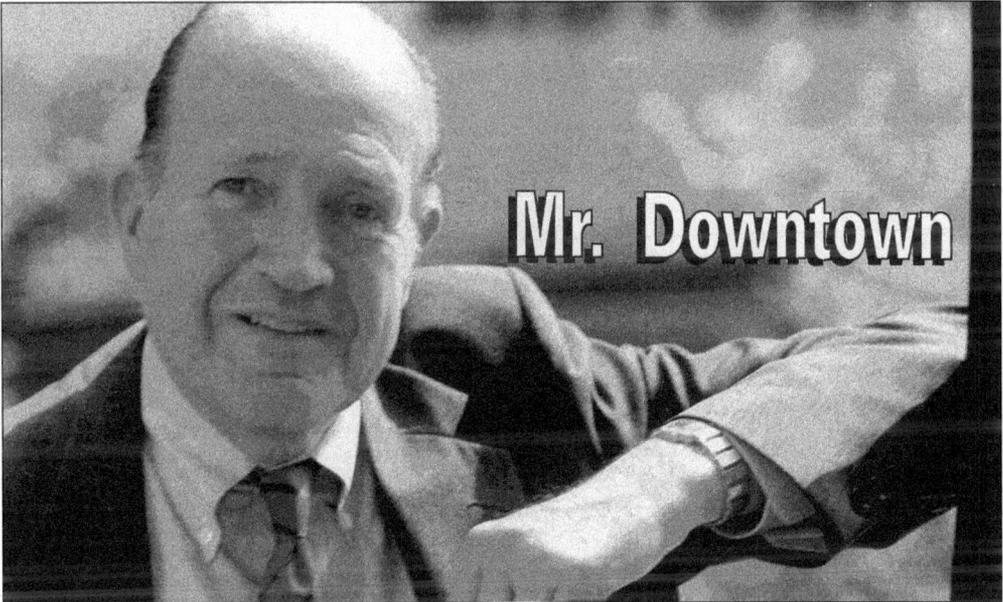

Mr. Downtown

The October 1, 1990, issue of *Rochester Business Profiles* stated, "Gil" McCurdy, Rochester's gentle giant, was "Mr. Downtown." Gil McCurdy joined the firm in December 1946 following service in World War II. Expansion grew to nearly a half-million square feet—ten times McCurdy's size in 1901. On July 5, 1994, the St. Louis May Company purchased eight McCurdy's stores. Mall stores in Greece, Irondequoit, and Marketplace were acquired by Kaufmanns. A 93-year family tradition and mecca for shoppers had ended.

Rochester's Fastest Growing
Exclusively Retail Establishment

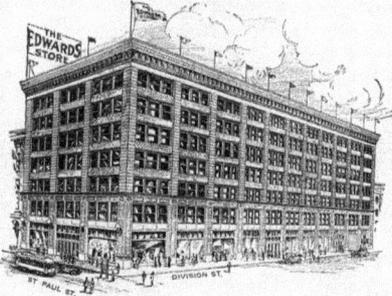

ESTABLISHED AND MAINTAINED
IN THE INTEREST OF THE
ENTIRE COMMUNITY

E. W. Edwards and Son

Once there were three major department stores downtown: Sibley's, McCurdy's, and Edwards. The E. W. Edwards and Son store, at 32–142 East Main Street, was a favorite of many Rochester residents. This 1906 advertisement announces the store as "Rochester's New Mercantile Establishment." Edwards offered youngsters a train ride at Christmastime.

The main floor of the E. W. Edwards store originally had indirect, incandescent lighting that kept the aisles dimly lit, as is shown in this photograph. In 1953, the store was remodeled with freshly painted walls and ceiling, and it was better illuminated with 150 watt florescent fixtures.

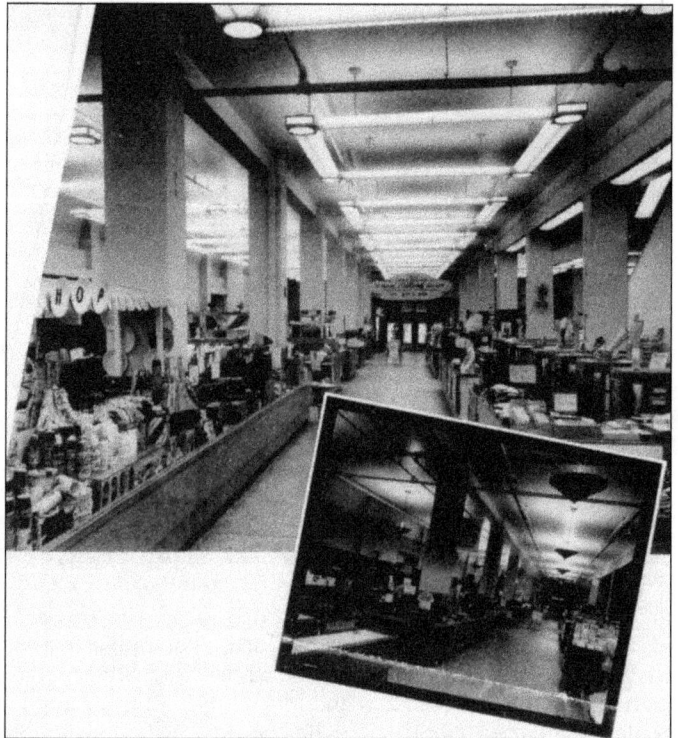

Established in 1860, McFarlin's was co-founded by Francis J. McFarlin (pictured) and Robert McFarlin. The pair opened the men's clothing and haberdashery store on State Street. In 1883, located at 126 East Main Street, McFarlin's was known as the C.O.D. Store, pioneering in the cash-on-delivery system. (Courtesy *Greater Rochester Commerce.*)

1860 **1960**

100 years of quality

McFARLIN'S

OF ROCHESTER

In 1887, after several moves, they relocated at 110 East Main Street, which became their home for 20 years. In June 1925, McFarlin's moved into a fine new store at 195 East Main Street. The handsome five-story building was designed in Italian Renaissance style. It was said that "Through its portals passed the best dressed men in western New York." (Courtesy *Greater Rochester Commerce.*)

Shown on this page are four of the principal founders of the Sibley, Lindsay, and Curr Company. Opening in 1868, it became "a store which would grow into one of the largest merchandising businesses of their time in the United States." Sibley and Lindsay lived to see their store celebrate its 50th birthday.

John Curr, one of Rufus Sibley's Scotch immigrant partners, took ill, moving to Colorado and disappearing forever from the store in 1875. His name, however, lives on in retail history. Thomas Ryder and Andrew Townson helped Sibley's continue to prosper during their stewardship. (Photographs courtesy Rochester Historical Society's *News and Notes*.)

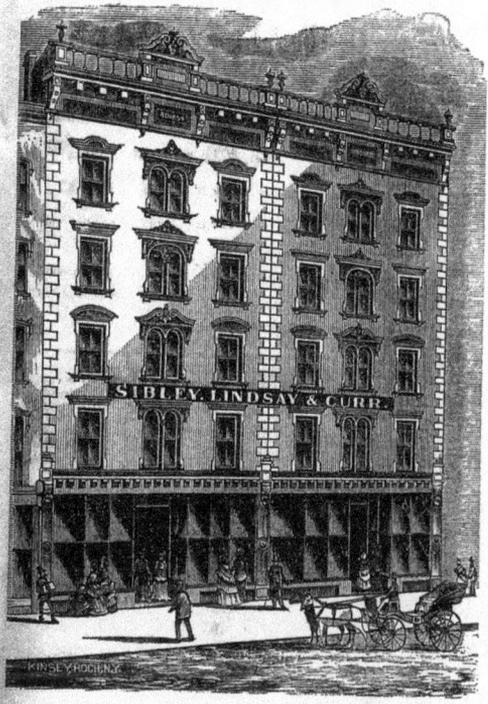

Following the disastrous flood of 1865, Sibley's sought dry quarters up the hill on Main Street, away from the Genesee River. Rufus Sibley's choice was 73 Main Street because it "is many feet above the high water mark." Their new five-story building, called the Marble Block, had elaborate cornices in its Victorian façade. It occupied the site of the former H. L. Green Company (150 feet east of St. Paul Street). Their first week's sales totaled almost $3,000.

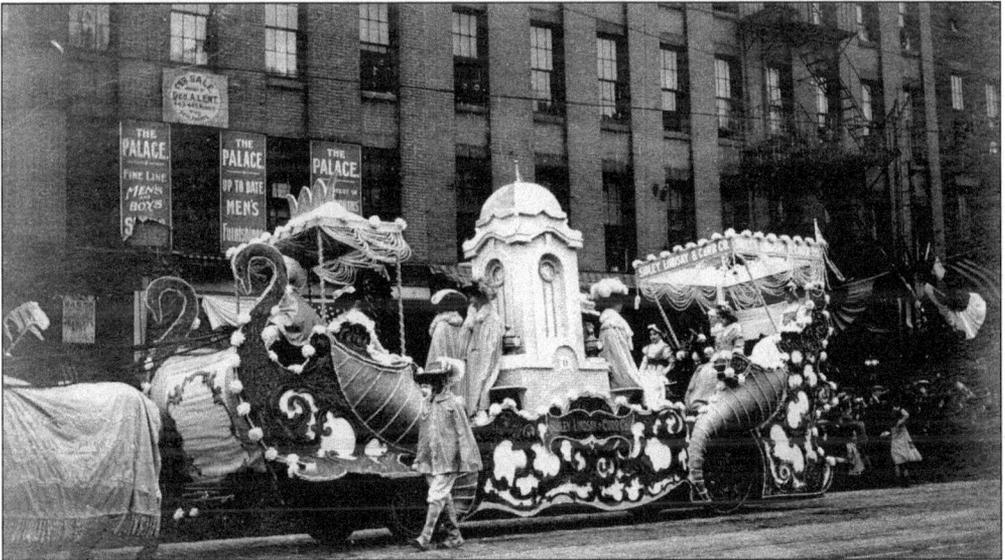

Sidney P. Hines of East Henrietta took this candid snapshot capturing the Sibley, Lindsay, and Curr Company's elaborate entry in the float parade. The float is passing a building on State Street near Allen Street. The event was a part of Rochester's Industrial Exhibition held in 1909.

72ND YEAR. TWO CENTS. ROCHESTER, N. Y., SATURDAY, FEBRUARY 27, 1904. FORECAST:

TOTAL LOSS: $2,935,750

ANOTHER BATTLE AT PORT ARTHUR--KOREA WILL ASSIST JAPAN

One and Three-Quarters Acres In the Retail District Completely Destroyed.

LOSS IS THREE-QUARTERS PROTECTED BY INSURANCE

Loss Pretty Evenly Divided—Rates May Be Raised in Consequence — Step Under Consideration Since the Baltimore Fire — All of the Burned Structures to be Replaced.

DESPITE MAGNITUDE OF THE FIRE NOBODY WAS SERIOUSLY INJURED

Chief Jaynes Alone Disabled—Buffalo and Syracuse Companies Fought Valiantly Beside Local Men. Help From Other Cities Not Needed—Wall on Main Street Pulled Down in the Afternoon—Many Out of Work.

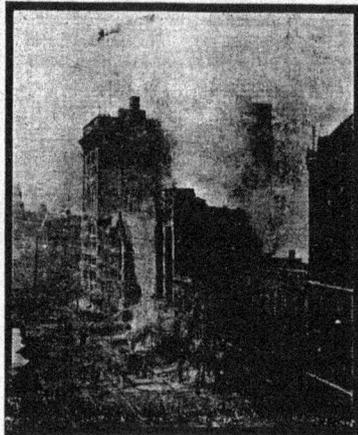

LOOKING WEST IN MAIN STREET EAST.

No Particular Damage Done in Friday's Crossfire.

Japanese Have Attacked Port Arthur Each Morning Since Wednesday—Korea Formally Announces Herself an Ally of Japan and Will Put a Fair-Sized Army, Well Trained, in the Field. Wiju Has Been Opened.

Losses and Insurance.

ALL FOUR FOUND GUILTY BY JURY

MACHEN, THE GROFFS AND LORENZ ALL GRAFTERS.

JURY WAS OUT NINE HOURS

The city's greatest property loss from fire was announced in the Saturday, February 27, 1904, issue of the *Democrat and Chronicle*. The fiery inferno, lasting 40 hours, devastated much of the city's retail district. In all, 1.75 acres of the downtown's buildings between East Main, St. Paul, and Division Streets were destroyed. Hardest hit was the Sibley, Lindsay, and Curr Company, which was housed in the Granite Building. Losses of contents and real estate were valued at $4 million, which was an enormous sum in 1904.

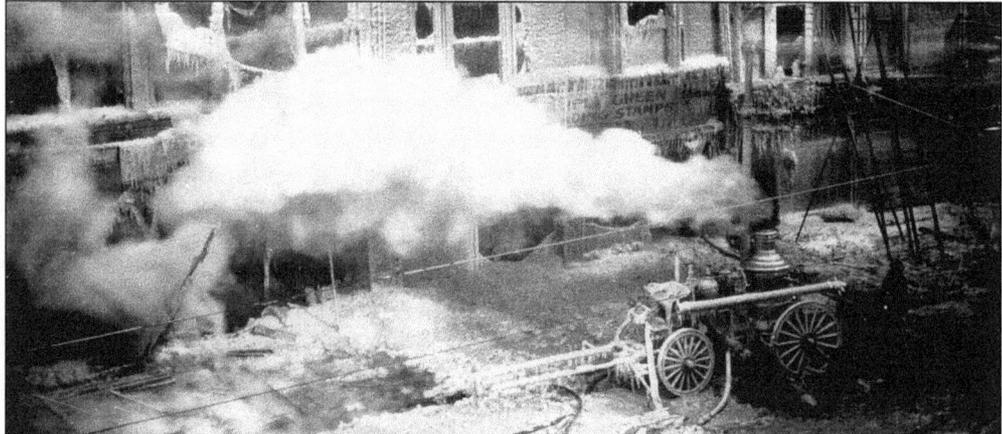

The boiler on the fire pump wagon provided pressure to the hoses used to quench the Sibley fire. The frigid February weather hindered the valiant efforts of Rochester's firefighters and their mutual aid firemen from Buffalo and Syracuse. Great blossoms of white steam and the icicle-draped, vacant windows tell their own story.

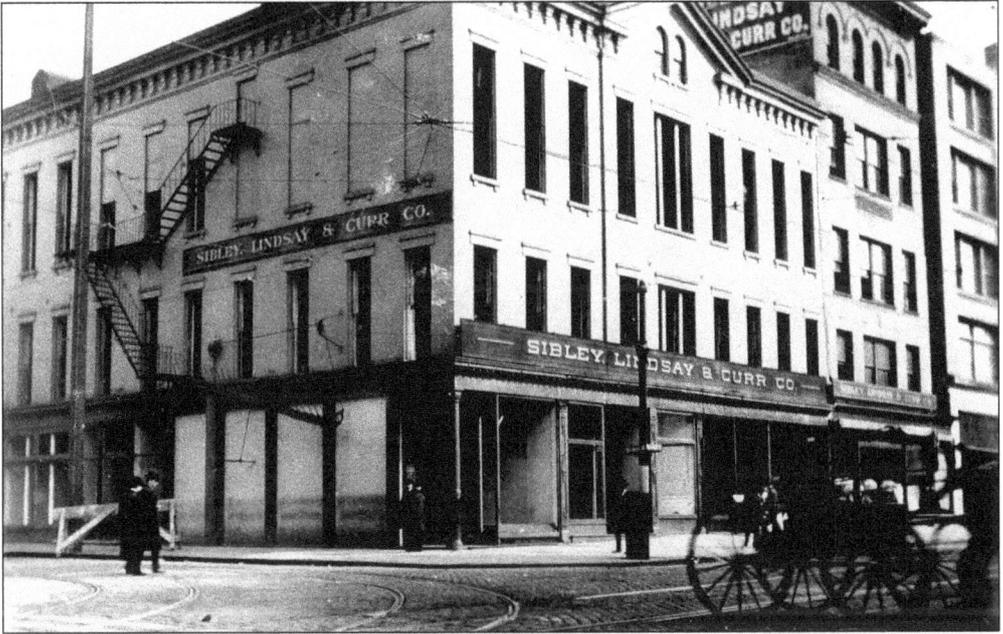

In 1902, the Sibley Company leased land at the corner of East Main Street and North Clinton Avenue. The Archer Building is shown is this faded photograph. At one time it held the Washington Theatre and later the Empire Theatre, where both early burlesque and vaudeville were attended by Rochester audiences.

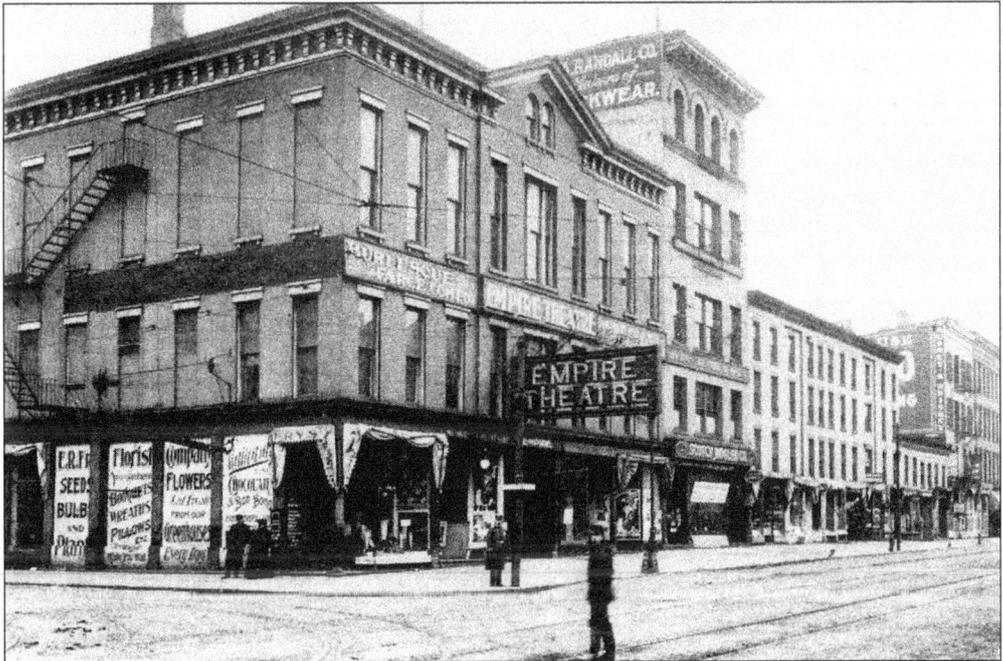

Within 30 days of the disastrous fire, Sibley's moved its merchandise into the block housing the Empire Theatre. Structures to the right of the Empire Theatre were also part of the real estate purchase. These makeshift quarters were used until their demolition made way for a new fireproof structure, which was erected on the site in 1905.

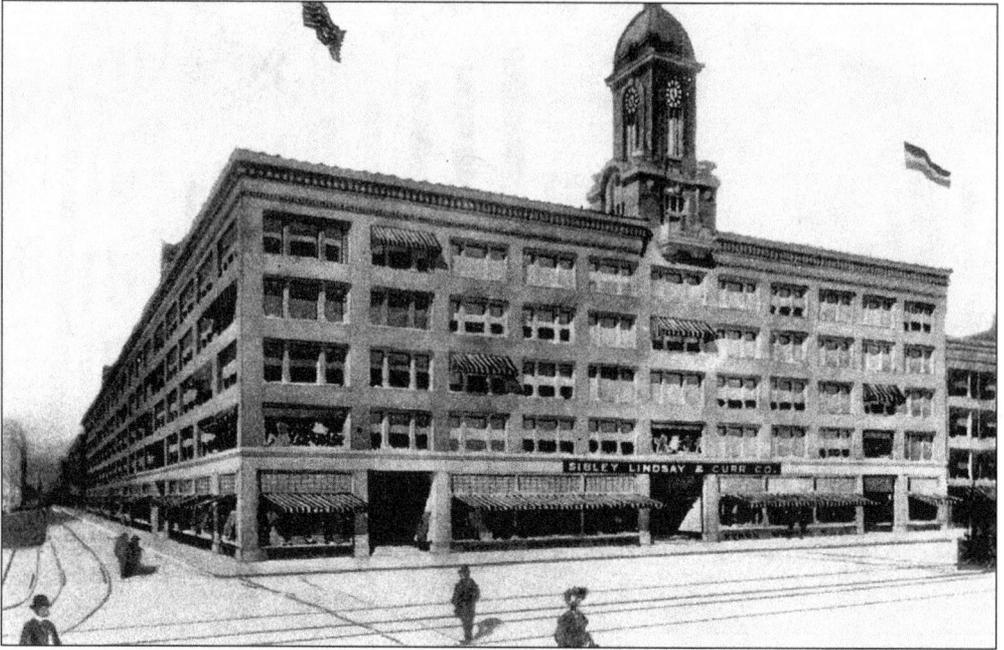

Renowned architect J. Foster Warner designed the new Sibley Department Store, a five-story structure, using Roman-type brick in commercial style with three section Chicago-type windows. It held fireproof doors, 11 elevators, 6 street entrances, and broad aisles to serve its customers. A grocery department and marble-columned soda fountain were added, plus an elegant tearoom. The dining patrons were cooled by a 30-ton refrigeration unit. It is said that the interior arc lighting equaled that of nine suburban towns. A mammoth grand opening celebration was held in 1906.

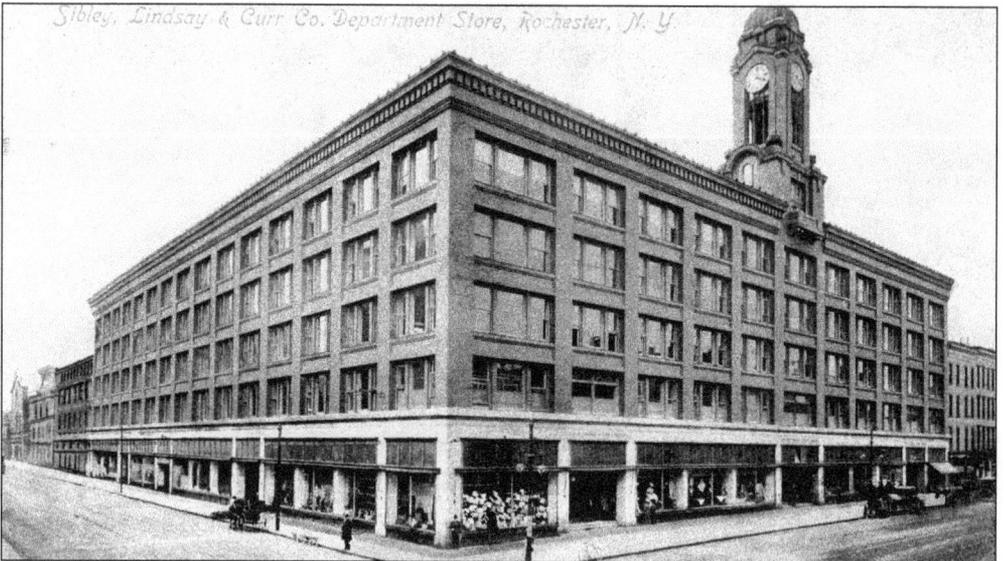

This image appeared in the *Rochester 1906* publication of the Rochester Chamber of Commerce. It may be the very first photograph published of Sibley's newest location. The article stated, "The company is now just completing its new store which will have a floor space of eleven acres and will be modern in every appointment."

The most imposing element of the new Sibley's was its clock tower. As time passed, it became a downtown landmark and was widely employed as the store logo in advertisements, on gift boxes, and on shopping bags. (Courtesy History Division, Rochester Public Library.)

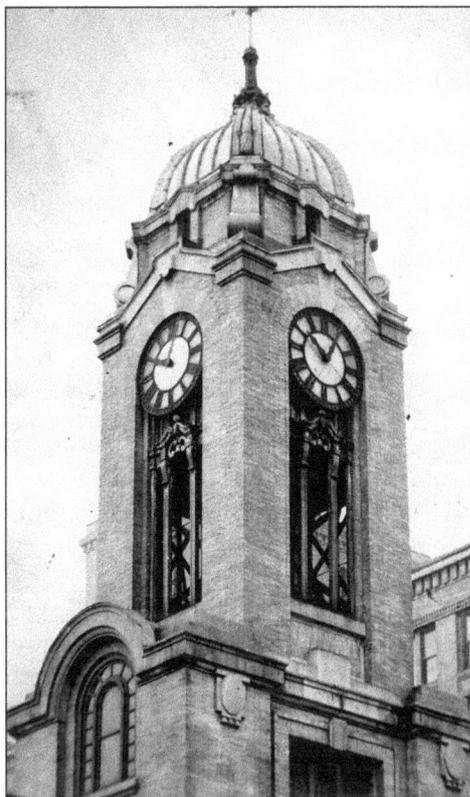

An expert clock-smith was employed to keep the 3,500 pound Seth Thomas time piece running smoothly over its many years. The skilled craftsman is working inside the tower behind one of the glass fronted clock faces. (August 1953 photograph; courtesy History Division, Rochester Public Library.)

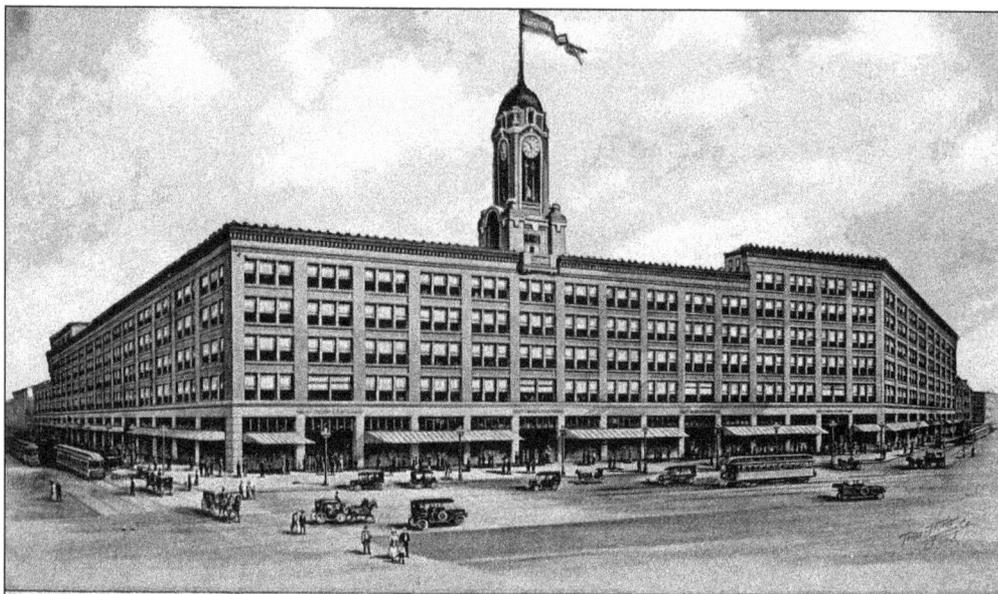

SIBLEY, LINDSAY & CURR CO., ROCHESTER, N. Y.

By 1910, the flourishing store required more space. A new six-story wing, the Mercantile Building, was added completing a block that now reached to North and Franklin Streets. The central aisle was expanded to stretch an impressive 373 feet, "one of the . . . longest store aisles in the world." J. Foster Warner designed the addition to perfectly mate with the original structure. The major addition was completed in 1911.

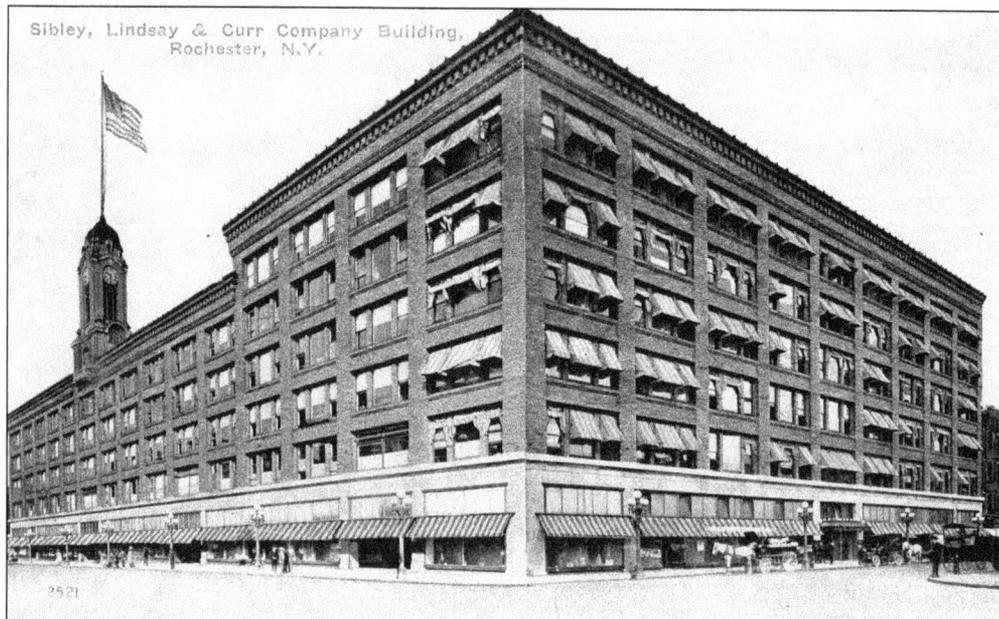

Sibley, Lindsay & Curr Company Building, Rochester, N.Y.

The addition, seen here from the corner of East Avenue and North Street, shows the expanded dry goods store. It had parlors, reading rooms, and a second floor balcony offering "most interesting views of the Main Floor." In 1911, Sibley's, at 43 years of age, was still growing "Over 2300 persons were employed in connection with the store." By 1918, Sibley's was employing one out of every 100 persons living in the city.

When the Order of the Elks held its convention in Rochester, city buildings were often decorated for the occasion. On July 7 through 14, 1911, the Sibley, Lindsay, and Curr Company welcomed the fraternal order with yards of red, white, and blue bunting, adding colorful pennants and emblems to the store's exterior.

As this 1911 Sibley's diagram reveals, the main floor was big. The combined floor spaces totaled 13 acres and included a post office, suburban trolley ticket office, and an information desk. The expansion created a street frontage of 618 feet, providing for scores of window displays. A Sibley brochure stated: "Circling the Main Floor traversing the outside aisles, one covers a trifle more than a quarter of a mile."

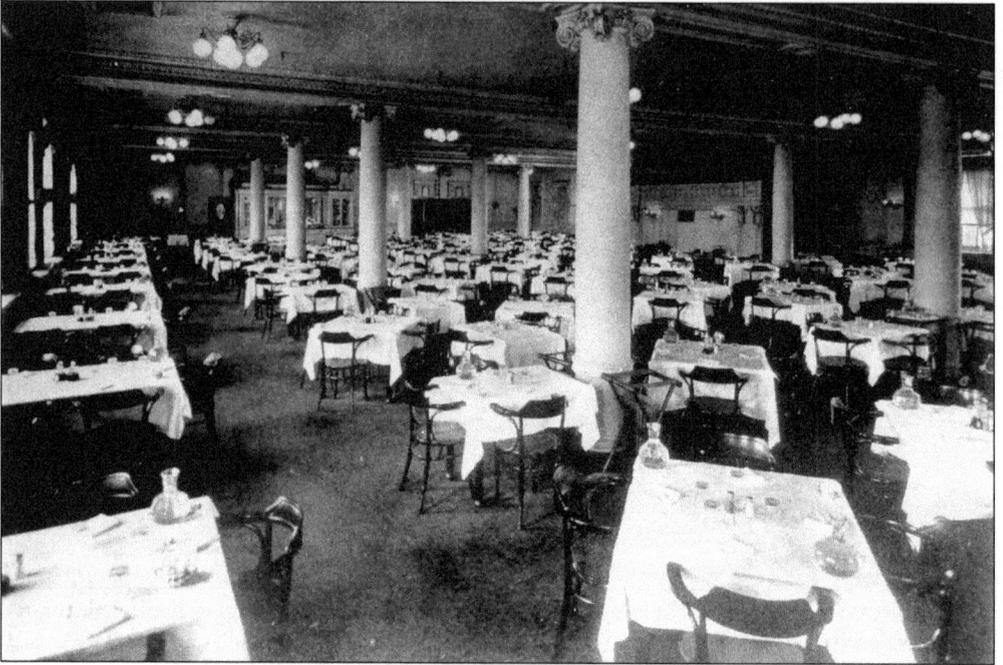

The sixth or top floor of the addition held a new tearoom. A pamphlet reads: "It is a delightful place for luncheon . . . cool, light, restful. In conjunction with the Pompeian Room, there's a men's cafe where smoking is permitted at the tables, it seats over 500 persons."

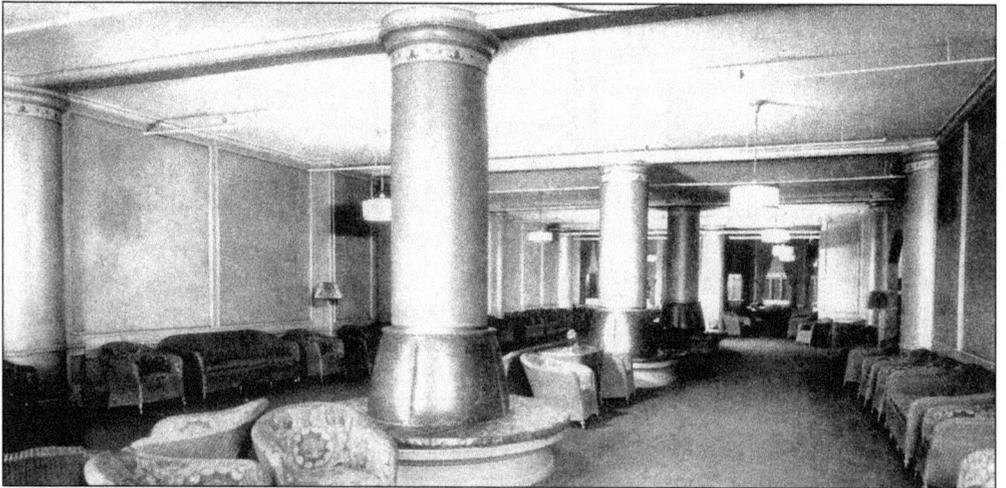

A lady's lounging area along the second-floor balcony provided Sibley patrons with a place to rest, meet, and converse with friends.

The annual picnic for Sibley's employees was a gala affair. Departing the store at 1:00 p.m., special trolleys took hundreds of workers to Ontario Beach Park on Saturday, July 18, 1916. Aboard the trolley and later at the picnic, a band provided music for singing throughout the day. The patriotic official picnic badge had to be worn by those invited. It held strips of coupons good for entrance, ice cream, lemonade, popcorn, dinner, supper, and "the time of your life." In feathered hats and Sunday best white dresses, the employees and families enjoyed watching contests, a popular part of the festivities.

The year 1912 saw Sibley's utilizing 14 automobiles, 29 delivery wagons, and 56 horses. This vintage photograph was taken in front of Rochester's early convention hall at Washington Square. By 1968, over 60 delivery trucks, with the familiar Sibley Tower logo, were delivering over 1.5 million packages a year.

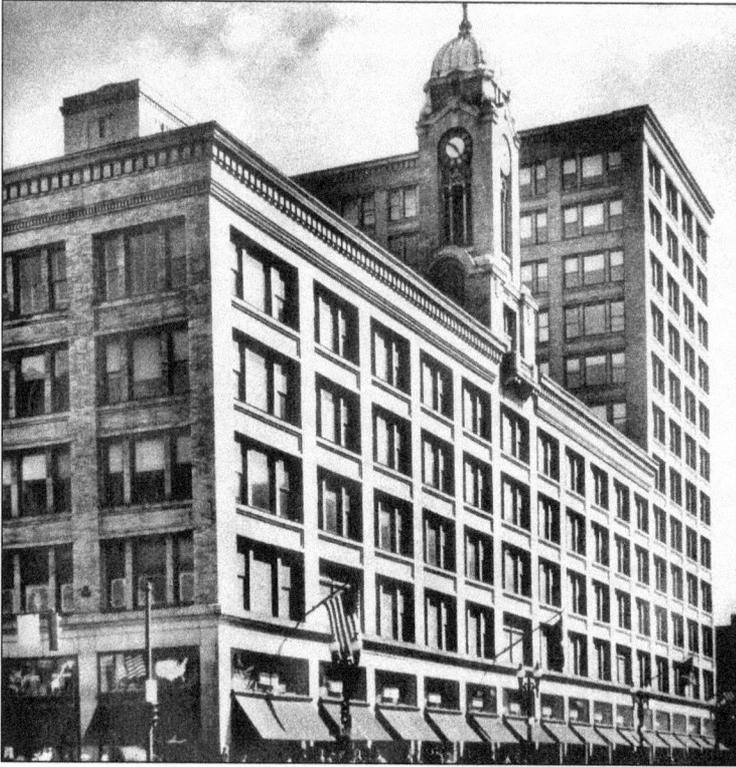

"Spreading beyond old walls" titled one account of Sibley's six-story addition to their Mercantile Building in 1926. A new terrazzo floor was laid on the enlarged main floor. Drug, candy, jewelry, and stationery departments were added. A bank of skilled telephone operators took orders, both local and regional. Even small orders were delivered to one's home. Once the mercantile's east wing had grown to 12 stories, it was renamed the Sibley Tower Building.

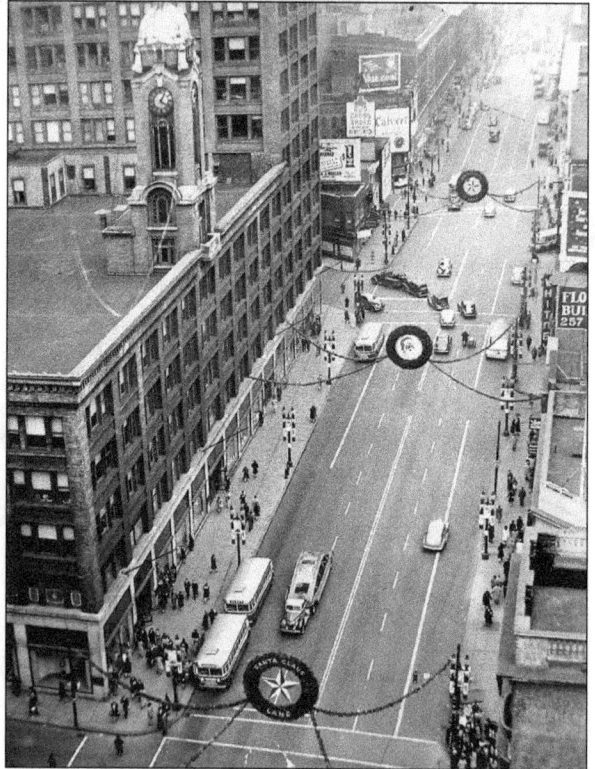

An aerial view of Sibley's, taken on the southeast corner of South Clinton Avenue around 1930, reveals pedestrian, bus, and automobile traffic passing the busy Clinton-East Avenue intersection. (Courtesy New York Museum of Transportation.)

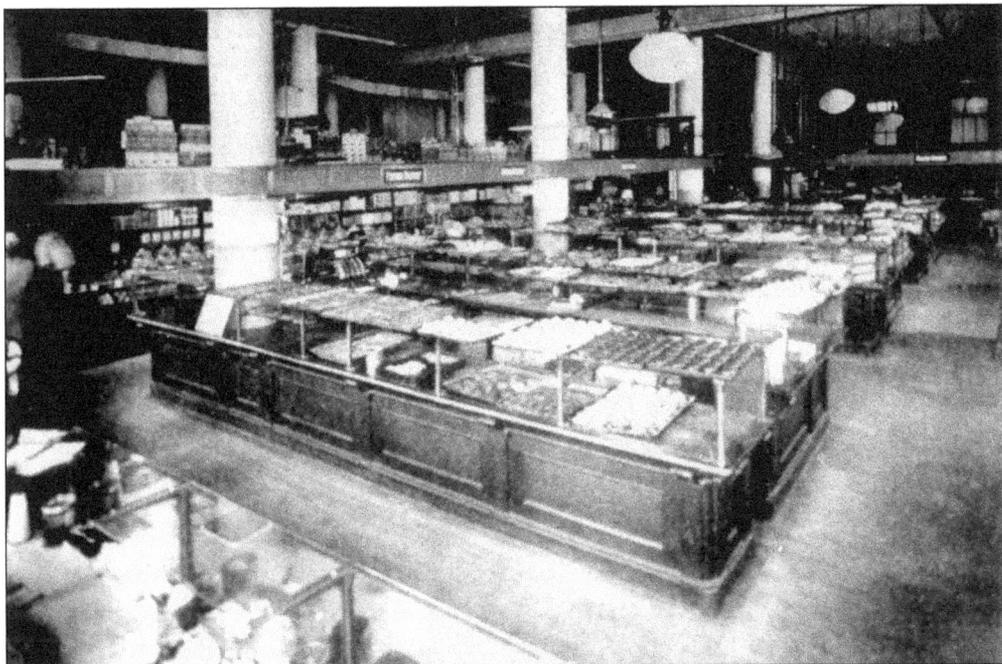

When residents visited Sibley's new grocery in 1926, they were amazed at the amount and variety of baked goods made by the store's bakers—especially the chocolate and mocha cakes and assorted pastries. Long rows of glass cases displayed trays of mouth-watering goodies.

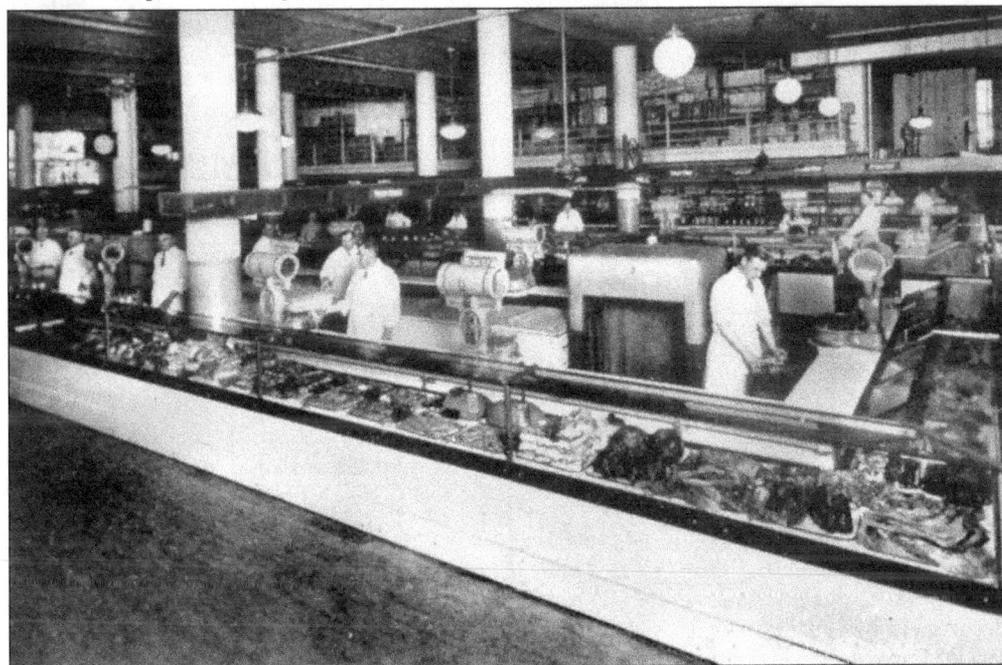

The fresh meat and delicatessen counters were filled with the choicest cuts and the tastiest delicatessen treats. Clerks in white coats were eager to serve the public, often making up delicious sandwiches to go. The grocery department, now on the main floor, became the largest in the nation outside of Macy's.

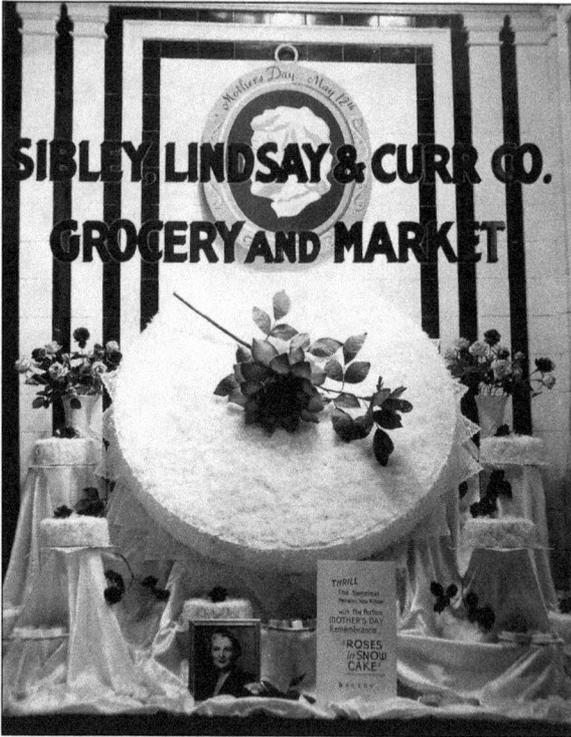

The window display, fashioned in 1941, is typical of the distinctive bakery treats for which Sibley's was famous. Positioned around the huge centerpiece pastry are a half-dozen Roses in Snow cakes. The bakery department used a special recipe to produce a cake fitting the occasion—Mother's Day. The cake was for "the Sweetest Person You Know." (Courtesy History Division, Rochester Public Library.)

The November 19, 1964, issue of the *Democrat and Chronicle* carried this advertisement for Sibley's "Food and Gourmet Center." The grocery department had a fancy new name, but its service and reasonable prices were still notable. Thanksgiving turkeys, packed in ice and delivered to one's door, were 59¢ a pound, or patrons could order a roasted turkey and dressing, boxed and ready to be picked up at the store, for $3.75.

Even children were encouraged to become Sibley's customers. A publication called the *Juvenile Magazine*, with stories and games, was published monthly in the 1920s and 1930s. The September 1928 issue displayed images of "Bobby and Tom in their new clothes from Boyland." The magazine's editor was Sybil Lee.

Sibley, Lindsay & Curr Co.

"A DILLER A DOLLAR
A TEN O'CLOCK SCHOLAR
WHAT MAKES YOU COME SO LATE?"
"AT BREAKFAST THE JUVENILE MAGAZINE
WAS LYING BESIDE MY PLATE"

SEPTEMBER © 1928

The
Juvenile Magazine
PUBLISHED MONTHLY

Young girls were encouraged to visit the Bobbing Shop on the sixth floor. It opened during the 1920s, when bobbed hairstyling was a popular fad among women and girls.

The Sibley, Lindsay, and Curr Company spent $250,000 to install an escalator system reaching its fourth floor. Ceremonies on September 30, 1936, initiated the moving stairway. Among the first to use Sibley's latest convenience were Rochester dignitaries Charles Stanton, mayor, (left) and John R. Sibley, Sibley's vice president. (Courtesy History Division, Rochester Public Library.)

On the first floor, the escalators were often surrounded by unusual sales attractions. To generate interest in springtime corsages for hat and dress adornment, a mannequin was posed on the branch of a simulated tree. No doubt in 1942, the unusual creation boosted sales. (Courtesy History Division, Rochester Public Library.)

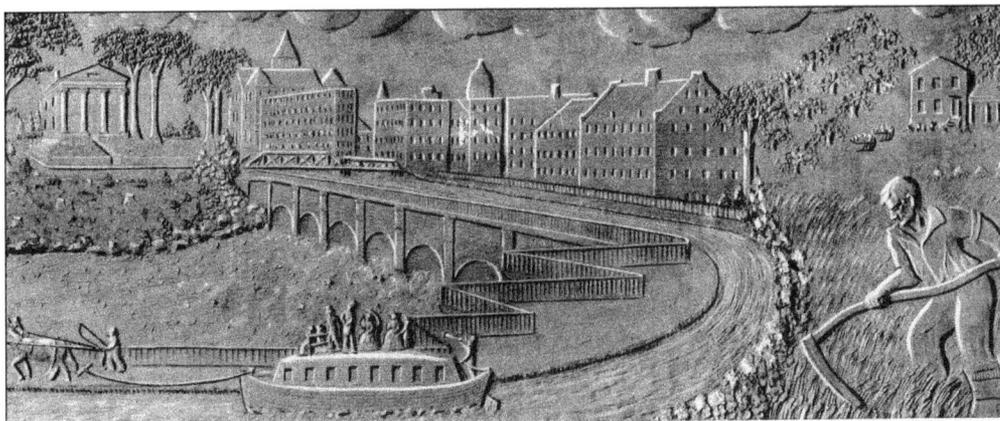

The Flour City · 1840 · 1860

On the main floor, a bank of elevators separated the dry goods departments from the grocery department. Sibley's commissioned an artist to design a trio of plaster art reliefs above the central elevator bank to rekindle memories of Rochester's glorious past. Highlighted above the left most elevator one sees the *Flour City 1840–1860*, showing the city's early origins and its connection to the Erie Canal.

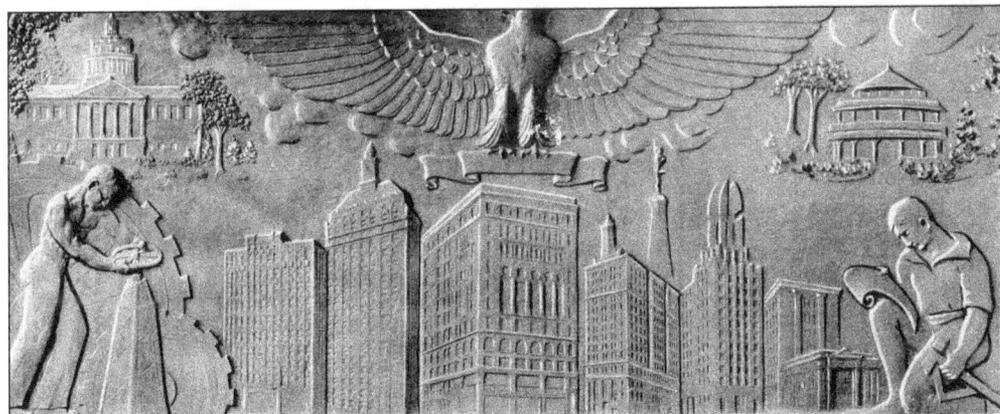

The Skyline of Our Modern City

The center plaster relief depicts the *Skyline of Our Modern City*, reminding patrons of the city's great industries, stores, public and private educational institutions, and beautiful parks. The elevator banks are set in a wall composed of polished marble bearing numerous fossils, which can still be viewed today.

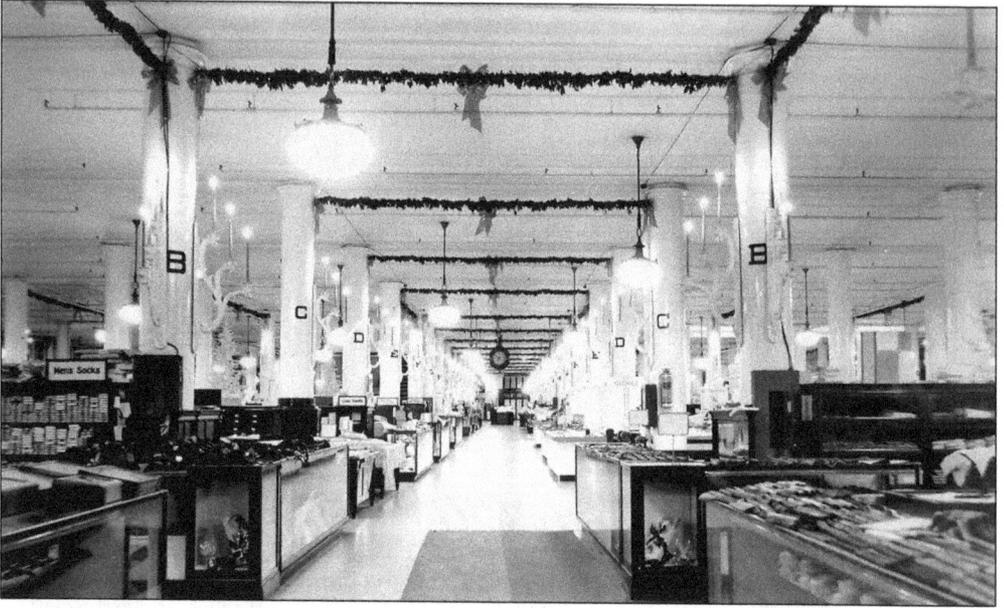

In 1938, Christmas shoppers may have encountered this view looking west and showing the store's main floor. Note the great copper-clad clock at the center of the main corridor. Many people met one another under this downtown landmark. Counter cases are seen filled with men's shirts, socks, and accessories. Lettered columns aided floorwalkers in directing patrons to the articles they sought. Red bows and green swags decorate the main aisle. (Courtesy History Division, Rochester Public Library.)

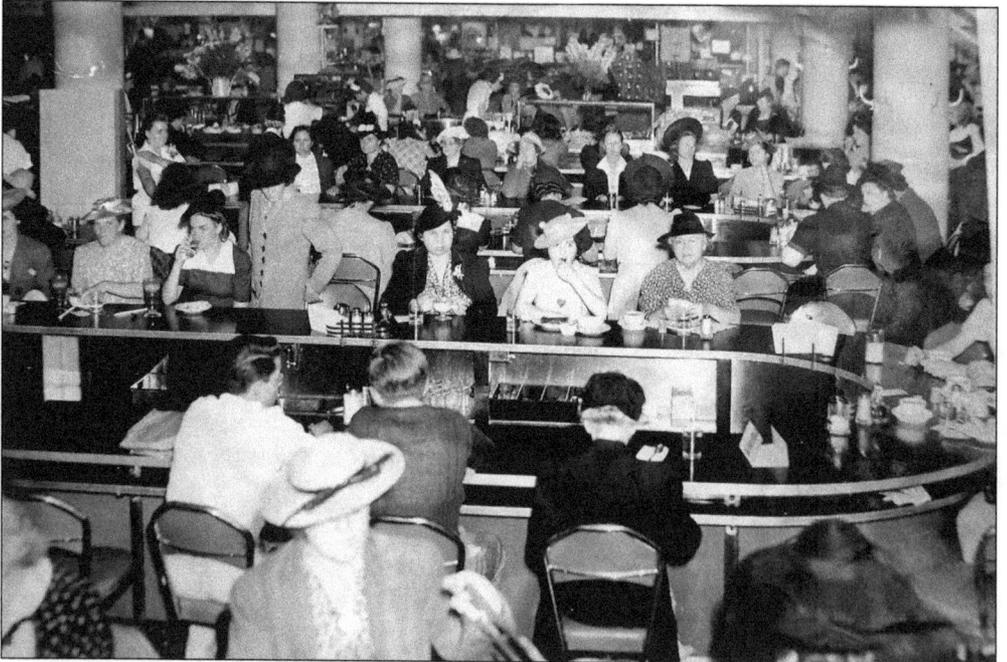

Many patrons sought Sibley's basement cafeteria as their preferred lunch spot in the 1930s. The food was both ample and inexpensive. Notice that women dressed up to go shopping, as all are wearing their favorite hats. (Courtesy History Division, Rochester Public Library.)

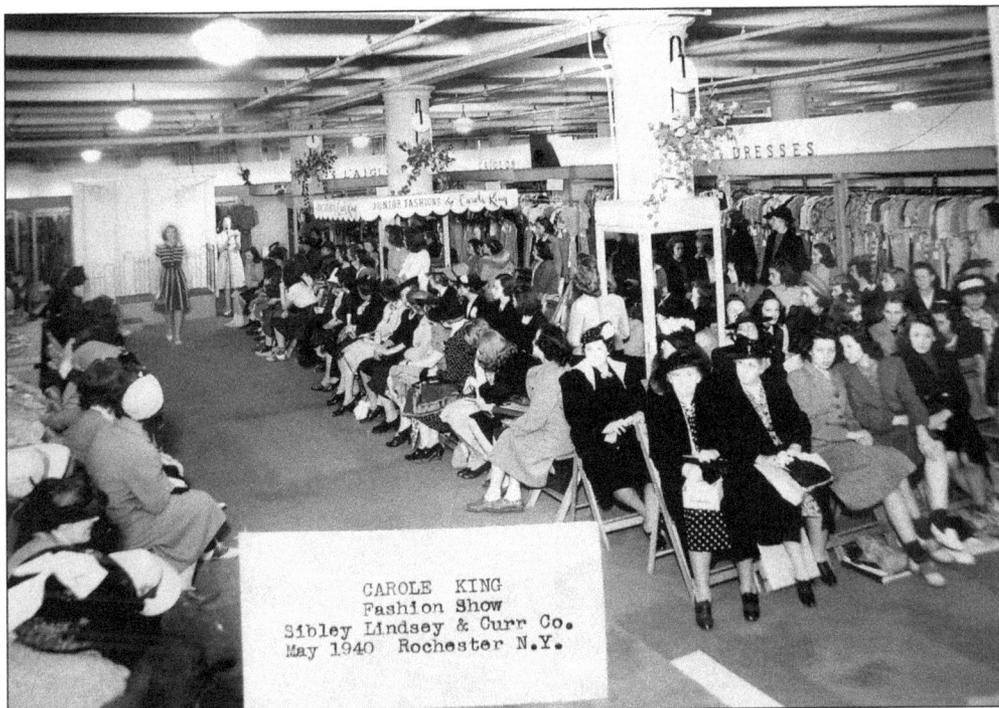

CAROLE KING
Fashion Show
Sibley Lindsey & Curr Co.
May 1940 Rochester N.Y.

One of the attractions missing today is the annual spring fashion show Sibley's sponsored. Interested patrons arrived early to get a good view of the latest junior fashions modeled by a dozen charming young women. (Courtesy History Division, Rochester Public Library.)

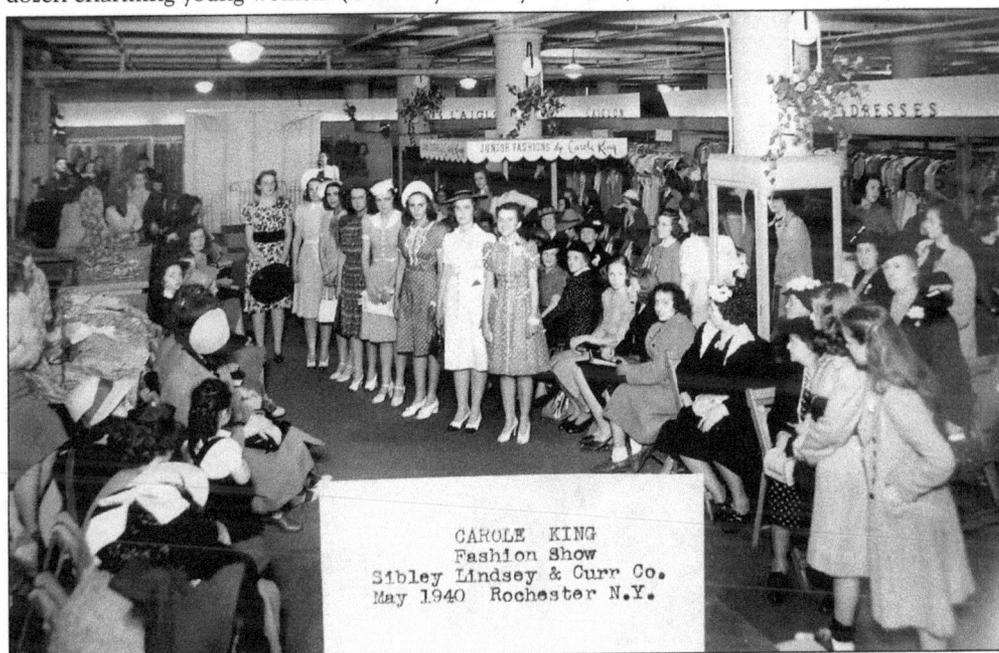

CAROLE KING
Fashion Show
Sibley Lindsey & Curr Co.
May 1940 Rochester N.Y.

The display of Carole King's new line of junior fashions was a major highlight for shoppers in May 1940. The models in high heels are seen before an enthusiastic audience packing Sibley's third floor. (Courtesy History Division, Rochester Public Library.)

In December, Sibley's fourth floor Toy Land became a wonderland for young kids. In the mid-1940s, *Gulliver's Travels* was depicted through a series of elaborate displays viewed while passing through Sibley's fabled Toy Land Tunnel. At the tunnel's entrance was the kazoo man. (Courtesy History Division, Rochester Public Library.)

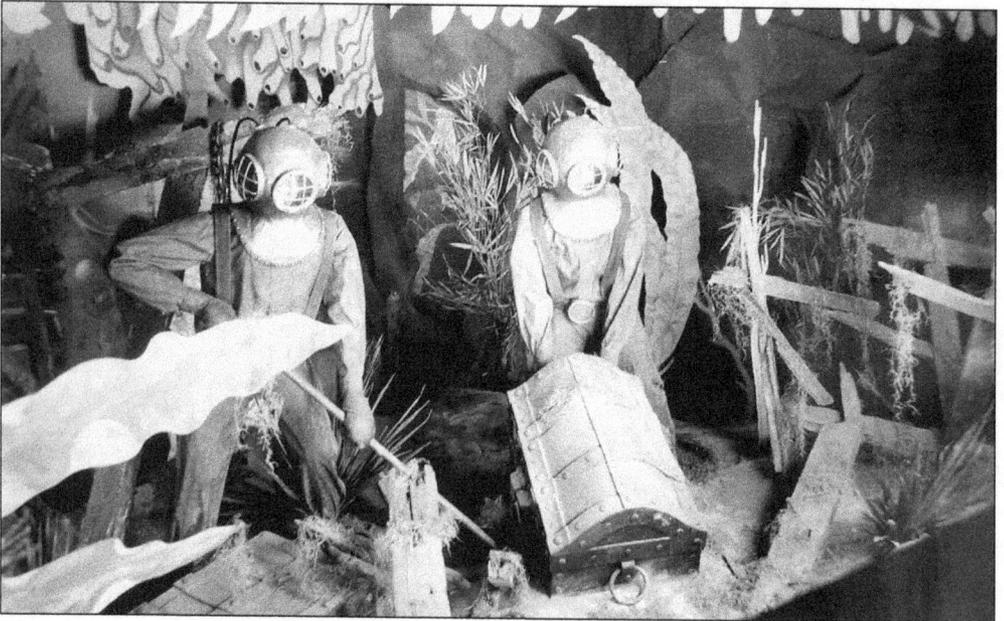

This elaborate underwater scene drew attention to a special sale or was part of a series of displays set up in the annual Toy Land Tunnel during a 1940s Christmas season. (Courtesy History Division, Rochester Public Library.)

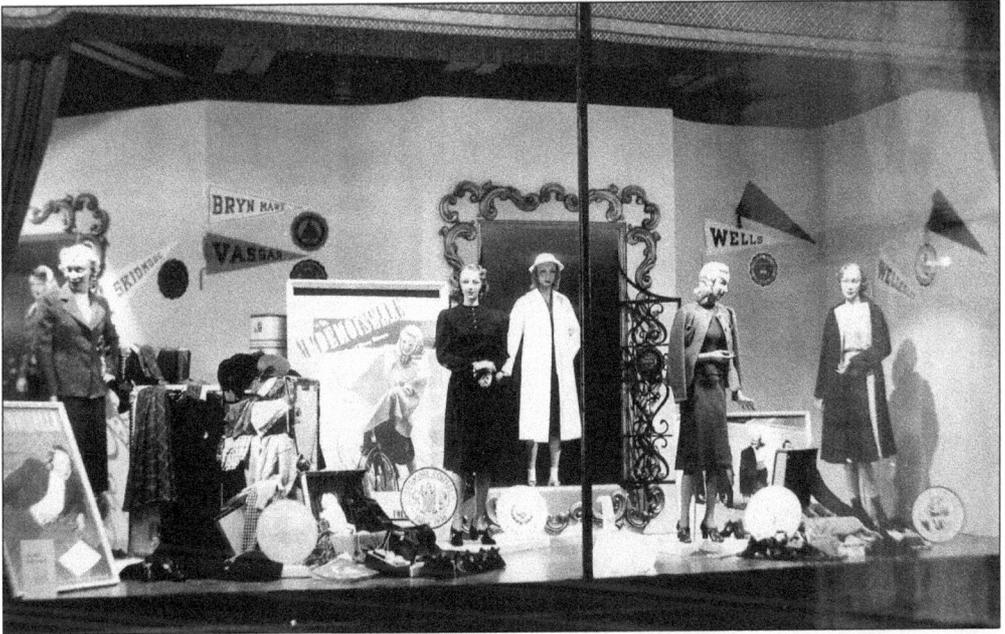

Sibley's department store boasted more display windows than Macy's or Gimbel's, employing a small army of window dressers. It was a delight to go window shopping downtown, a pastime lost today. When area coeds entered or returned to college, they may have been outfitted by Sibley's. In the late 1940s, this store window was dressed with a fashionable array of appealing apparel. (Courtesy History Division, Rochester Public Library.)

Both hobbyists and sports-minded fans were drawn to the sporting goods and hobby shop, located in a corner of Sibley's fourth floor. Here was equipment for tennis, archery, football, or golf. The counter in the background displays model ship and airplane kits and philatelic supplies. (Courtesy History Division, Rochester Public Library.)

Sibley's music department is shown here around 1930. It sold spinet, grand, and upright pianos, as well as accordions, strings, reeds, and brass musical instruments. A study of the photograph reveals a portion of their stock displayed with bouquets of fresh flowers. (Courtesy History Division, Rochester Public Library.)

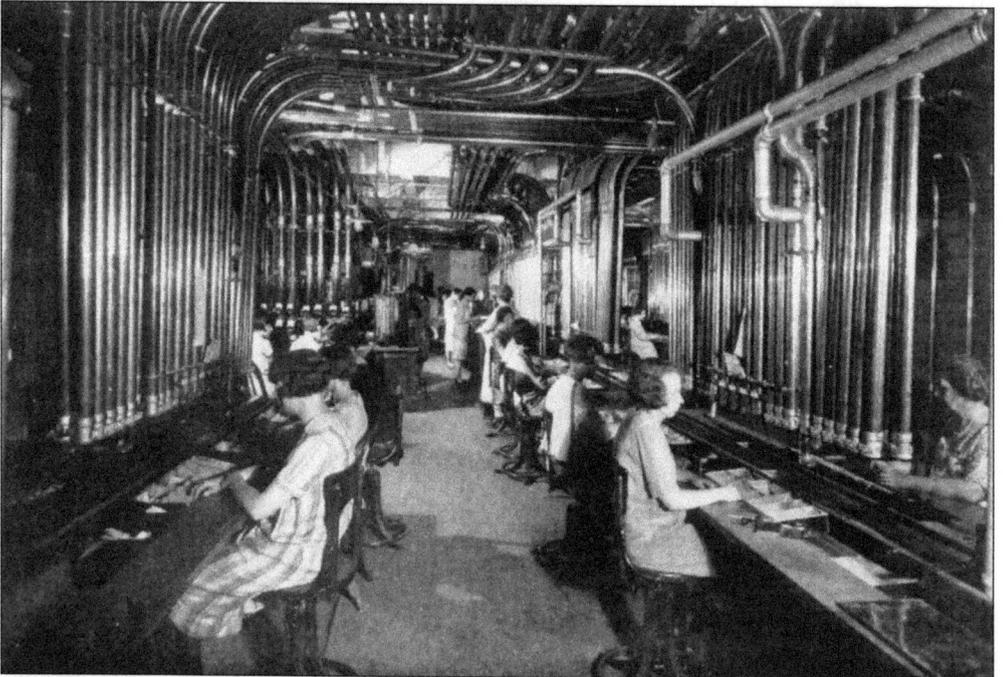

In many of the Sibley photographs, a series of pneumatic tubes can be seen. These carried sales transactions from each department to the basement tube room. There, dozens of women made change, wrote receipts, and sent a brass capsule whooshing back to the store clerk. Sibley's had 34 miles of copper, pneumatic tubing, the largest such system in the nation.

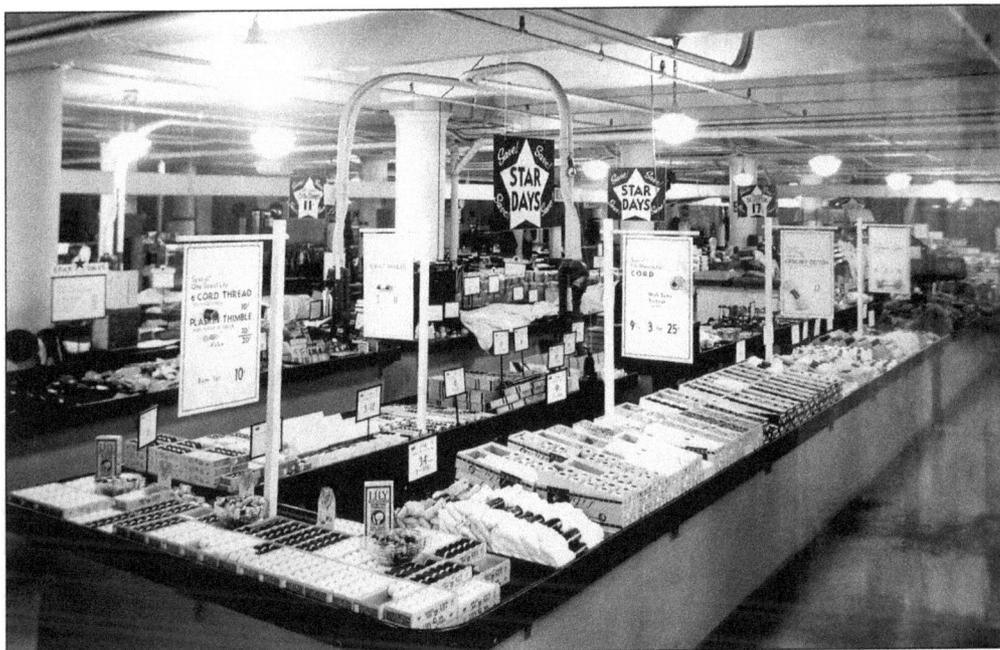

Sibley's basement was often the location for budget items. Yarn, thread, and other needle-craft notions were promoted during Sibley's Star Days sale. Prices of the 1940s seem modest by today's standards. Note the many curved pneumatic tubes in the background. (Courtesy History Division, Rochester Public Library.)

One of many Sibley innovations was the charga-plate, a 2.5 inch aluminum disk that came in a handy red carrying case. Long before the plastic charge card was marketed, Sibley's and its associates introduced Rochester residents to this handy method of shopping without cash. An edge notch in the aluminum frame designated other stores where the convenient system could be used.

Rochester Charga-Plate Associates

ROCHESTER CHARGA-PLATE ASSOCIATES
"Use Your Charga-Plate For Better Service"

Mrs _____ avis

PLEASE SIGN NAME HERE IN INK

RDS & SON
CO. McCURDY & CO. INC
 SIBLEY, LINDSAY & CURR
 ROCHESTER 4, NEW YORK
225 BURKE BLDG. PHONE STONE 5864

HERE'S NEW SHOPPING CONVENIENCE FOR YOU!

This letter brings to you your personal Charga-Plate to make your shopping even more pleasant in those of the stores listed above where you have accounts.

Each square notch in the edge of your Plate represents an open account in a member store; the circular notch represents the city of Rochester.

Your Charga-Plate contains the notches of those member stores where you have accounts, and it may be used only in those stores. Just hand it to the salesperson whenever you make a charge purchase, whether you are taking the merchandise with you or having it sent. That's all there is to it when you shop the Charga-Plate way!

Look inside this letter for your Charga-Plate and the simple directions for using it.

This modern shopping service is so convenient that you'll want to have your Charga-Plate with you ys. Please sign it right now and slip it into your urse, ready for your next shopping trip.

Yours for better service,
Rochester Charga-Plate Associates

GOES "BATS" ABOUT BONDS
We'll See You at the Ball Park
SIBLEY NIGHT
Wednesday, June 21—7:45 P. M.
SPONSORED BY THE FIFTH WAR LOAN COMMITTEE AND
THE RECREATION CENTER COMMITTEE
Admission: Men, 90c — Women, 33c — Children, 55c

FIFTH WAR LOAN DRIVE

This is your ticket for the Sibley
reserved section. . . . Keep It!

Nº 1002

Good for Box Seat
S. L. & C. Co.
BASE BALL - BOND NIGHT
June 21, 1944

A patriotic Sibley's sponsored the city's fifth war loan drive by promoting an evening at the ball park. "Sibley's Goes Bats about Bonds" invited customers to attend a Red Wings game on Wednesday, June 21, 1944, for only 33¢ a ticket. Women were given box seats in their own special lady's section.

SIBLEY'S . . . Upstate New York's largest department store

SHERATON HOTEL . . . Rochester's best address

Realizing that shopping during the Christmas Season can become a test of endurance, Sibley's Rochester and the Sheraton Hotel have combined to offer you "Shopping First Class" in Rochester.

You and your friends may drive to downtown Rochester, have a room at the Sheraton Hotel from 9 A.M. to 7 P.M., to be used as your "base of operations" (a place to freshen-up, relax, store your packages). The cost of the room . . . only 3.85 (for one to four people). Your car will be parked free of charge . . . of course! This service available through December 31st.

Sibley's, Upstate New York's largest department store with over 150 shops and services, will have a gift package awaiting you in your room with helpful information to aid in planning your day of "Shopping First Class."

Wishing you a most enjoyable shopping trip and a very Merry Christmas.

William P. Gorman, Vice President
Sheraton Hotel

Arthur J. O'Brien, President
Sibley, Lindsay & Curr Company

Another highly imaginative idea Sibley's originated was a combination free parking space and an overnight stay at the Sheraton Hotel. The nominal price of $3.85 was used to lure out-of-town shoppers to Sibley's at the Christmas season during the 1950s.

During May 5 through 29, 1953, Sibley's celebrated its 85th anniversary. The menu from the Sibley Tower Restaurant is dated May 8, 1953. A comparison of the prices of the restaurant's 1953 luncheons with those of today shows what inflation has done to the dollar.

Our Tower Luncheons

Served from 11 A.M. to 3 P.M.

Hot Chicken Consomme Chilled Tomato Juice
Manhattan Clam Chowder Chilled Prune Juice

	Luncheon	Entree
1. VIRGINIA BAKED SMOKED HAM with Fruit Sauce, Diced in Cream Potatoes, Buttered Green Peas	1.60	1.30
2. BAKED CREAMY MACARONI and Cheddar Cheese En Casserole, Buttered Fresh Broccoli, Tossed Fresh Greens Salad with French Dressing	1.20	.90
3. BROILED FRESH JUMBO WHITE FISH with Lemon Points, Parsley Buttered Potatoes, Buttered Fresh Carrots	1.40	1.10
4. ASSORTED FRESH VEGETABLE PLATE: 4 Vegs. (With Poached Fresh Egg, .20 Extra)	.85	.55
5. BAKED SPANISH MACARONI and Fresh Ground Beef En Casserole, Buttered Corn, Jellied Salad on Crisp Lettuce	1.20	.90

"MAY SALE SPECIAL"
Chilled Tomato Juice
Fresh Fish Newburg on Southern Style Corn Bread
Crisp Cole Slaw Coffee, Tea, Milk
Ginger Bread with Apple Sauce
1.00
(No Substitutions, Please)

Choice of

Chocolate Layer Cake Jellied Fruit, Freshly Whipped Cream
Ice Cream Frosted Whipped Custard Sherbet
Coffee Tea Milk

Half Portions May Be Had for Children for One-Half Entree Price

YOU MAY SELECT YOUR LUNCHEON FROM OUR

Buffet Table

Turkey Salad	.90	Turkey	1.30
Cold Cuts or Eggs	.80	Jellied Meat Loaf	.80
Ham	1.05	Tunafish Salad	.80

CAKES, PIES, BREADS AND ROLLS SERVED IN THE TOWER RESTAURANT ARE SOLD IN THE ROLLING PIN AND PANTRY MAIN FLOOR, NEAR AISLE G

Minimum Check 25c

SIBLEY TOWER RESTAURANT, FRIDAY, MAY 8, 1953

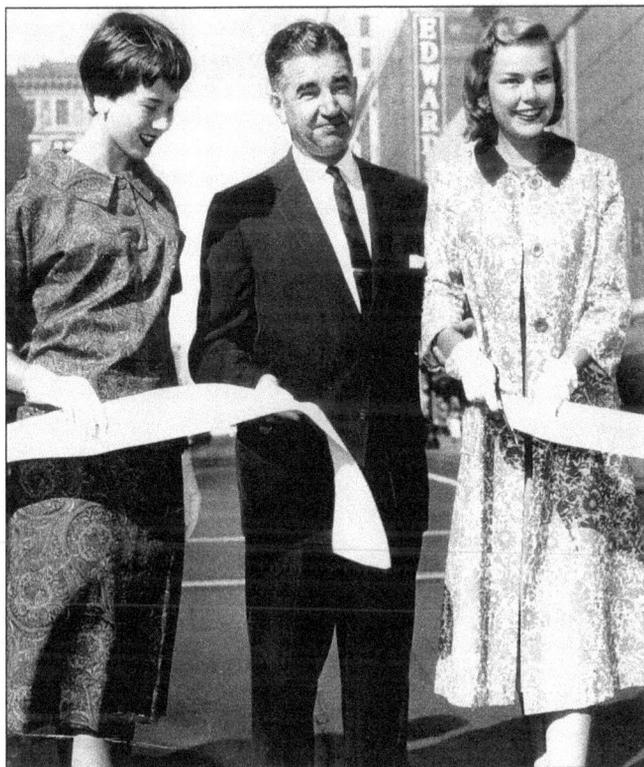

Another promotion was a ribbon-cutting ceremony to open a summer shopping spree at Sibley's. On August 19, 1958, the newly appointed Sibley president, Arthur J. O'Brien, shares the spotlight with Harvest Queen Lynette (left) and attendant Kathleen Webster. The event took place at the intersection of East Main Street and Clinton Avenue. Sibley's did $30 million in business that year. O'Brien's wife was a granddaughter of Thomas B. Ryder, a Sibley's partner from 1857 to 1942. (Courtesy History Division, Rochester Public Library.)

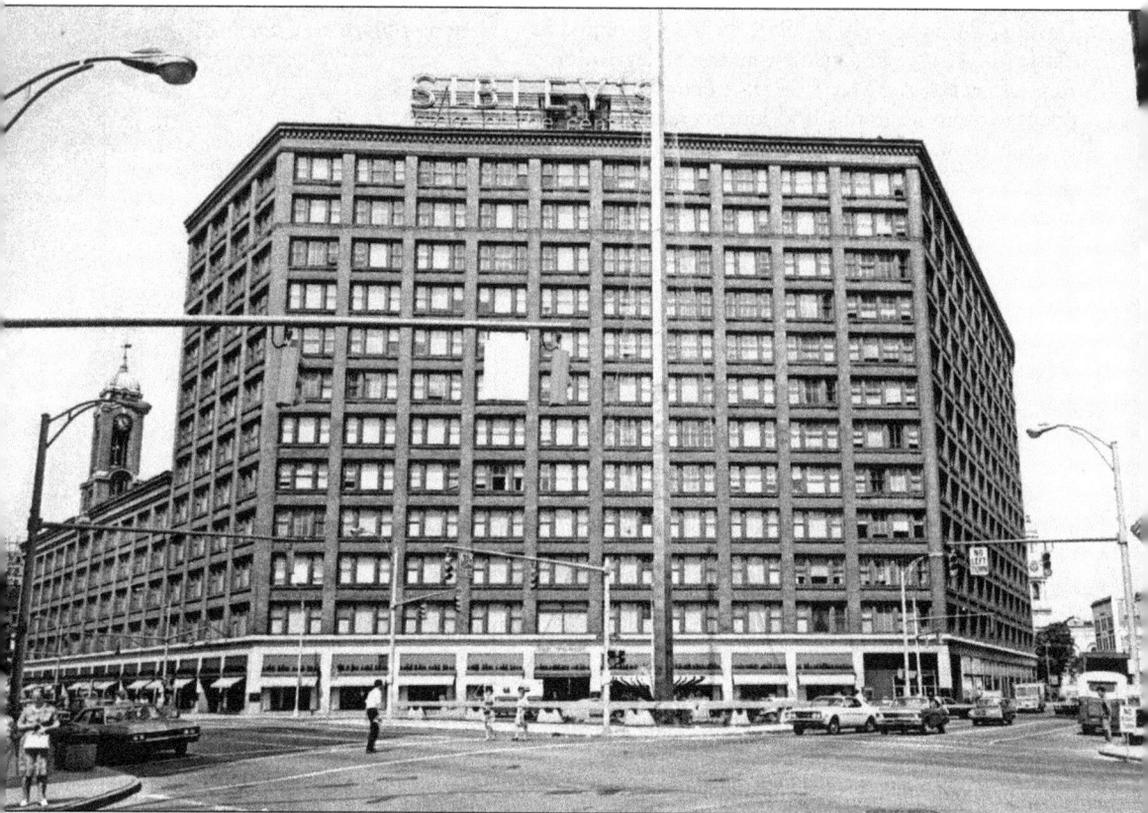

This 1970s photograph by Carleton Allen shows the "Late, Great Sibley's." Becoming part of Associated Dry Goods in August 1957, it became part of the May Department Stores in July 1968. Later, it merged with Kaufmann's Department Stores. The building was purchased by Wilmorite around 1990. Skip Mangone wrote this fitting lament to Sibley's to the tune of *Swanee*. It appeared in Mike Zeigler's column in the *Democrat and Chronicle* newspaper.

"Sibley's, why you leavin'? Why you leavin'?
Our dear old Sibley's.
You've been our cornerstone,
A place that we call H-O-M-E goin' crazy,
We'll miss your escalators, elevators,
Please stay here, Sibley's.
Us city folks cannot be the same
If we don't see the Sibley's name.
The folks downtown will see you no more,
You've always been our favorite store."